# PARIS

## 500 PHOTOS

*8083*

Note: the abbreviation "arr." used throughout the text refers
to the Paris "arrondissement," or district, as shown on the
map on pages 484–485.

Translated from the French by Adam Weiss
Copyedited by Lisa Barnett
Cartography: Raimond Guardia
Color separation by Penez Édition, Lille

Published simultaneously in French as *Paris 500 Photos*
© Flammarion, 2003

English-language edition
© Flammarion, 2003

07 08 09 10 6 5 4 3

ISBN: 978-2-0803-0426-1
Dépôt legal: 02/2003

Printed in Singapore by Tien Wah Press

MAURICE SUBERVIE

## Library

# CONTENTS

Photographing Paris...
by Bertrand Delanoë
*page 6*

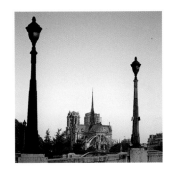

The Right Bank
*page 111*

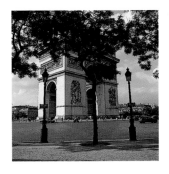

# Passageways

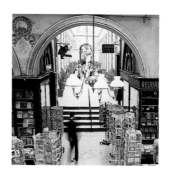

# The Left Bank

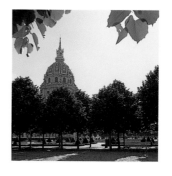

# Gardens

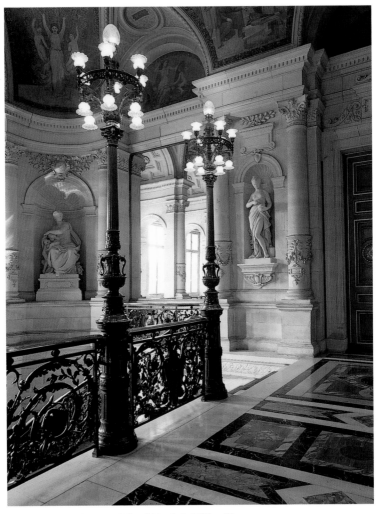

The majestic decor of the Hôtel de Ville, 4th arr.

# Photographing Paris…

by Bertrand Delanoë

How many people, during an aimless stroll through our city, have felt the urge to seize a color, an instant, a piece of the azure sky, or a fragment of the night?

The art of photography, an inexhaustible pursuit, opens wide the doors of the imagination, inspiring us to record everything from the strange and unusual to the purely aesthetic and representational. To photograph Paris is to enter a setting with infinite possibilities, in which the spirit of creation blossoms with each and every step.

A child drawing on a gravel path in the Luxembourg Gardens, the mist as it envelops the steps of Montmartre, the gaze of an anonymous passerby fascinated by the reflections in the Seine: so many images captured in furtive moments are passed on to posterity and thus transformed into signatures of this universal city, loved the world over.

To photograph Paris is to manufacture memories, lasting impressions that bring back a rush of sensations and sentiments that we cling to whenever the weather is a bit too cold or our hearts a bit too heavy.

Can I even say what images I associate with Paris, which "snapshots" come to mind whenever I hear the word? It would be a difficult task indeed, given how richly diverse this city is, from its people to its architecture.

The stunning movement of Niki de Saint Phalle's mobile sculptures, the gargoyles atop Notre-Dame, the ceramic façades of old storefronts in the *marais*, the harmony of the Buttes-Chaumont, the charm of rue Lepic: the list is endless but would not be complete without the people themselves, their faces, their gestures, their professions, their lives—all of which offer a limitless treasure just waiting to be captured.

Maurice Subervie does just that, with a talent and a sharpness that show how deeply he loves Paris.

Paris by night, the dome of the Invalides, and the Arc de Triomphe.

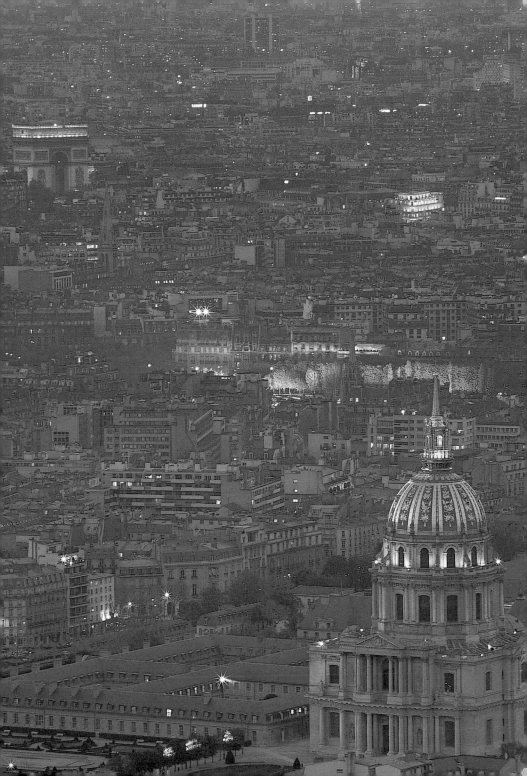

His photographs are filled with color, flooded with sunshine, or illuminated by the city's evening lights. Subervie's Paris reflects the graceful encounter between our city's modern landscape and its historical legacy, and invites us on an intimate tour, guided by the aesthetic magic that characterizes each place and every situation. Movement is always present in these photographs. Perhaps it is because each picture forcefully records a dazzling swirl of activity, or perhaps it is because with such a magnificent backdrop, the city awakens each day prepared to welcome onto its stage the actors of daily life and the rhythm that they bring with them.

This book invites us on a voyage of sensations that introduces us to the rich variety of Paris's visual splendor. It is a voyage inspired by this gifted artist, and one that is well worth the journey.

Saint-Sulpice church,
in the heart of the left bank.

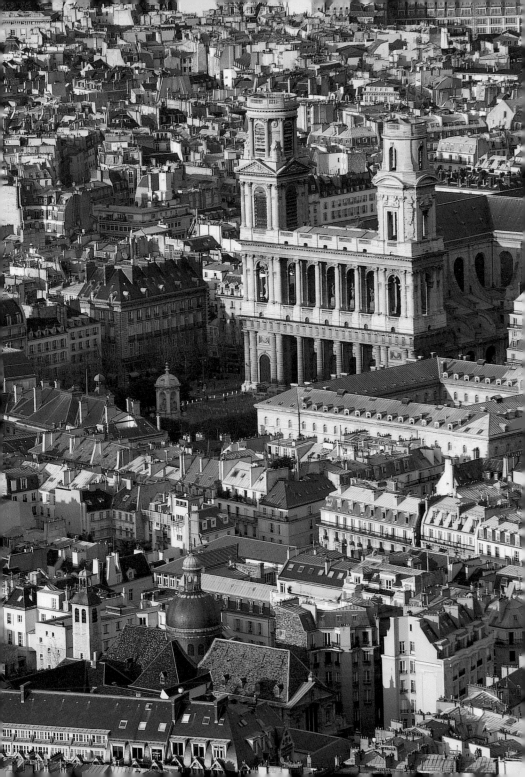

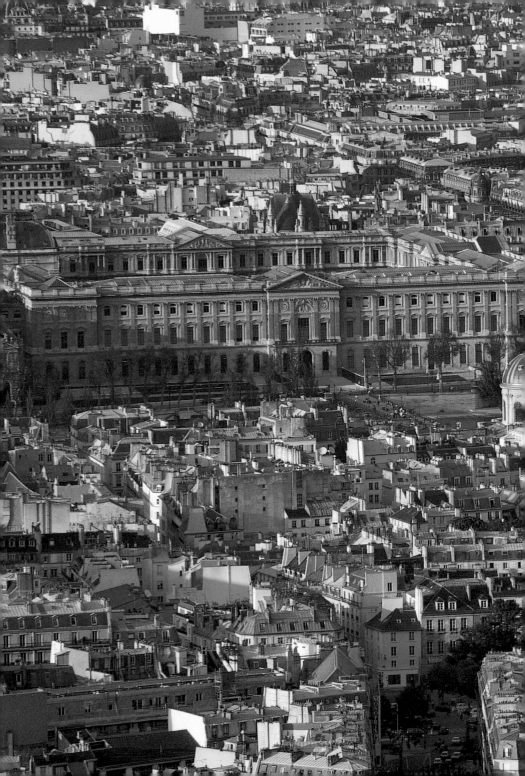

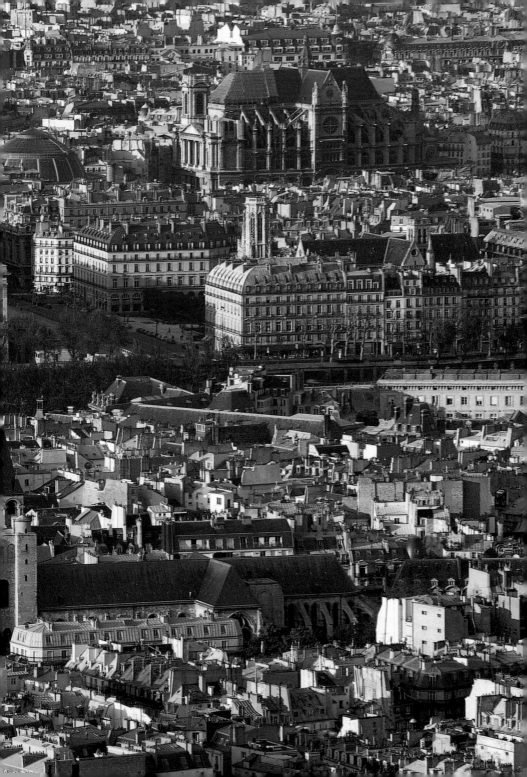

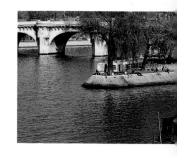

# The Seine and Its Islands

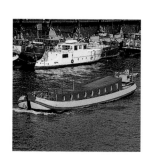

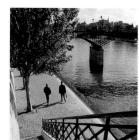

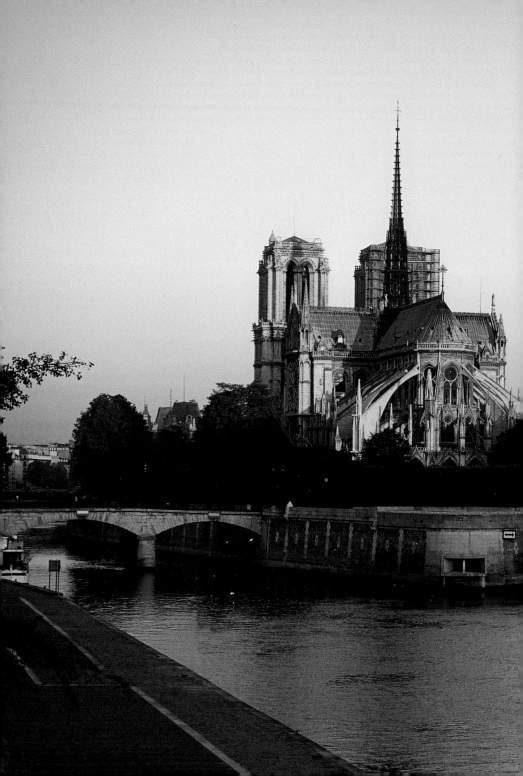

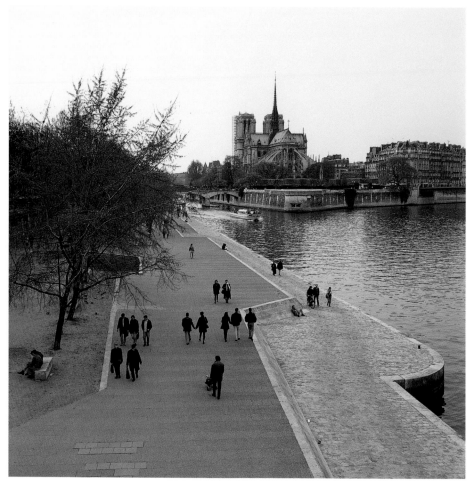

The quai de la Tournelle, Notre-Dame, and l'île de la Cité, 4th arr.

*preceding double page*

Notre-Dame and l'île de la Cité,
from the pont de la Tournelle, 4th arr.

The square in front of Notre-Dame, 4th arr.

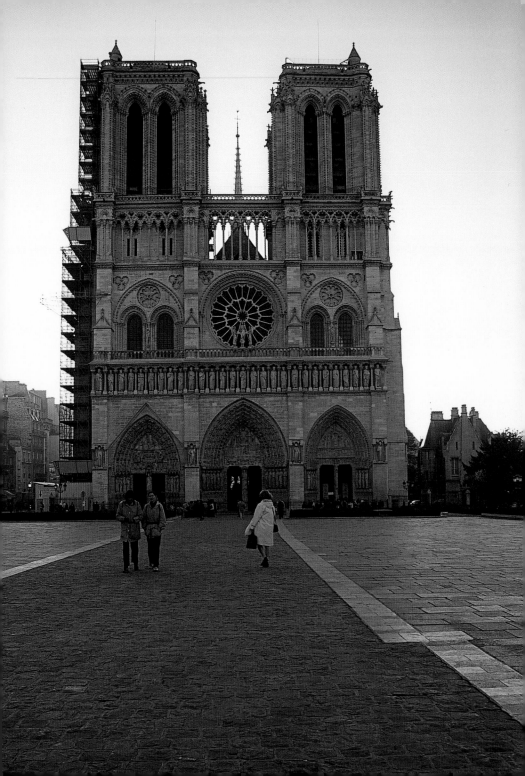

# The Seine and Its Islands

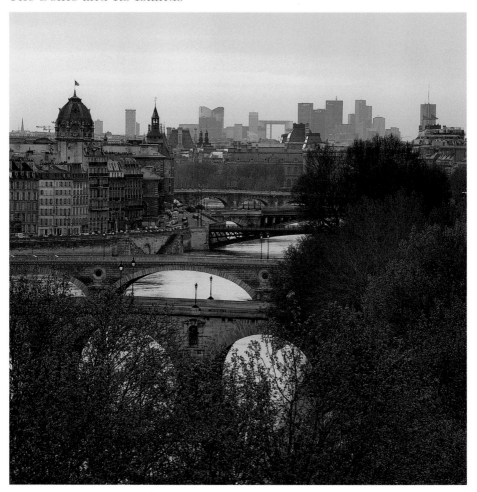

Bridges spanning the Seine, from the Pont-au-Change to the pont Royal.

Notre-Dame,
from the Pont-au-Double, 4th arr.

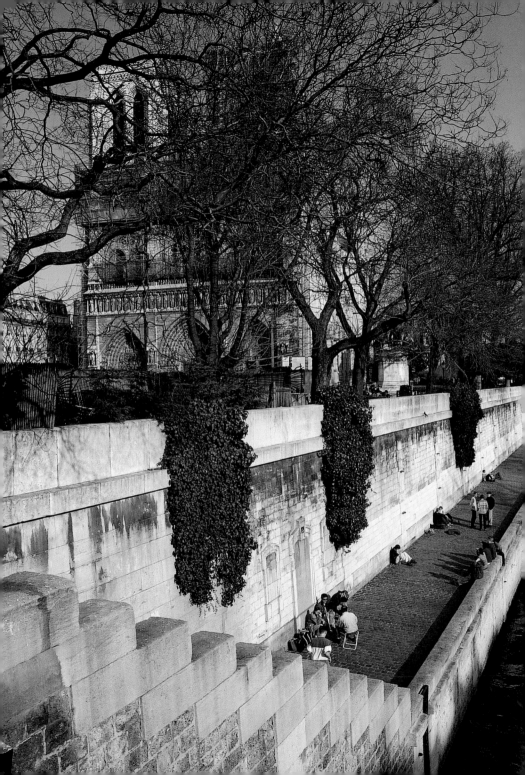

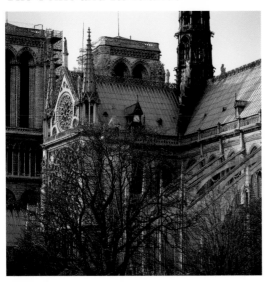

Rose window and slanted roof of Notre-Dame,
from the quai d'Orléans, 4<sup>th</sup> arr.

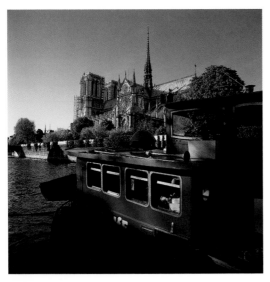

Notre-Dame Cathedral,
from the quai de Montebello, 4<sup>th</sup> arr.

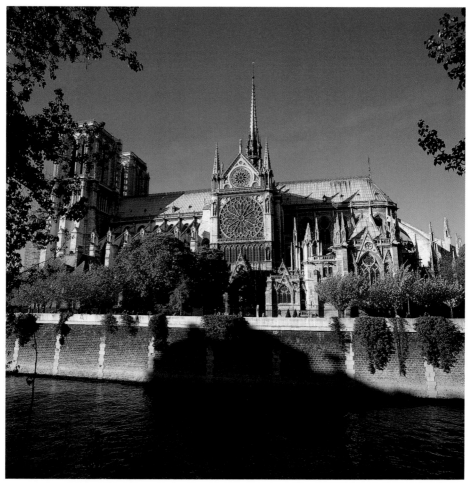

Notre-Dame and Jean XXIII Square, overlooking a narrow passage of the Seine, at the tip of l'île de la Cité, 4th arr.

*following double page*

The famous *bouquinistes*, or booksellers, on the quai de Montebello, 4th arr.

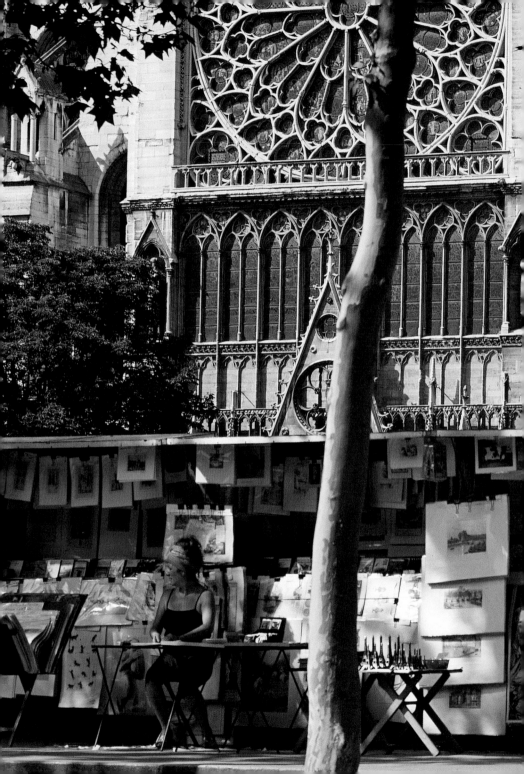

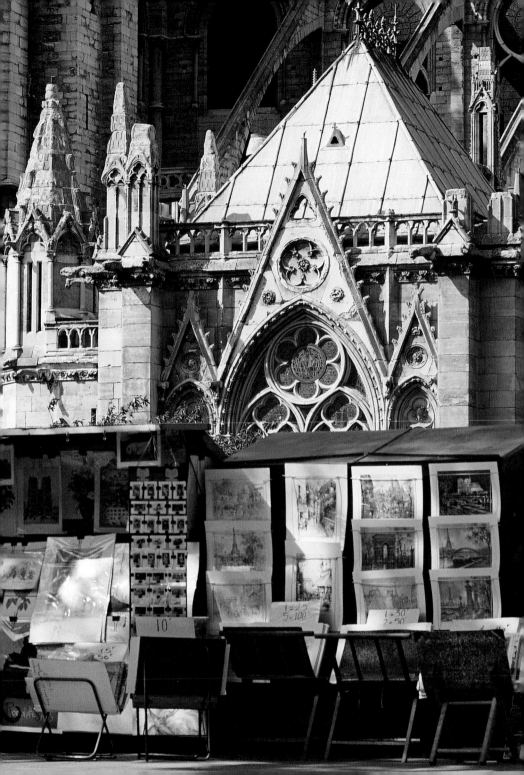

The Louvre, from the quai Malaquais, 6<sup>th</sup> arr.

*Bouquiniste* on the quai Malaquais, 6<sup>th</sup> arr.

*Bouquiniste* along the
banks of the Seine.

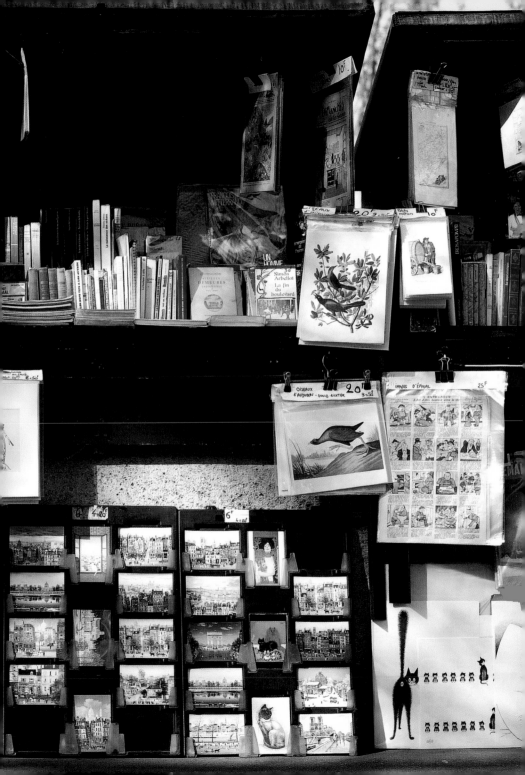

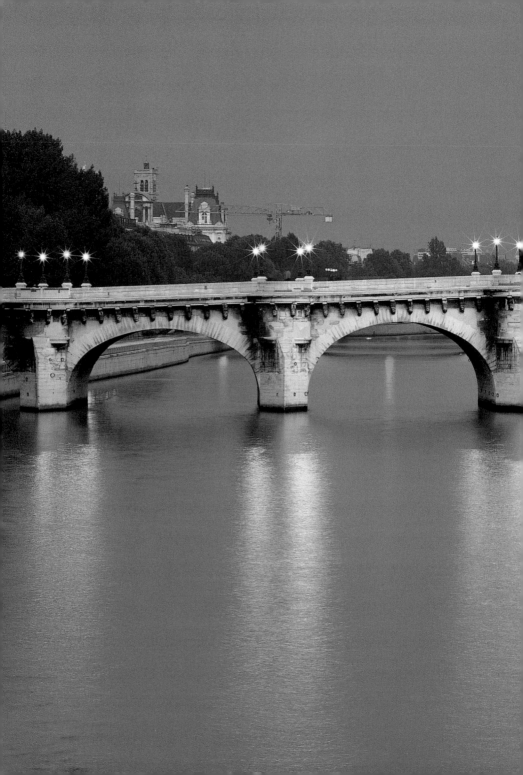

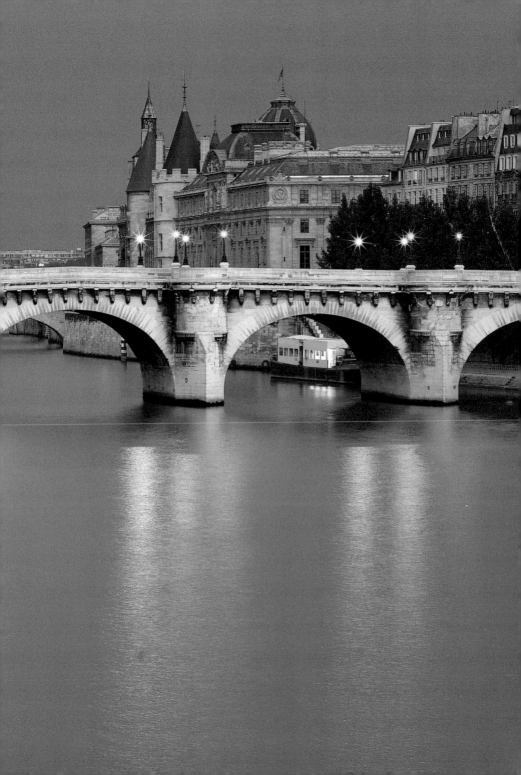

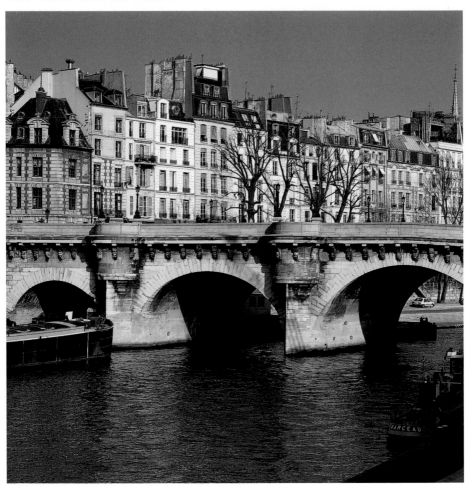

The Pont-Neuf where it reaches the Left Bank
and the façades along the quai des Orfèvres, 1st arr.

*preceding double page*

The Pont-Neuf and the Conciergerie, 1st arr.

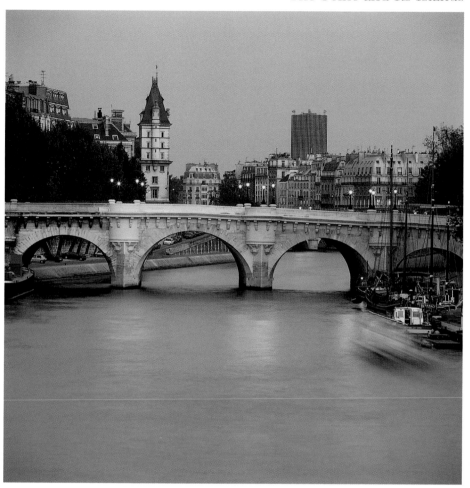

The Pont-Neuf—or "New Bridge," which is actually Paris's oldest bridge—
where it reaches the Right Bank, 1ˢᵗ arr.

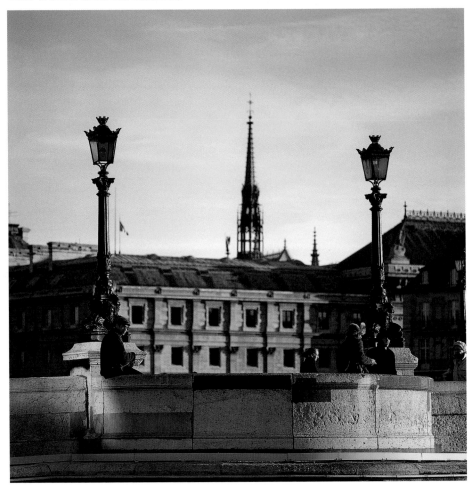

The spire of the Sainte-Chapelle, from the Pont-Neuf, 1st arr.

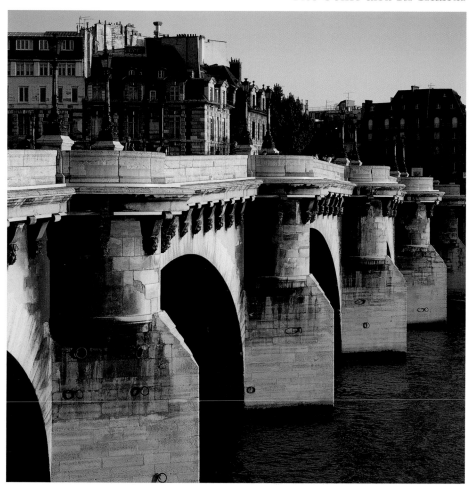

The Pont-Neuf and the façades along the quai de l'Horloge on l'île de la Cité, 1st arr.

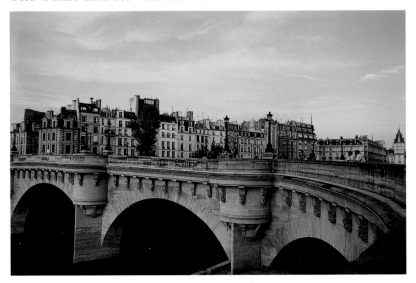

The Pont-Neuf and the homes along the quai des Orfèvres, from the quai Conti, 1$^{st}$ arr.

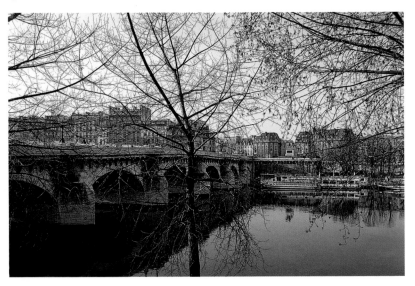

Tour boats leaving from the Pont-Neuf to offer visitors a view of Paris from the Seine.

An arch of the Pont-Neuf.
Between the streetlamps on the bridge,
the profile of Henri IV's statue, 1$^{st}$ arr.

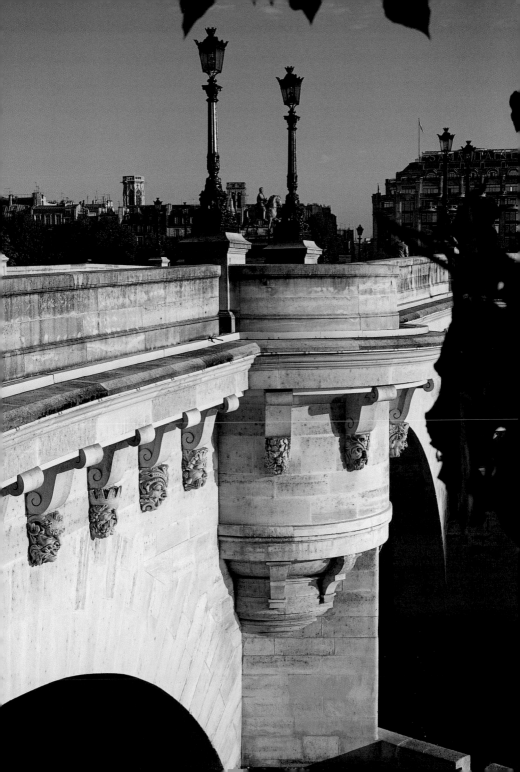

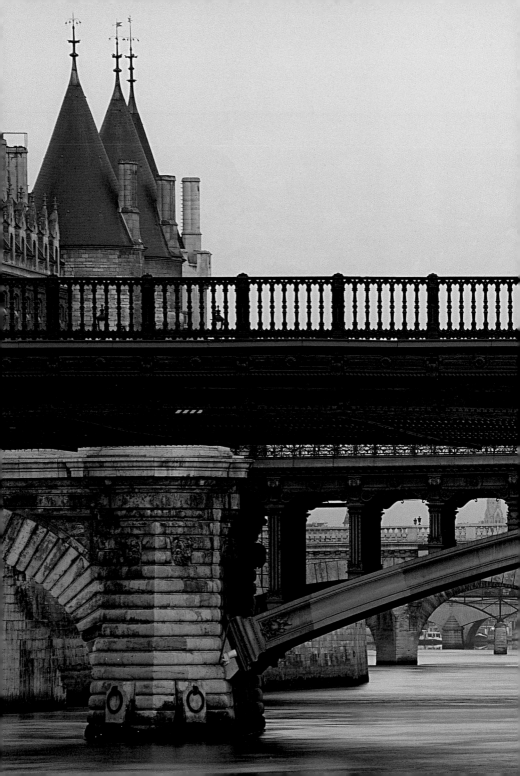

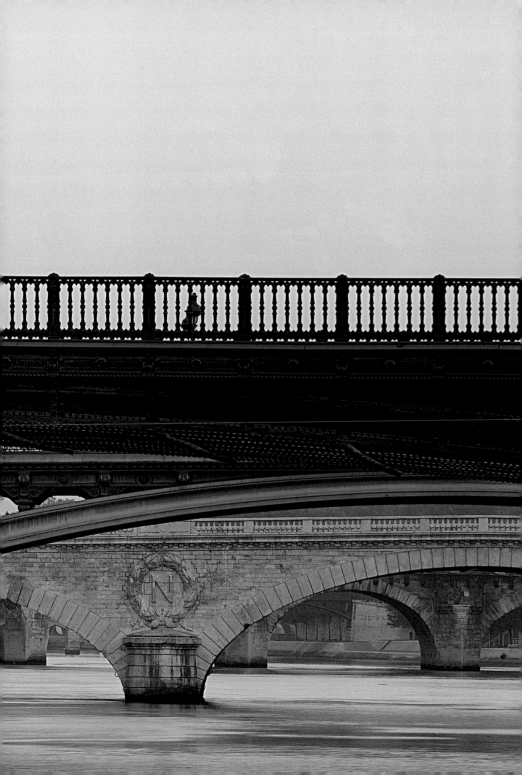

The quai d'Orléans, l'île Saint-Louis, 4th arr.

*preceding double page*

Pont d'Arcole, pont Notre-Dame, Pont-au-Change,
Pont-Neuf, pont des Arts, pont du Carrousel.

The houses along the quai des Orfèvres on l'île de la Cité, 1st arr.

# The Seine and Its Islands

Façades along the quai d'Orléans,
l'île Saint-Louis, 4th arr.

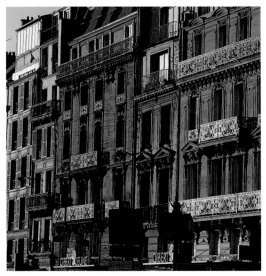

The quai Saint-Michel, 5th arr.

The Seine along the quai Saint-Michel, 5th arr.

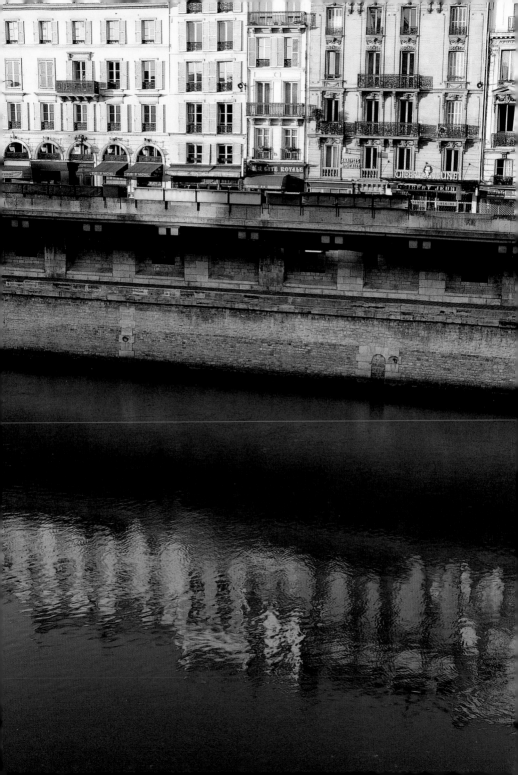

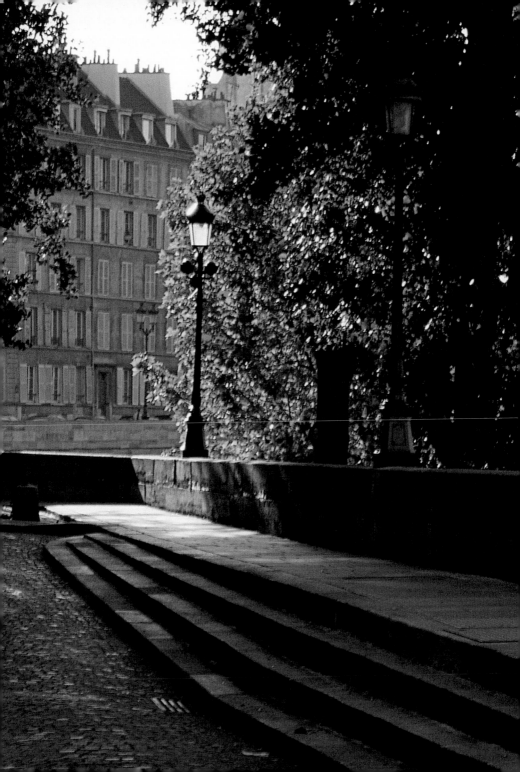

# The Seine and Its Islands

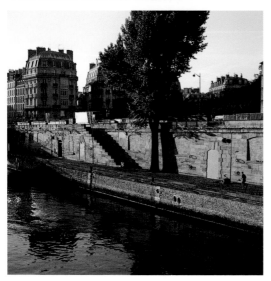

The quai de Montebello, 5ᵗʰ arr.

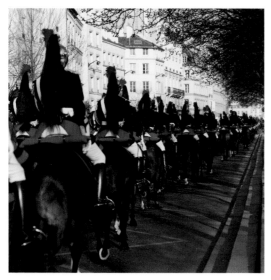

The Republican Guard,
on the quai de Montebello, 5ᵗʰ arr.

*preceding double page*

At the tip of l'île Saint-Louis, the quai de
Bourbon overlooking buildings along the
quai aux Fleurs, Left Bank, 4ᵗʰ arr.

Birds sitting on the edge
of the Seine, quai aux Fleurs, 4ᵗʰ arr.

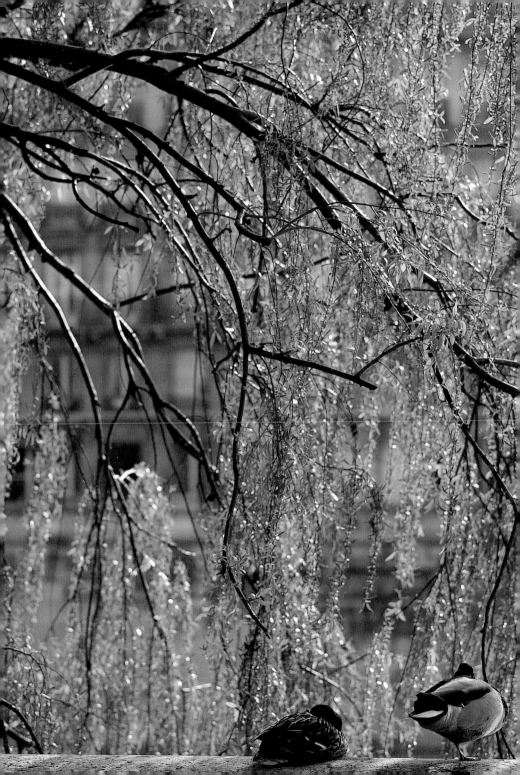

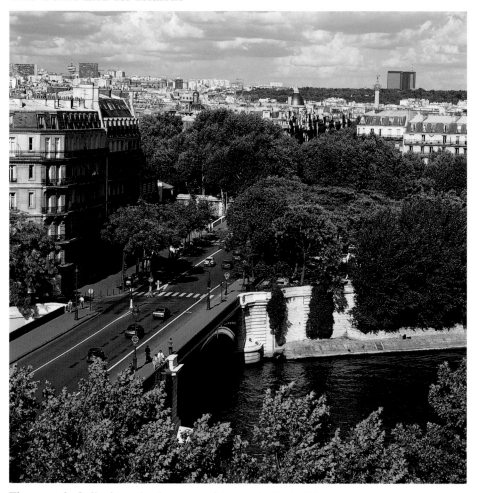

The pont de Sully, from the Institute of the Arab World, 5th arr.

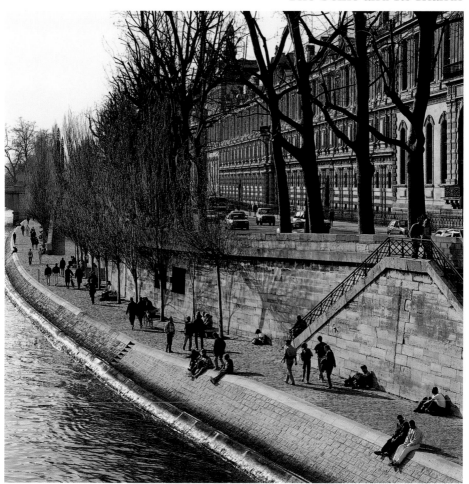

The quai du Louvre, 1st arr.

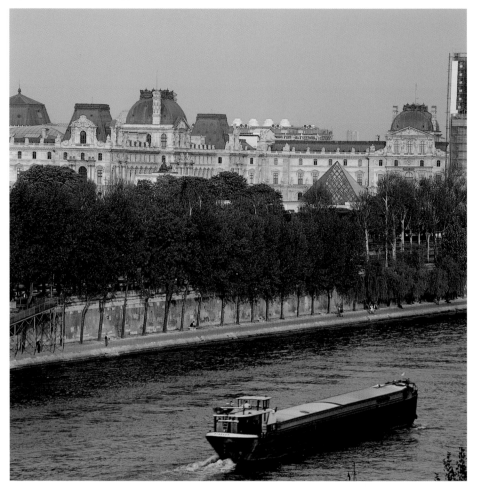

Barge in front of the Louvre. The point of the Louvre Pyramid above the trees, 1ˢᵗ arr.

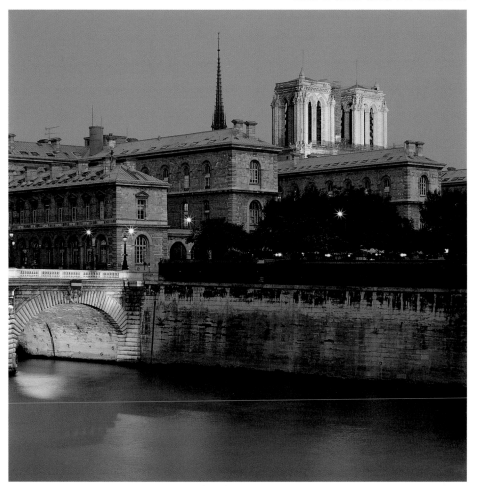

The pont Notre-Dame, l'Hôtel-Dieu, and the spire and belltowers of Notre-Dame, 4<sup>th</sup> arr.

# The Seine and Its Islands

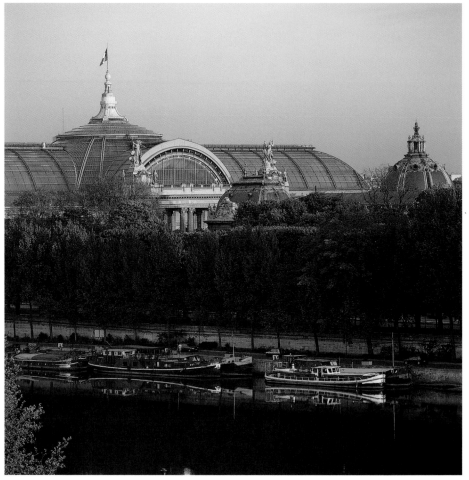

The Seine with the Grand-Palais and the cours de la Reine in the background, 8th arr.

The pont des Arts and the Musée d'Orsay, 7th arr.

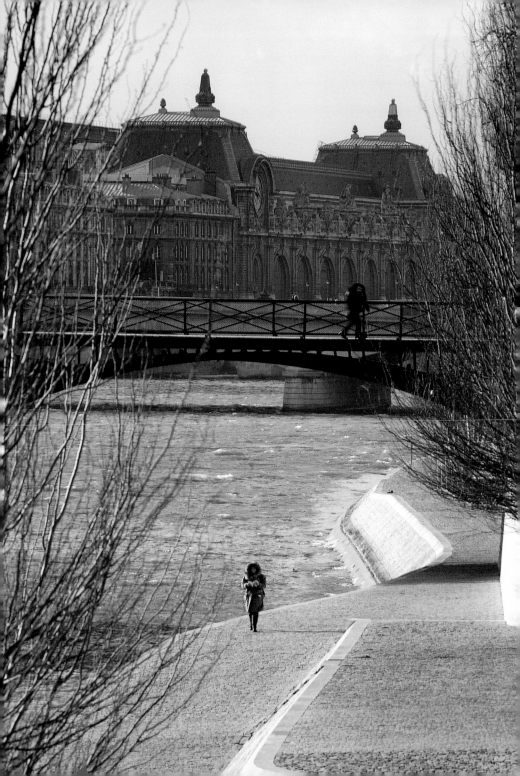

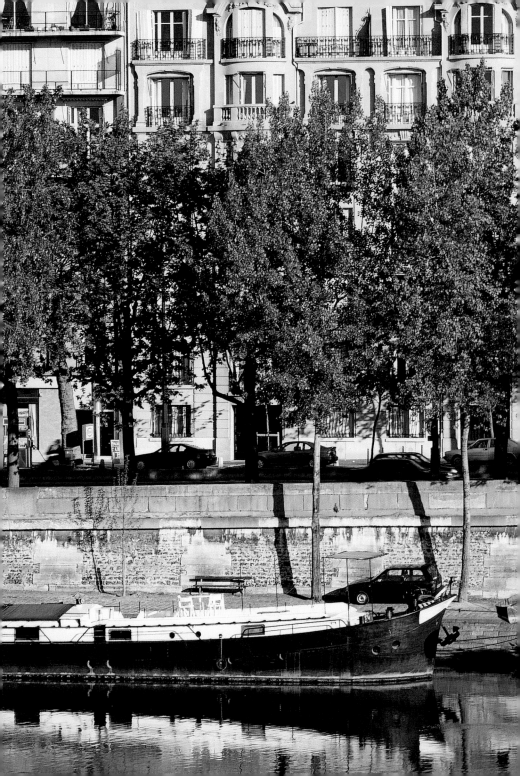

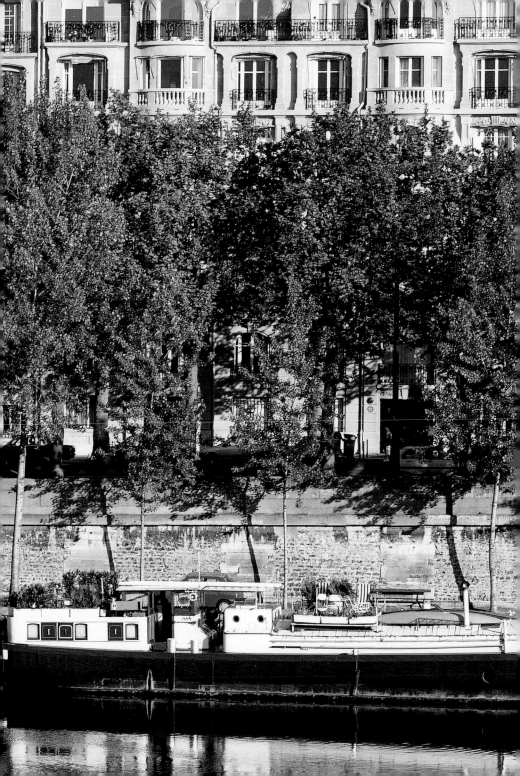

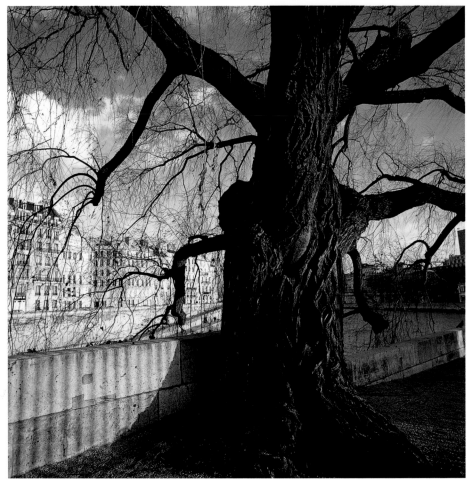

The weeping willow in Jean XXIII Square, l'île de la Cité, 1st arr.

*preceding double page*

Barges at the port de Passy, 16th arr.

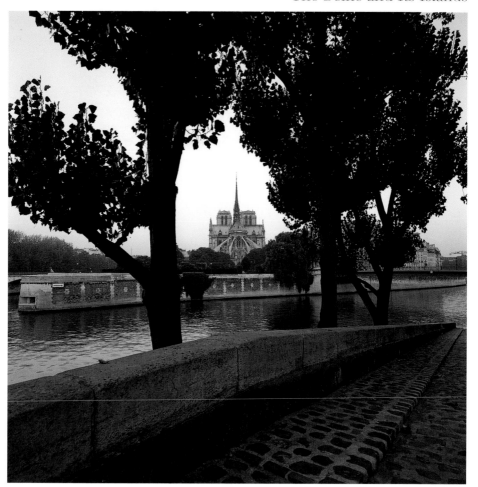

Notre-Dame, from the quai d'Orléans on l'île Saint-Louis, 4th arr.

Place Dauphine, dotted with chestnut trees. In the background, peeking through the trees, the Palace of Justice, 1st arr.

The houses on the place Dauphine also overlook the Seine and the quai de l'Horloge, l'île de la Cité, 1st arr.

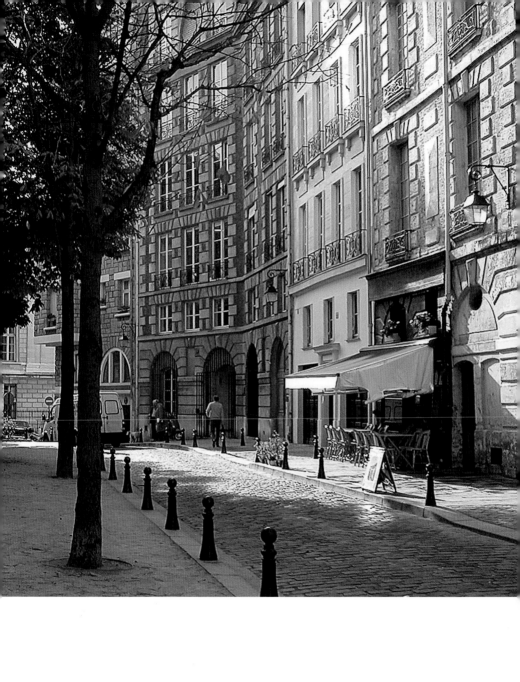

Place Dauphine, one of the most sought-after addresses in Paris,
l'île de la Cité, 1st arr.

A small, romantic hotel on the place Dauphine, l'île de la Cité, 1st arr.

Numerous bistros overlook place Dauphine,
l'île de la Cité, 1st arr.

# The Seine and Its Islands

The flower market on l'île de la Cité, 4th arr.

Place Saint-Michel, 5th arr.

*preceding double page*
Brasserie on l'île Saint-Louis, 4th arr.

Bistro on l'île Saint-Louis,
with a view of the Panthéon, 4th arr.

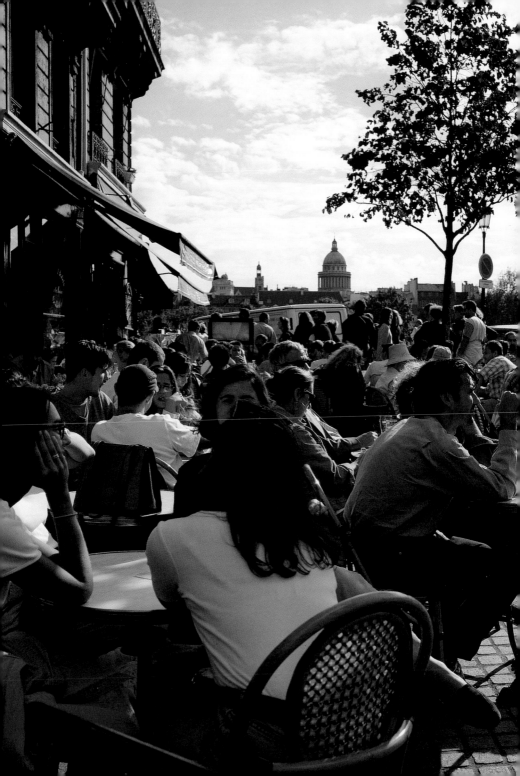

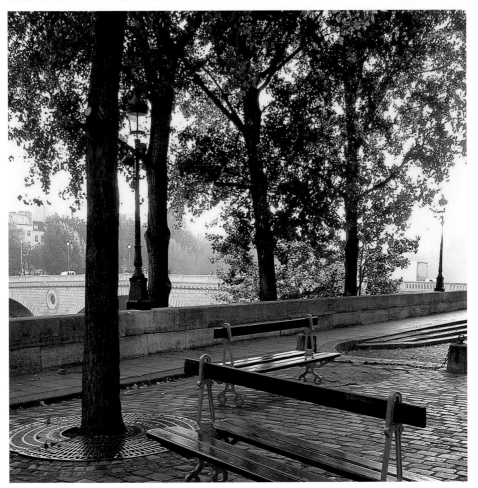

The quai de Bourbon, l'île Saint-Louis, 4<sup>th</sup> arr.

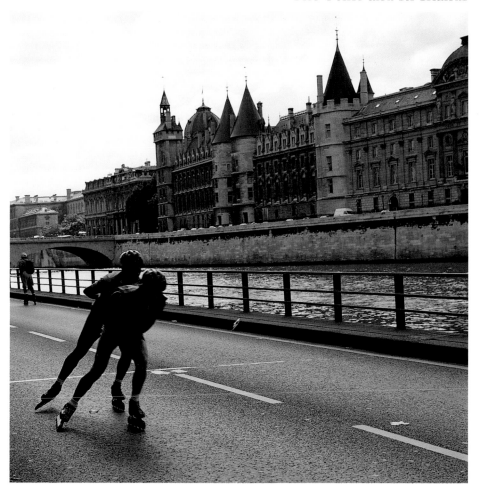

In-line skating along the quai de la Mégisserie, 1ˢᵗ arr.

*following double page*

Barge on the Seine
in front of the Conciergerie, 1ˢᵗ arr.

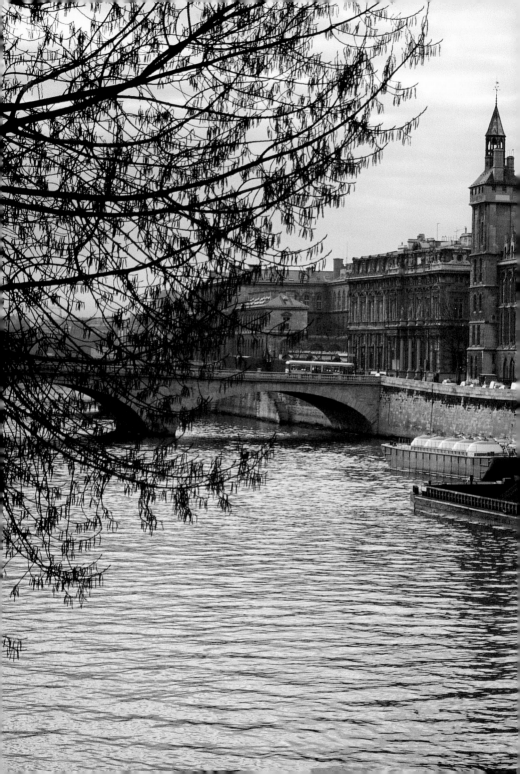

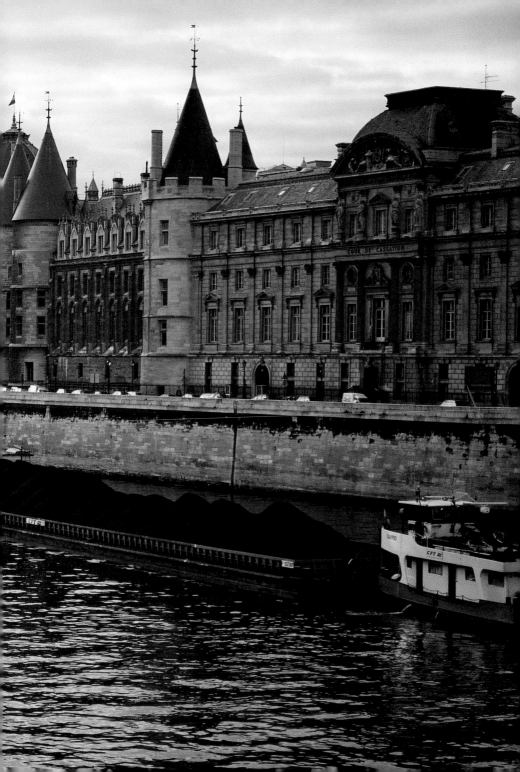

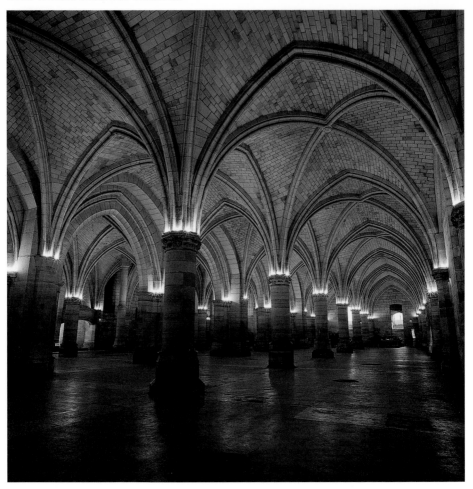

Salle des Gens d'Armes, Conciergerie, 1ˢᵗ arr.

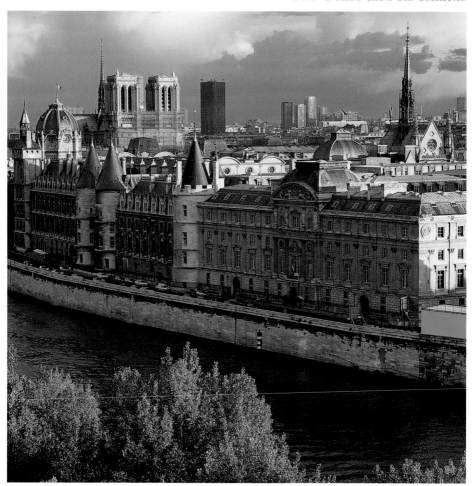

L'île de la Cité, the Conciergerie, Notre-Dame, and the spire of
the Sainte-Chapelle, 1st arr.

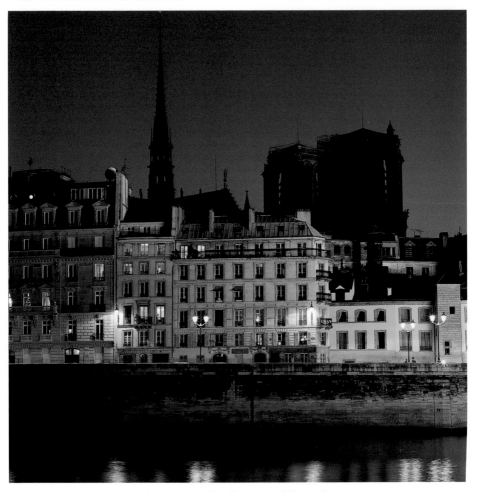

The quai aux Fleurs, and the spire and belltowers of Notre-Dame,
on l'île de la Cité, 4th arr.

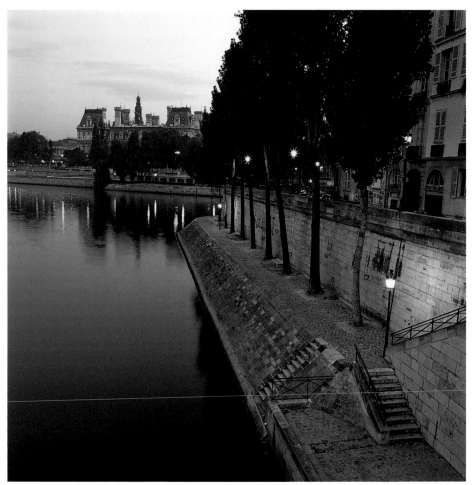

L'île Saint-Louis, the quai d'Orléans, and, in the background, the Hôtel de Ville, 4th arr.

*following double page*

The pont des Arts, from the terrace
on top of the department store Samaritaine, 1st arr.

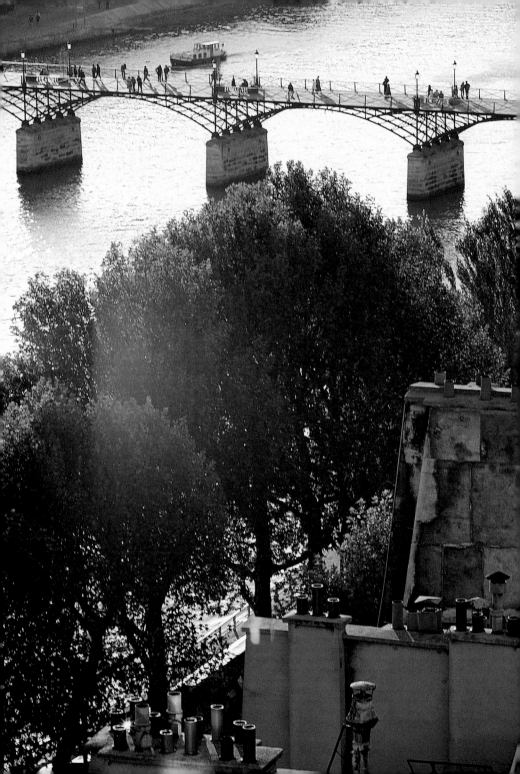

# The Seine and Its Islands

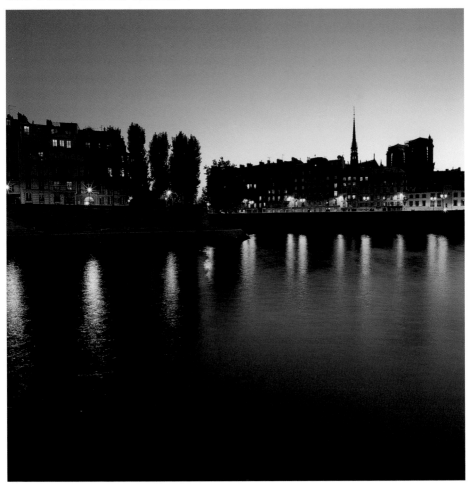

L'île de la Cité, and the tip of l'île Saint-Louis, 4th arr.

The Hôtel Lambert, quai d'Anjou,
on l'île Saint-Louis, 4th arr.

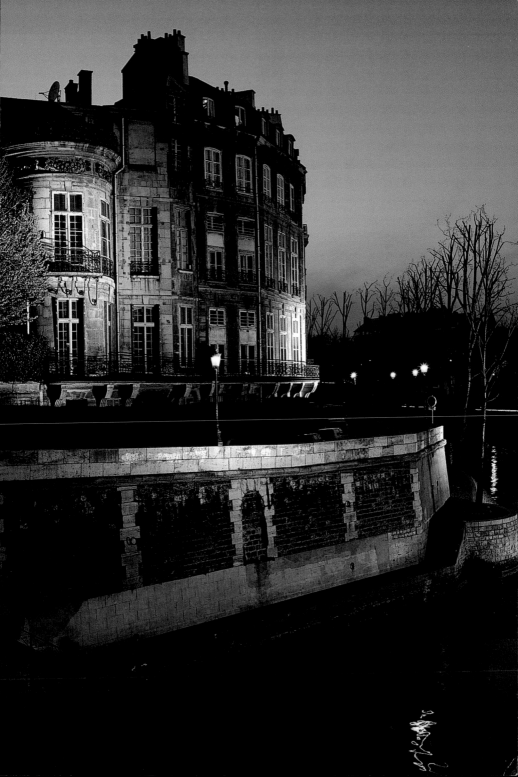

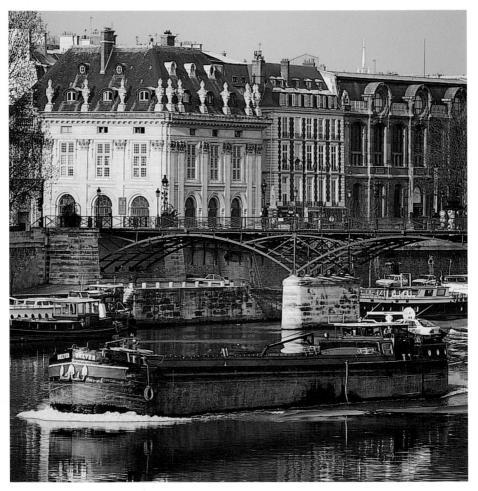

Barge emerging from under the pont des Arts, and houses along
the quai Malaquais, 1st arr.

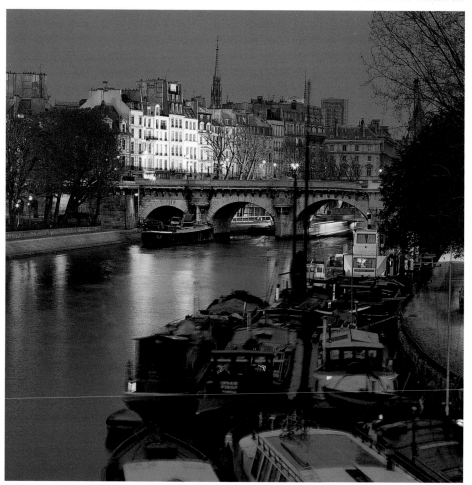

The Pont-Neuf and the buildings along the quai des Orfèvres,
from the quai de Conti, 1st arr.

*following double page*

L'île de la Cité,
the square du Vert-Galant,
and the Pont-Neuf, 1st arr.

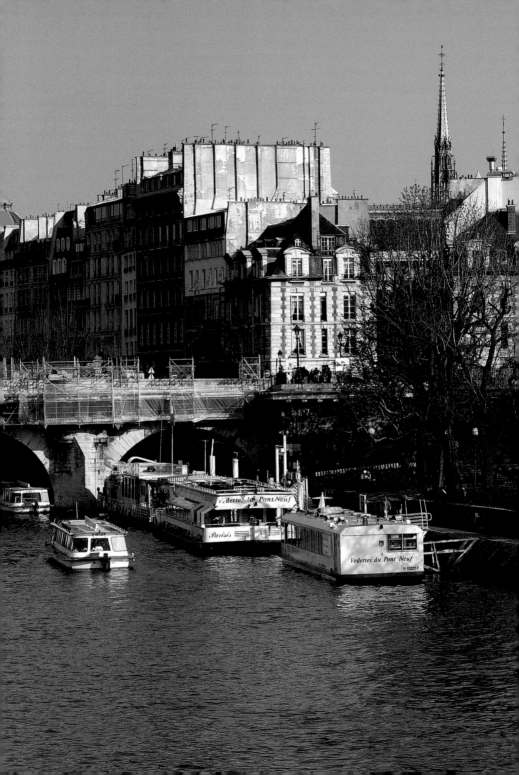

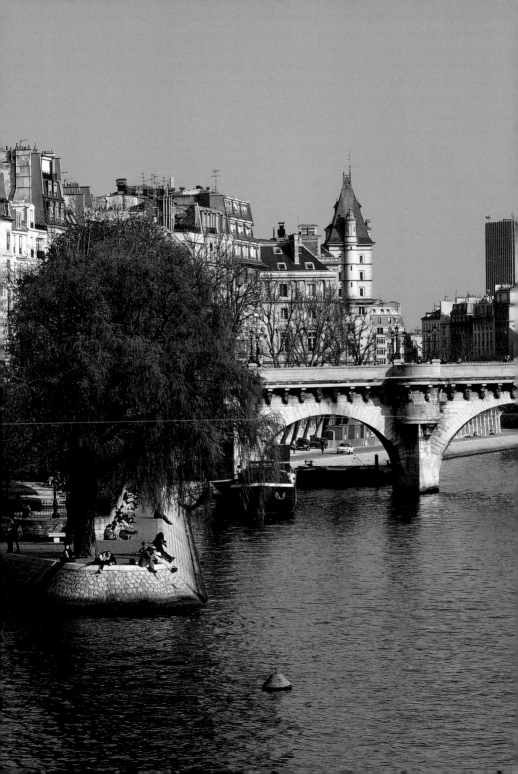

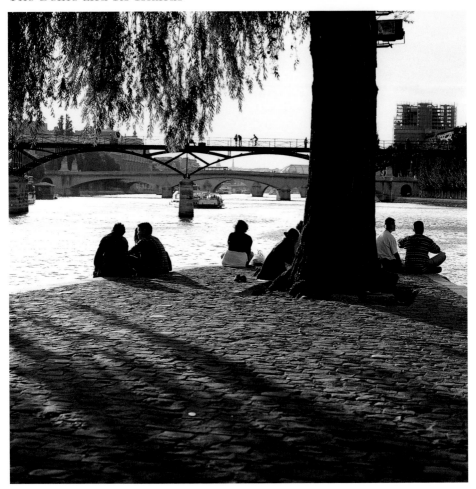

The pont des Arts, from the square du Vert-Galant, 1st arr.

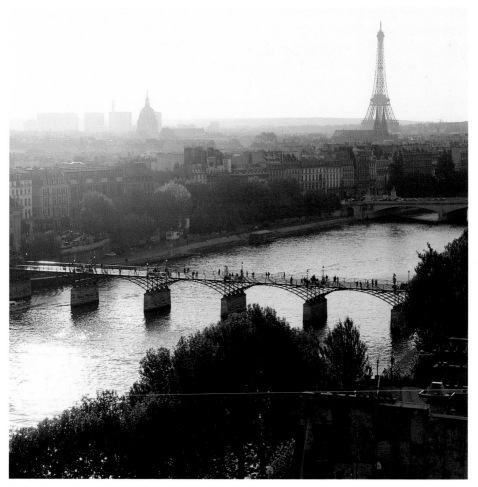

A dazzling view of the Left Bank up to the Eiffel Tower,
from the terrace of Samaritaine, 1ˢᵗ arr.

*following double page*

Stained-glass windows and the nave,
inside Sainte-Chapelle, l'île de la Cité, 1ˢᵗ arr.

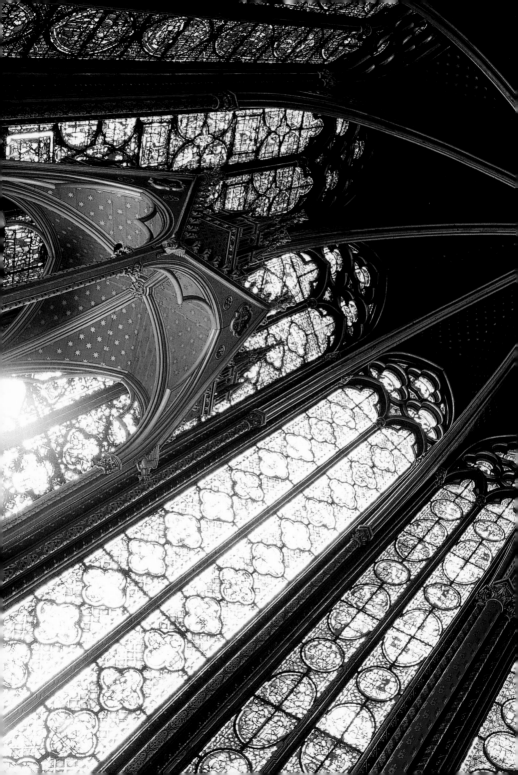

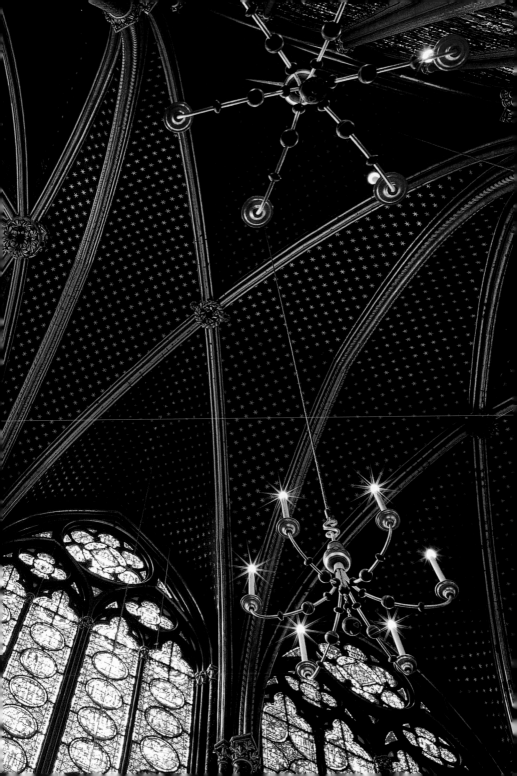

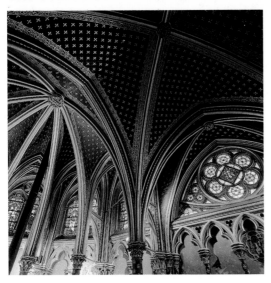

Vaults inside the Sainte-Chapelle, 1$^{st}$ arr.

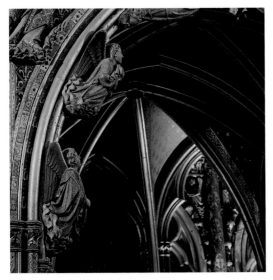

Sculpted angels inside the
Sainte-Chapelle, 1$^{st}$ arr.

Nave of the high chapel
inside the Sainte-Chapelle, 1$^{st}$ arr.

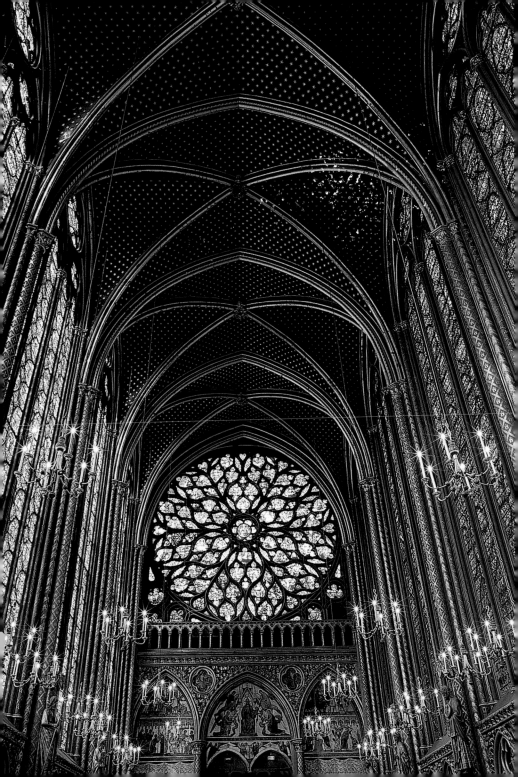

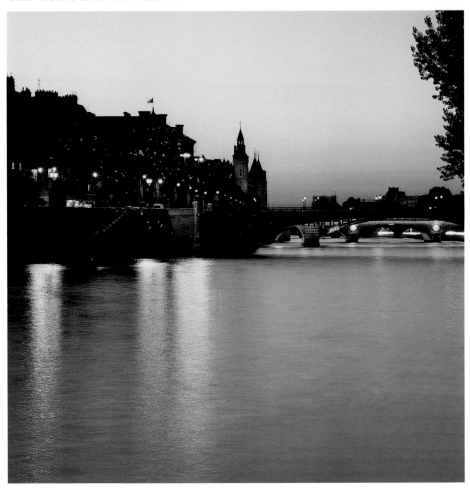

The pont d'Arcole and l'île de la Cité. In the background, the Conciergerie, 4$^{th}$ arr.

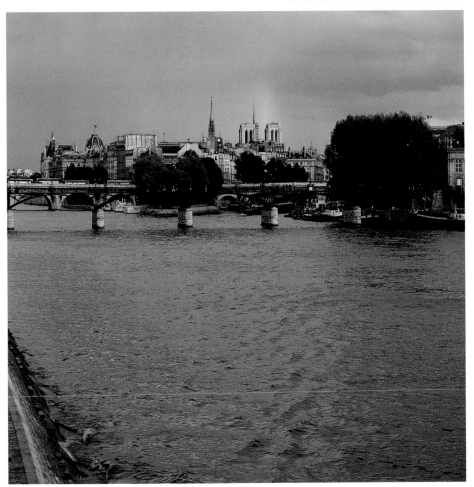

The spires of Notre-Dame and Saint-Chapelle
dominate the skyline of l'île de la Cité, 1$^{st}$ arr.

*following double page*
The pont des Arts and l'île de la Cité, 1$^{st}$ arr.

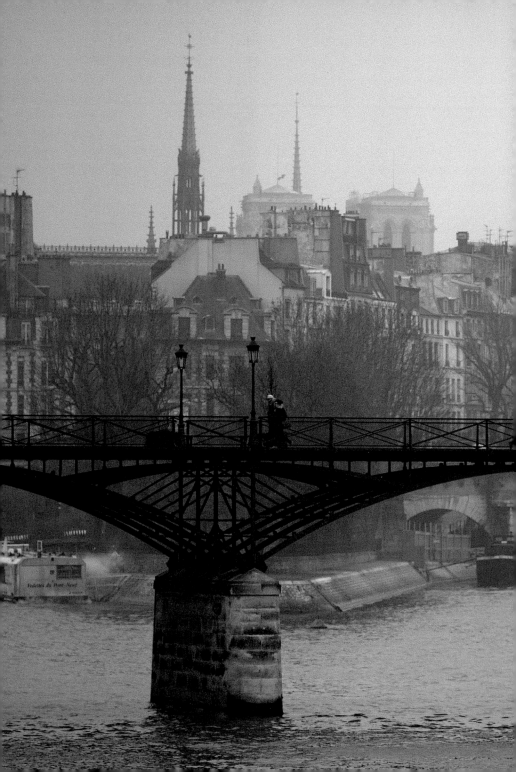

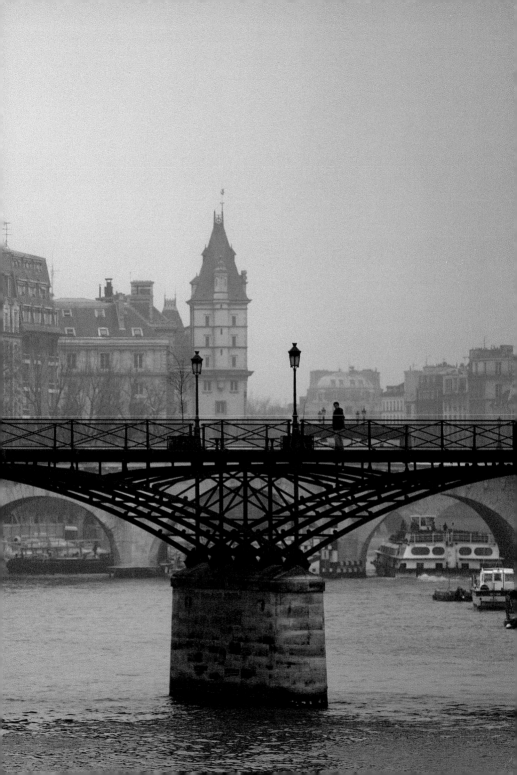

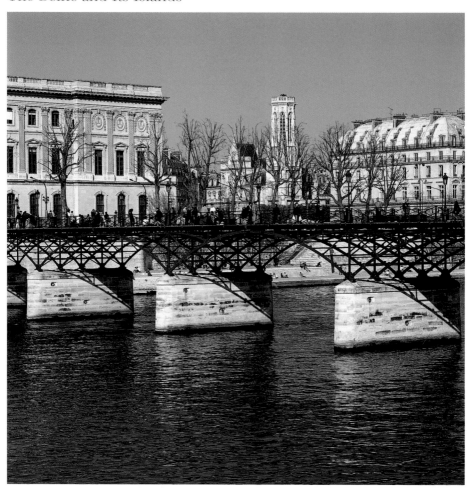

The Louvre and the Saint-Germain-l'Auxerrois Church, from the quai Voltaire.
In the foreground, the pont des Arts, 1ˢᵗ arr.

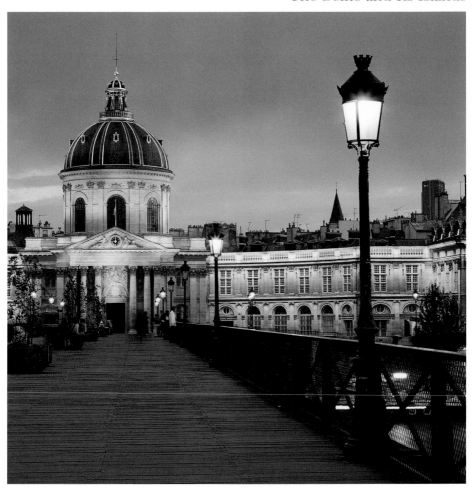

Pedestrians strolling across the pont des Arts between the Louvre
and the Institut de France, 6ᵗʰ arr.

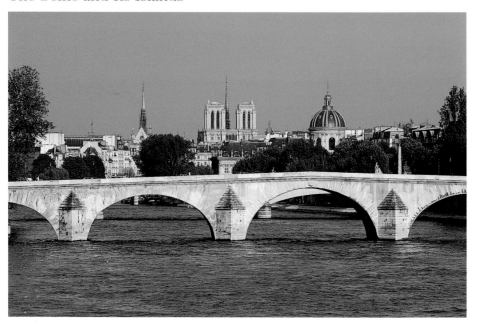

The pont Royal, the pont du Carrousel, the dome of the Institut de France, and l'île de la Cité.

The Seine flowing beneath the pont Royal, 6th arr.

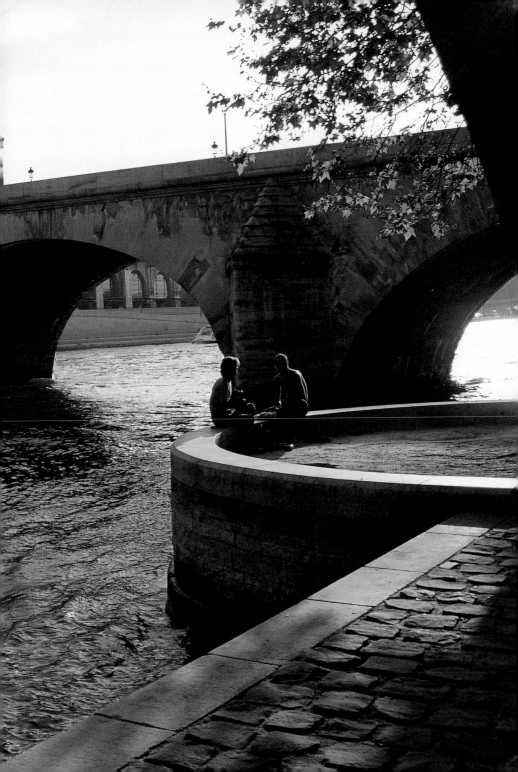

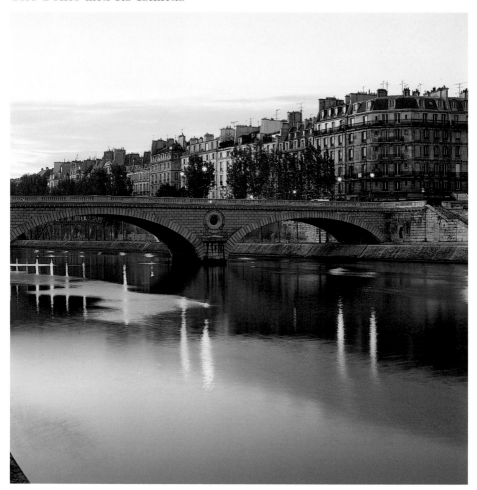

The pont de Sully and the houses along the quai de Béthune, 4th arr.

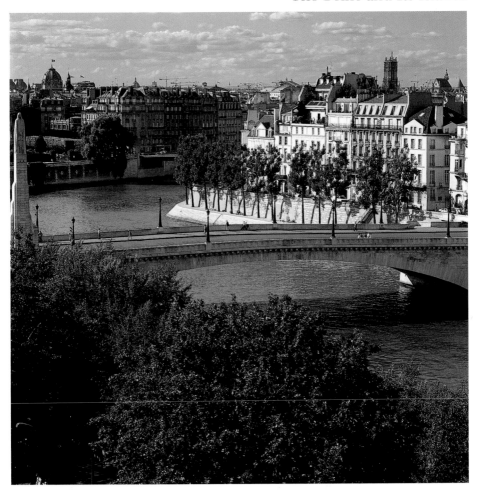

The pont de la Tournelle, l'île Saint-Louis, and l'île de la Cité, 4th arr.

*following double page*

Statue looking out from the pont Alexandre III, 7th arr.

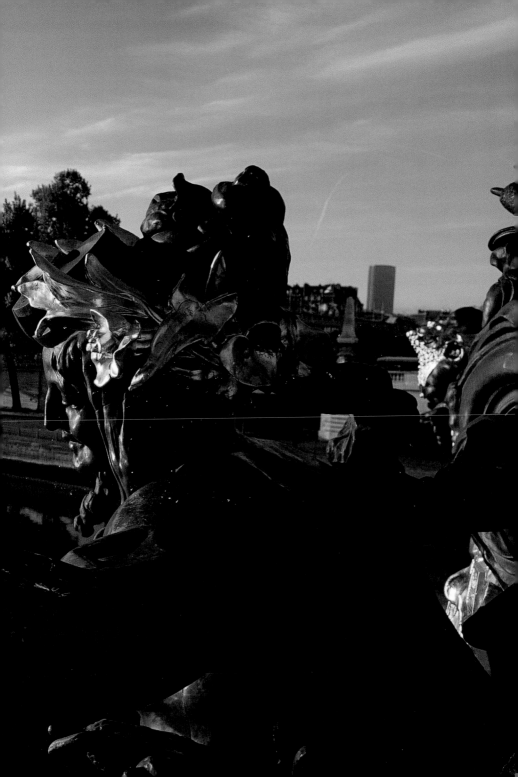

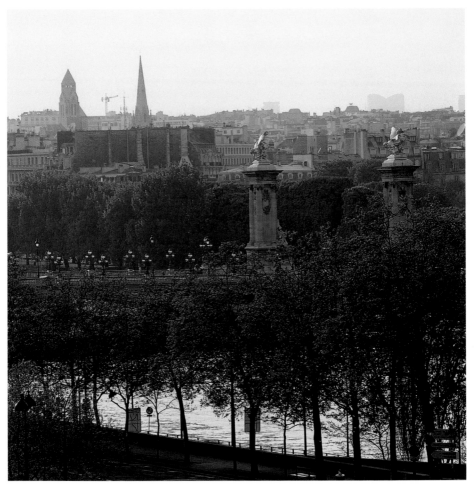

Statues of horses in gilded bronze adorn the pillars of the pont Alexandre III, 7th and 8th arr.

The pont Alexandre III
and the dome atop the Invalides, 7th and 8th arr.

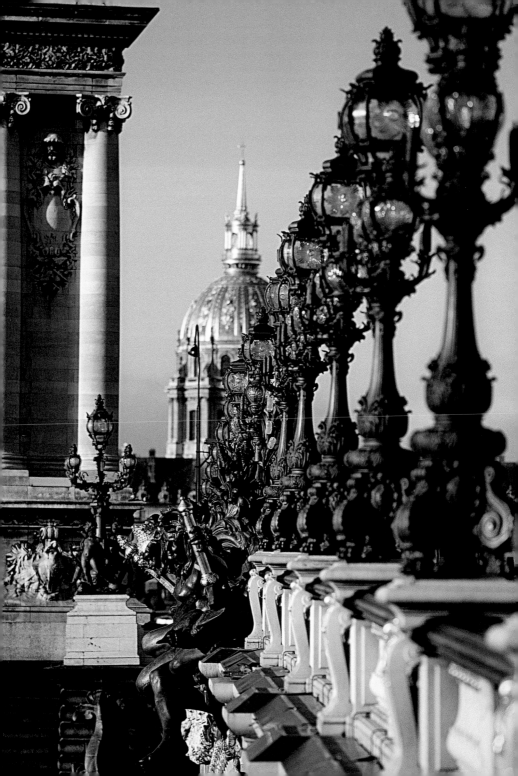

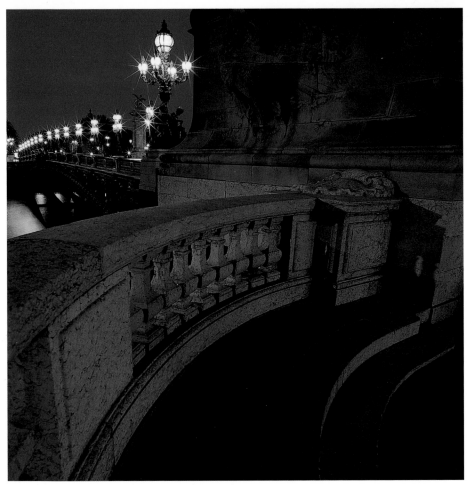

Imposing stone pillars at the entrance to the pont Alexandre III, 7th and 8th arr.

The pont Alexandre III as it reaches the Right Bank, with the Grand Palais in the background, 8th arr.

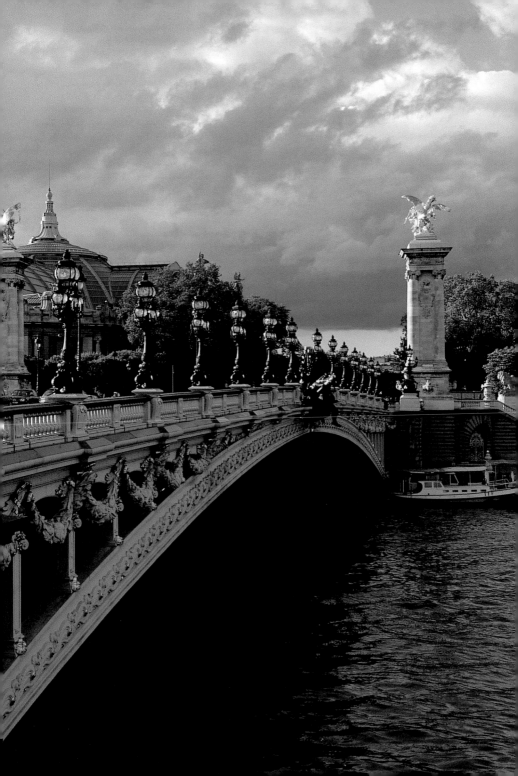

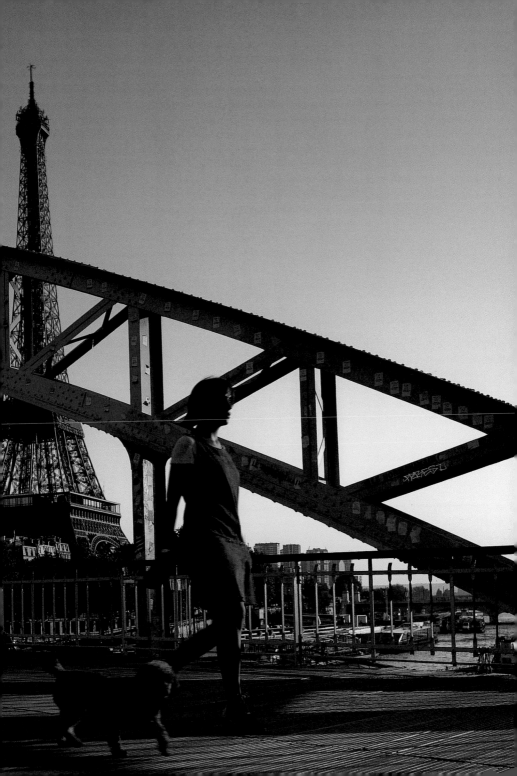

# The Seine and Its Islands

The pont du métro and the quai de la Rapée,
12th arr.

The pont de la Rapée and Notre-Dame,
from the quai de la Rapée, 12th arr.

*preceding double page*

The Eiffel Tower,
from the Debilly footbridge, 7th arr.

Barge at the Pont-au-Change, 4th arr.

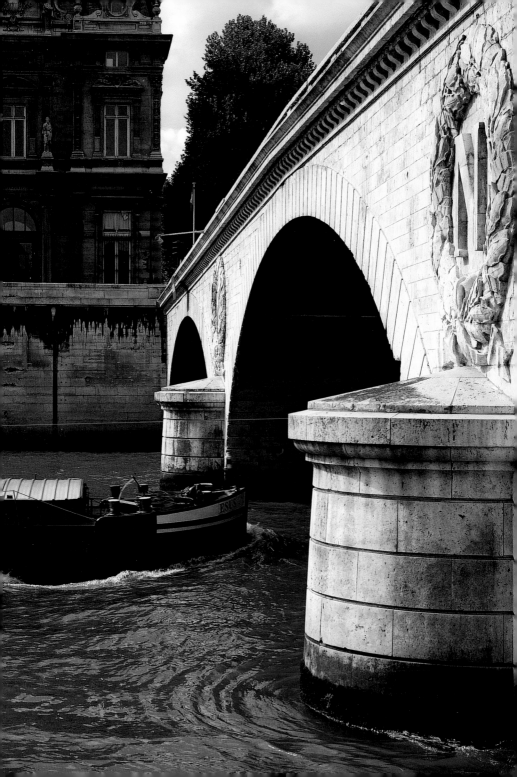

# The Seine and Its Islands

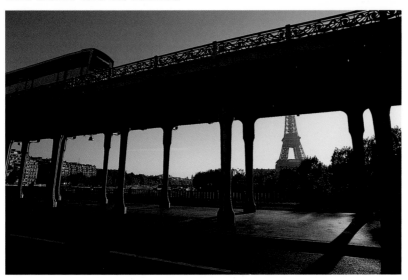

Metro viaduct at the pont de Bir-Hakeim, 15th arr.

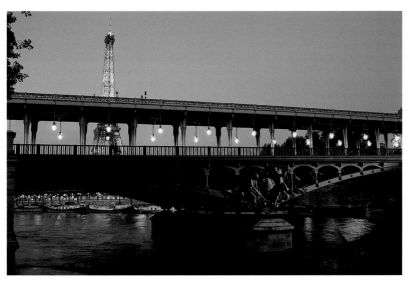

The double-decker pont de Bir-Hakeim leads to l'île des Cygnes, 15th arr.

The pont de Bir-Hakeim, connecting the Passy neighborhood
and the Champ-de-Mars, 15th arr.

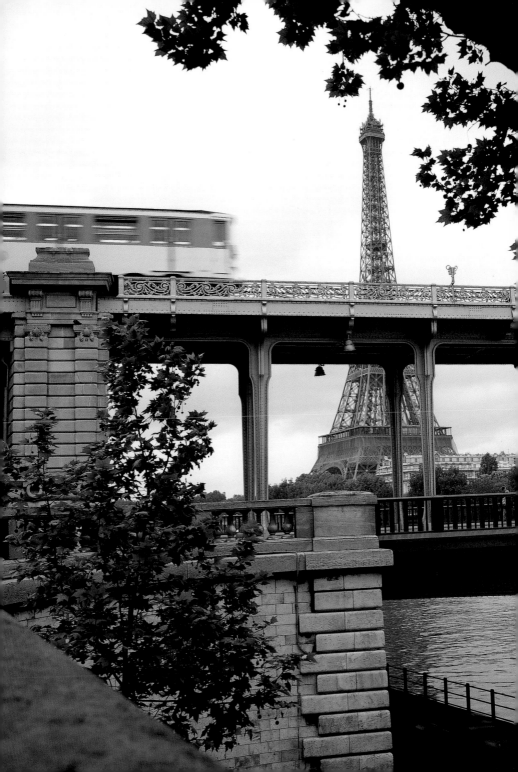

# The Seine and Its Islands

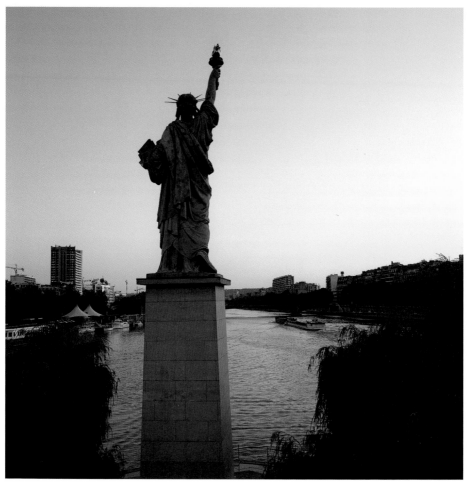

At the tip of l'île des Cygnes, the Statue of Liberty, 15th arr.

The quai de Grenelle, from the pont Mirabeau, 15th arr.

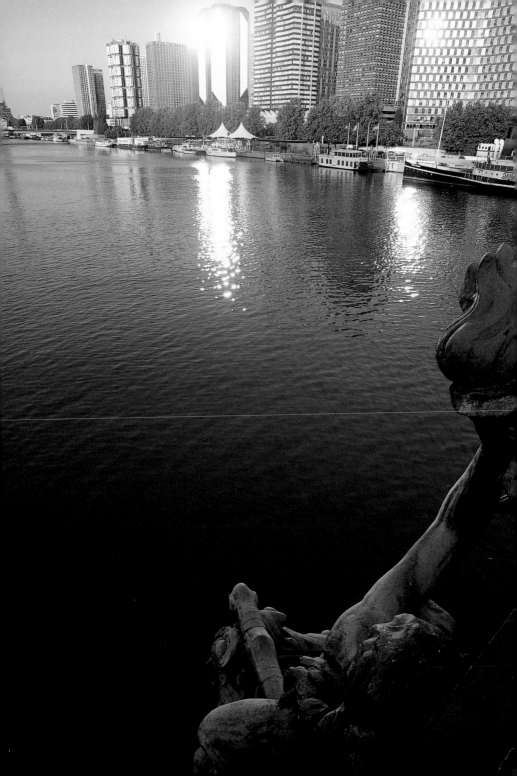

# The Right Bank

 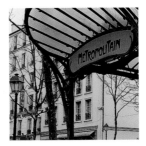 

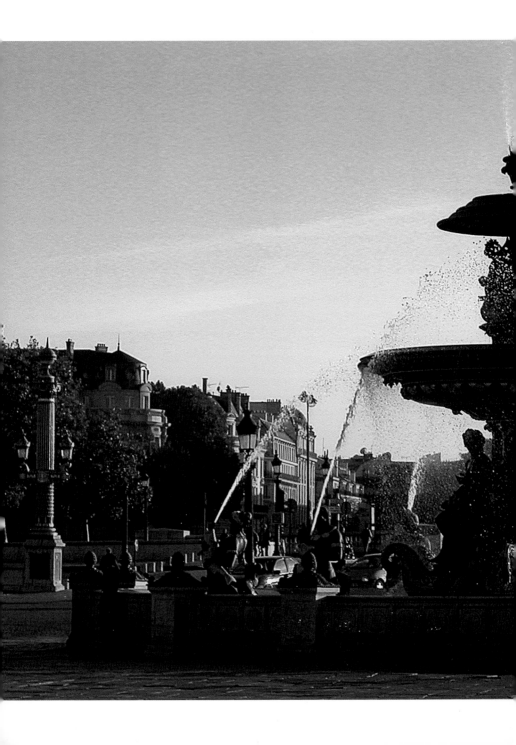

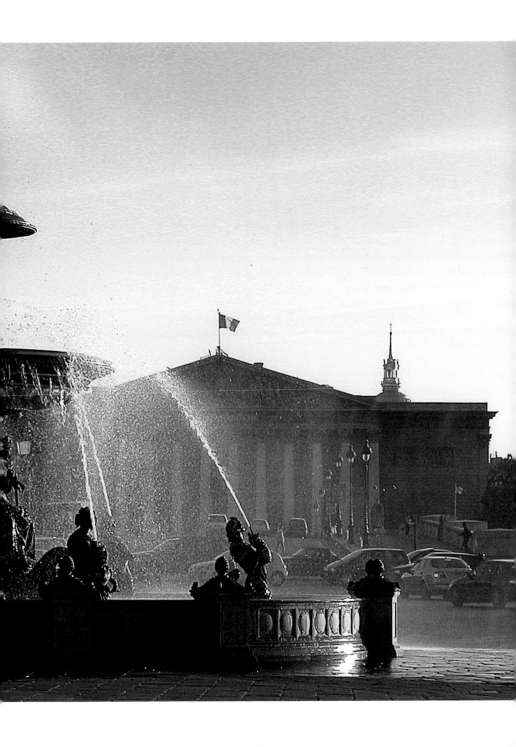

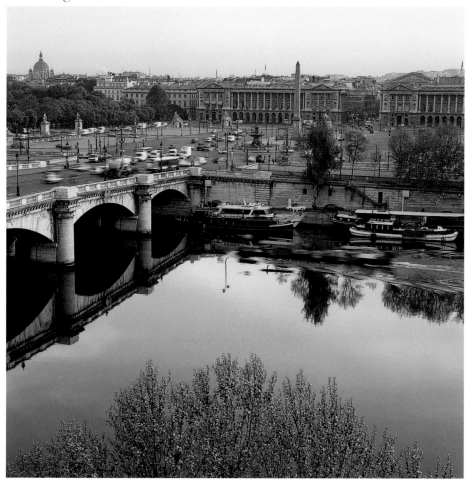

The pont de la Concorde and the Champs-Élysées port,
underneath the place de la Concorde, 8<sup>th</sup> arr.

*preceding double page*

View of the Fountain of the Rivers by Jacques Hittorff,
place de la Concorde. In the background,
the National Assembly, 8<sup>th</sup> arr.

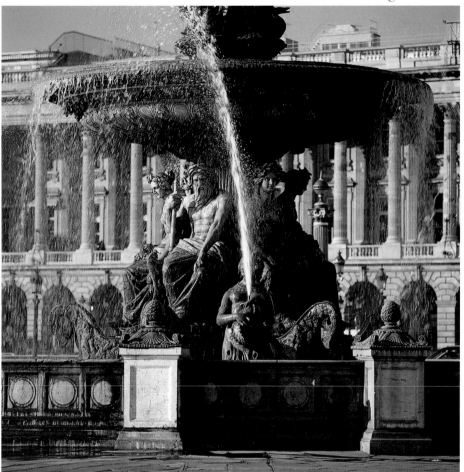

The Fountain of the Seas by Jacques Hittorff, place de la Concorde.
In the background, the Ministry of the Navy, 8th arr.

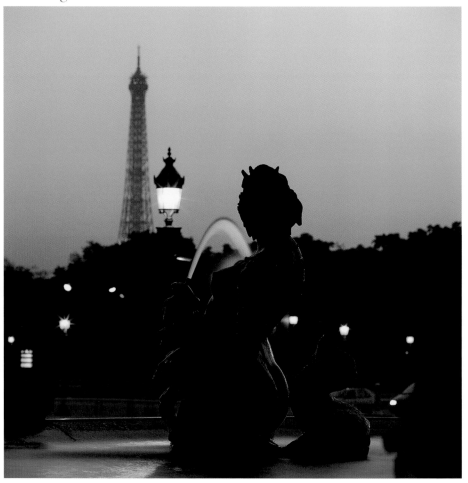

The Eiffel Tower, from the Fountain of the Rivers, place de la Concorde, 8th arr.

Lampposts illuminating the
place de la Concorde,
the egyptian Obelisk,
and the Eiffel Tower, 8th arr.

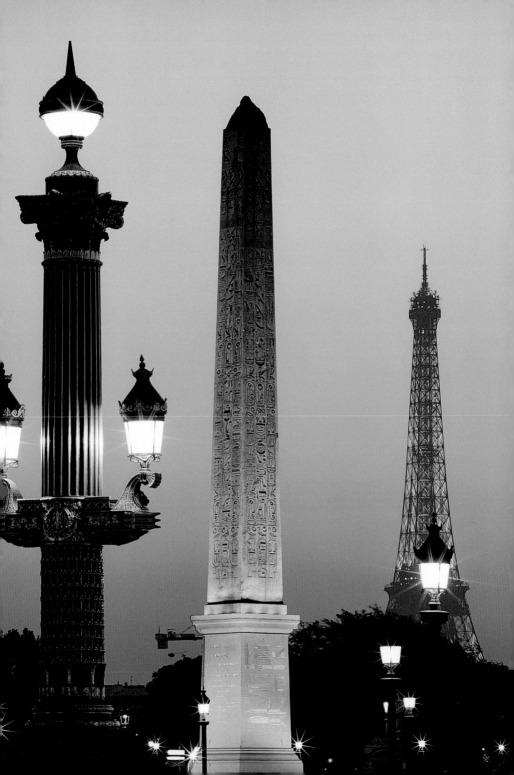

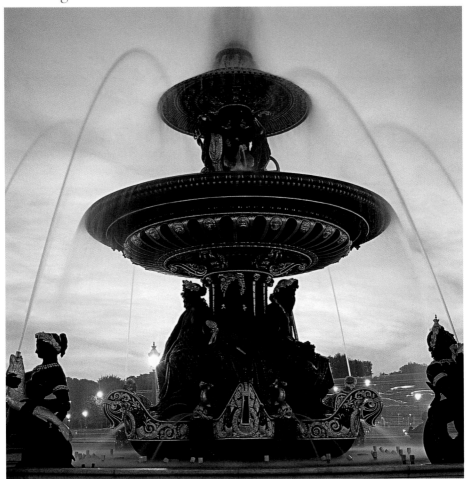

Jacques Hittorff's fountain dedicated to river navigation,
place de la Concorde, 8th arr.

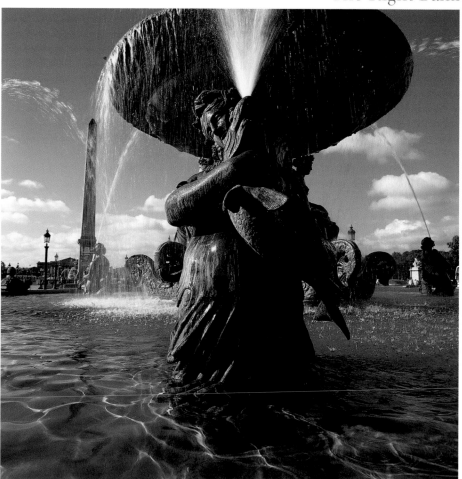

Jacques Hittorff's fountain dedicated to sea navigation;
on the right, the entrance to the Tuileries Gardens, 8th arr.

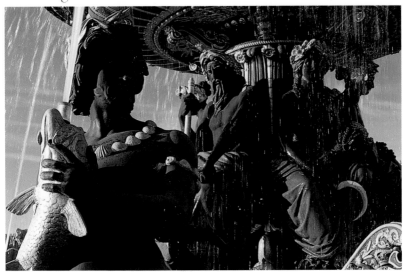

Bronze statues of mythical figures decorate the Fountain of the Seas, place de la Concorde, 8th arr.

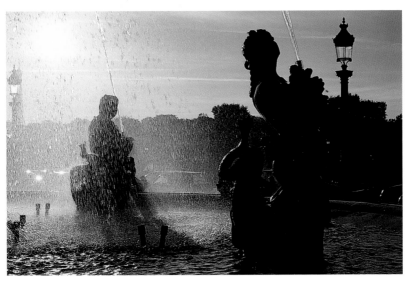

The basin of the Fountain of the Rivers, decorated with allegorical figures, place de la Concorde, 8th arr.

Place de la Concorde,
Hittorff's fountains, and the Obselisk, in
line with the rue Royale, 8th arr.

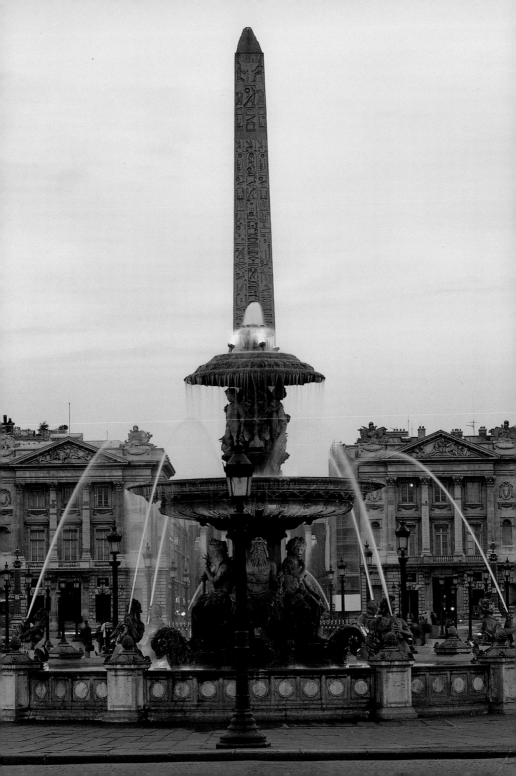

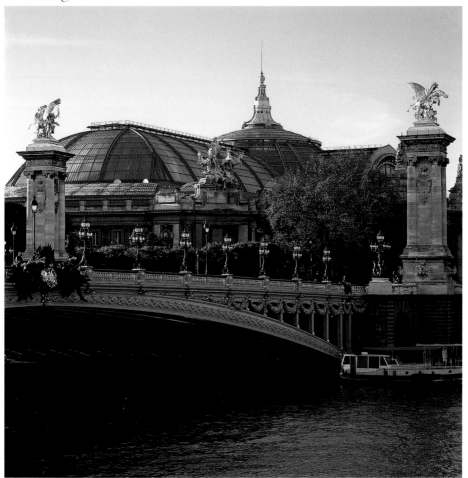

The pont Alexandre III and the Grand Palais, 8th arr.

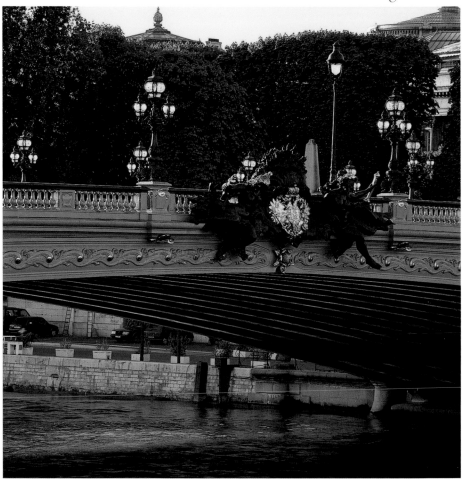

An ornate copper sculpture on the side of the pont Alexandre III, 8<sup>th</sup> arr.

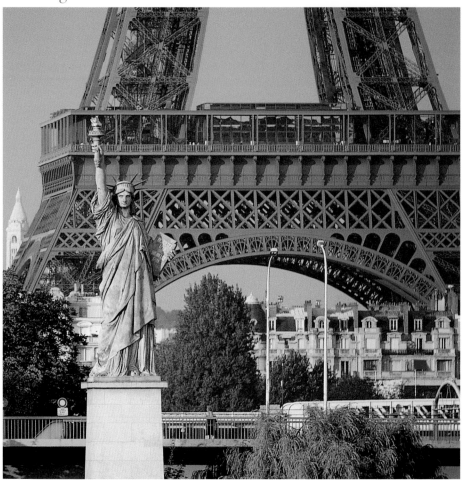

At the tip of l'ile des Cygnes, the pont de Grenelle and the Statue of Liberty, 15th arr.

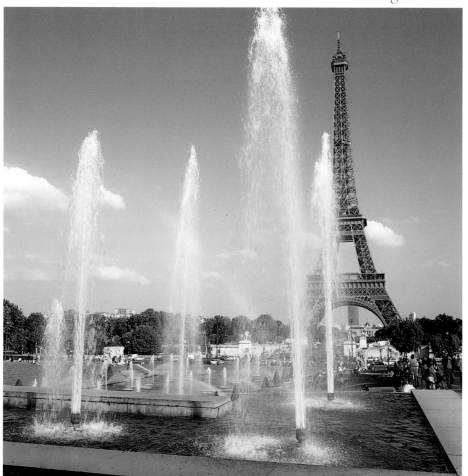

View of the Eiffel Tower through the fountains in the Trocadéro Garden, 15th arr.

The Eiffel Tower seen through a statue at the Trocadéro Garden, 16th arr.

The Palais de Tokyo,
home of Paris's
modern art museum, 16th arr.

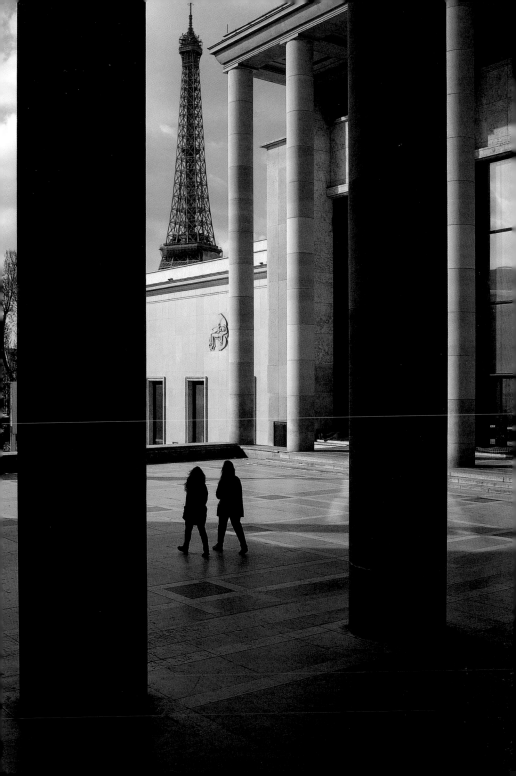

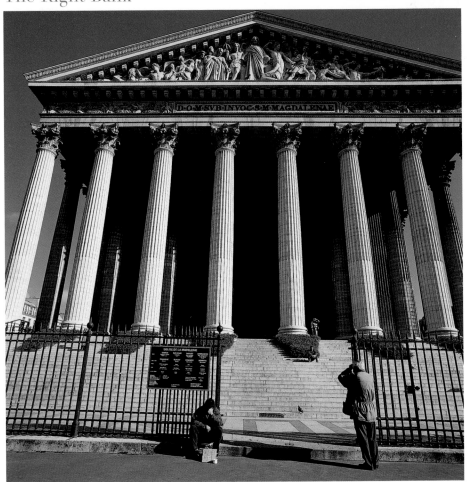

Sainte-Marie-Madeleine Church, place de la Madeleine, 8th arr.

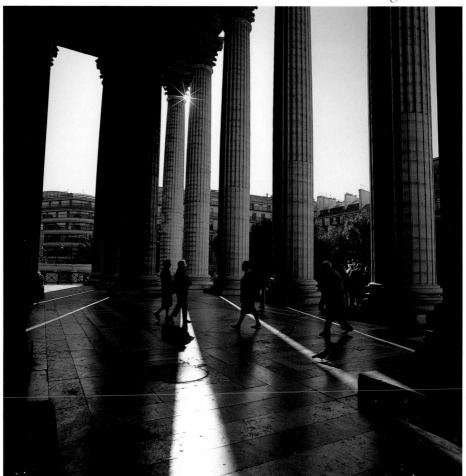

Sunday morning at the Sainte-Marie-Madeleine Church, 8th arr.

Boulevard des Capucines, with the Eiffel Tower in the background, 9th arr.

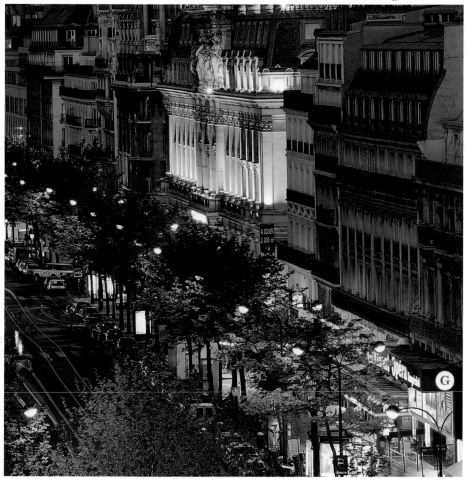

Boulevard des Capucines between the Opéra and the place de la Madeleine, 9th arr.

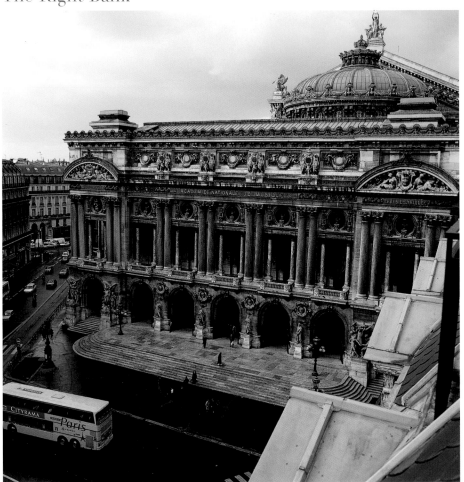

The Opéra Garnier at the place de l'Opéra, 9ᵗʰ arr.

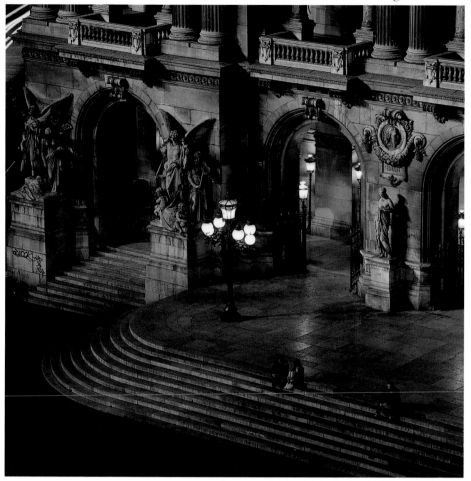

On the staircase of the Opéra, the arcades are adorned by groups of sculptures, 9th arr.

# The Right Bank

The Café de la Paix and
the place de l'Opéra, 9th arr.

Human statue, place Colette, 1st arr.

Café American Dream,
rue Daunou, 2nd arr.

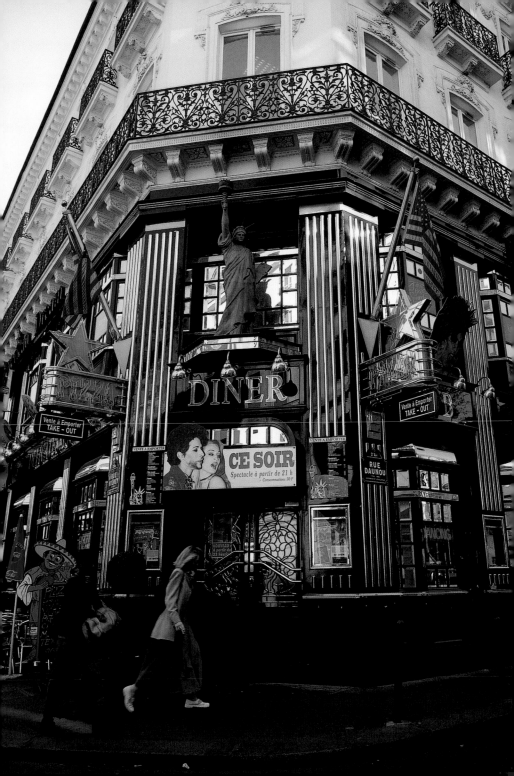

# The Right Bank

The Printemps department store window display draws crowds, boulevard Haussmann, 9th arr.

The Christmas display windows outside Samaritaine, 1st arr.

Organ grinder hoping to entertain passersby on the Grands Boulevards, 9th arr.

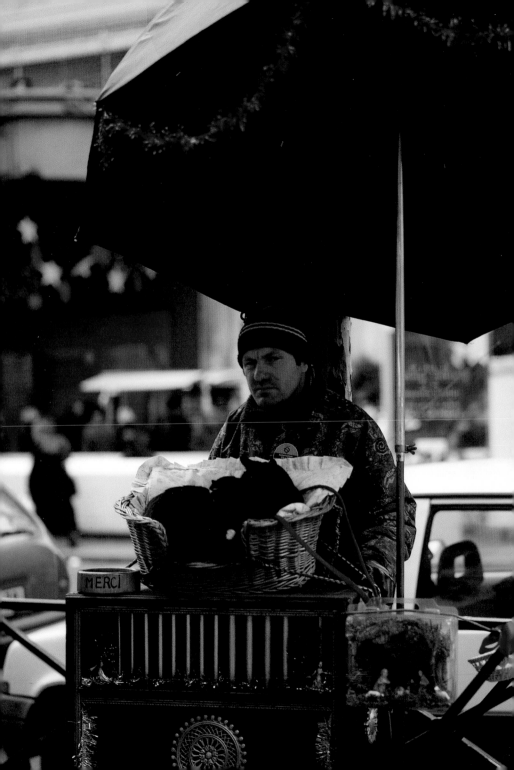

# The Right Bank

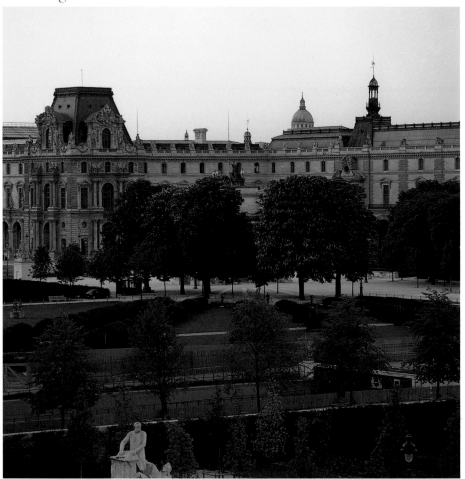

The Louvre, from the Carrousel Garden, 1st arr.

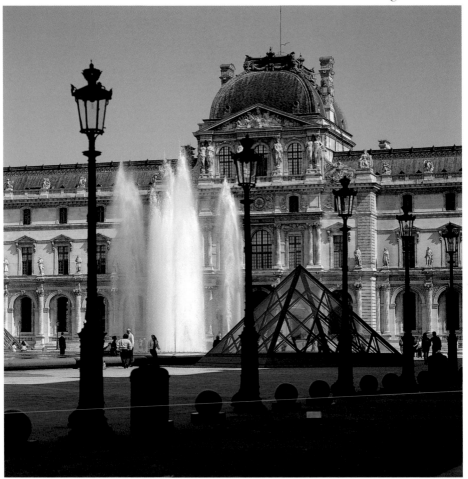

The Sully Pavilion and the little Pyramid, at the Louvre, 1st arr.

*following double page*
The Louvre Pyramid,
designed by architect Ieoh Ming Pei, 1st arr.

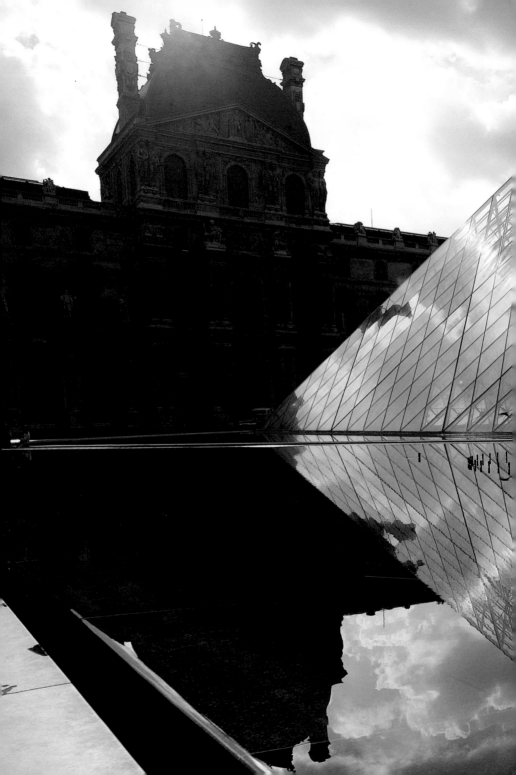

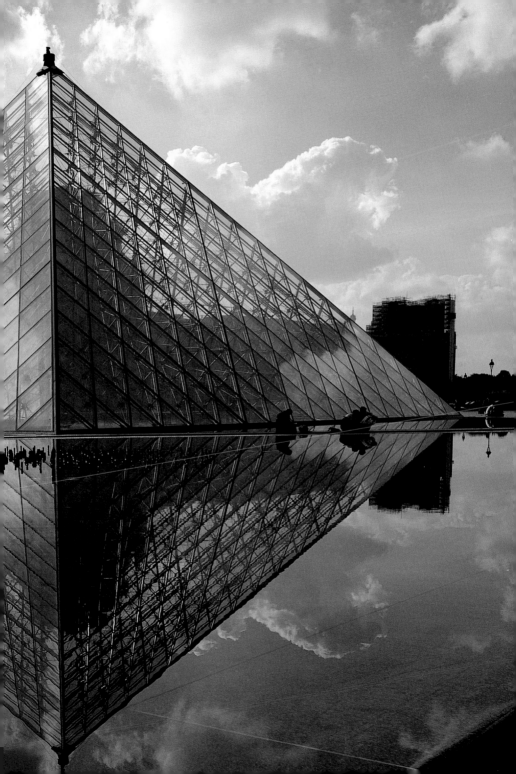

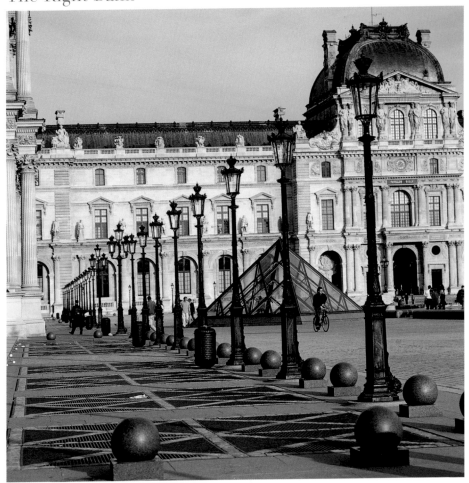

Cour Napoléon, the Louvre, 1ˢᵗ arr.

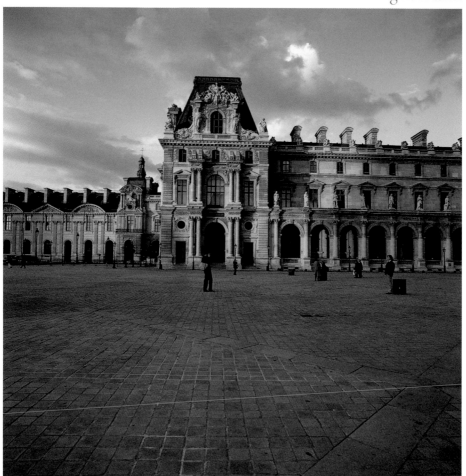

Cour Carrée, the Louvre, 1st arr.

# The Right Bank

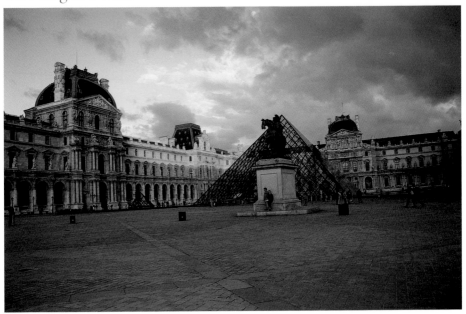

Cour Napoléon, the Pyramids, and the Richelieu wing of the Louvre Museum, 1ˢᵗ arr.

Statue of Louis XIV by Italian sculptor
Bernini, the Louvre, 1ˢᵗ arr.

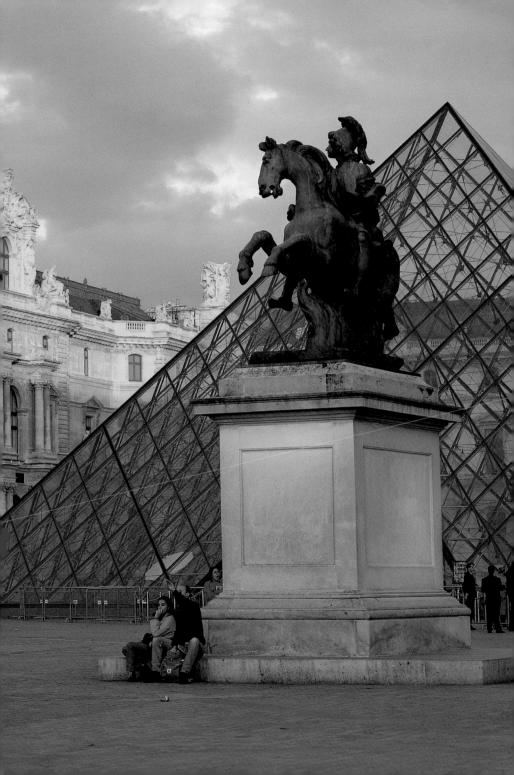

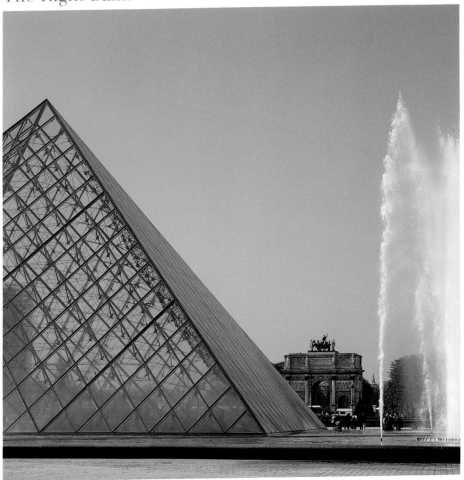

Reflecting pools shooting jetstreams of water surround the large Pyramid.
In the background, the triumphal arch of the Carrousel, 1st arr.

Large and small Pyramids at the
Louvre, seen through the arch
of the Richelieu wing coming
from the place du Palais-Royal, 1st arr.

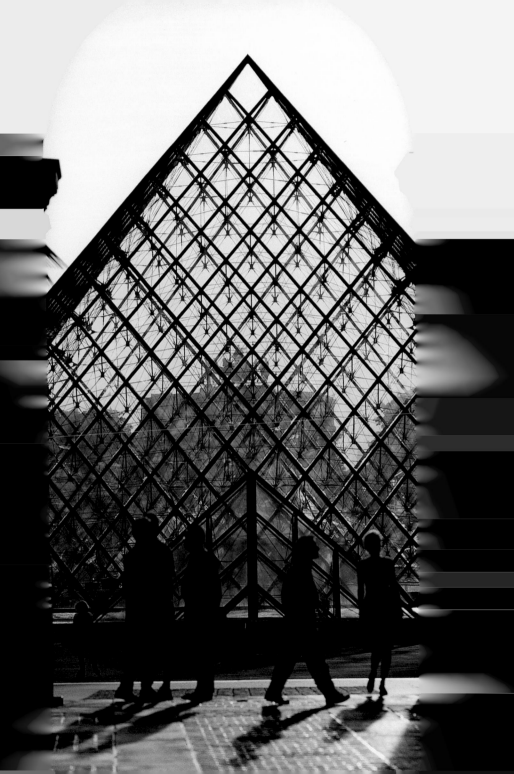

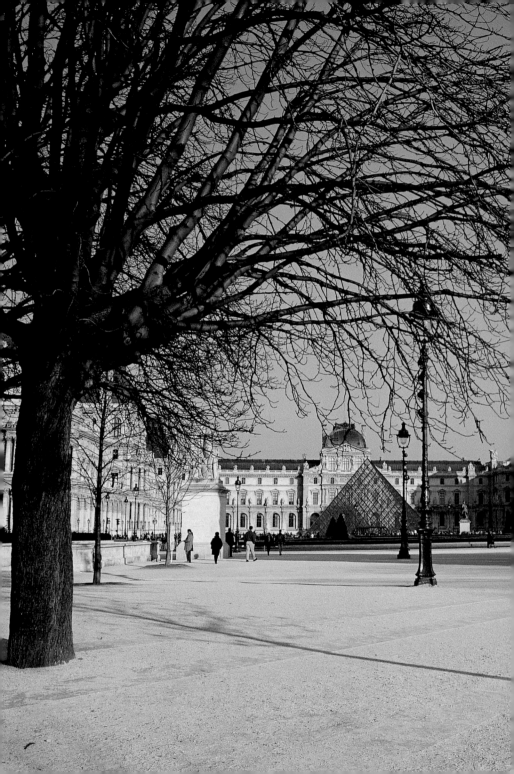

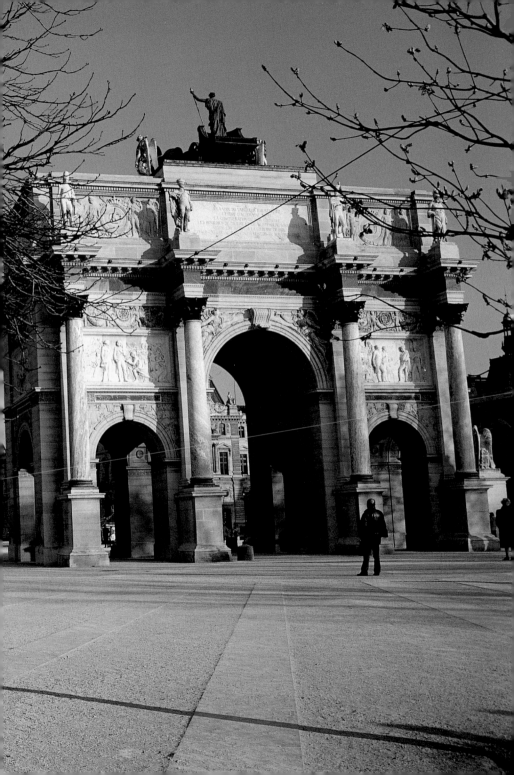

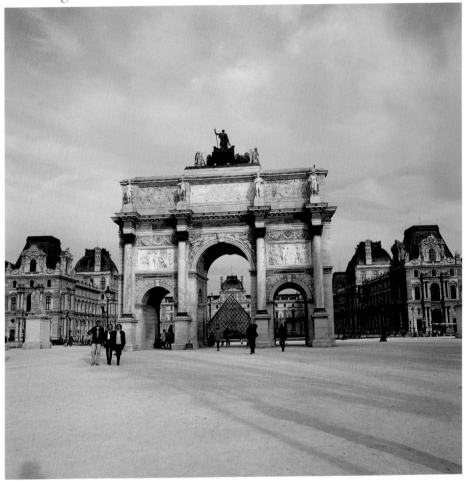

The large Pyramid at the Louvre, seen through the triumphal arch of
the Carrousel, 1$^{st}$ arr.

*preceding double page*

The triumphal arch of the Carrousel
and the Cour Napoléon,
from the Carrousel Garden, 1$^{st}$ arr.

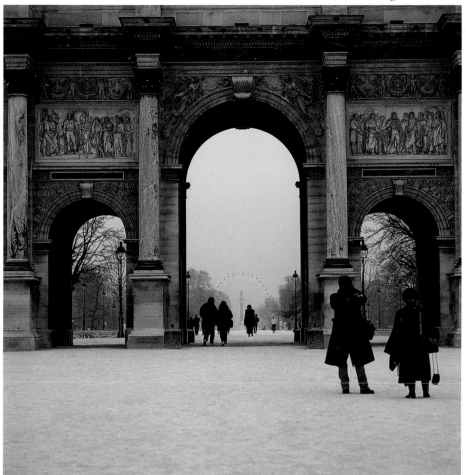

The triumphal arch of the Carrousel, facing the Tuileries Gardens, 1ˢᵗ arr.

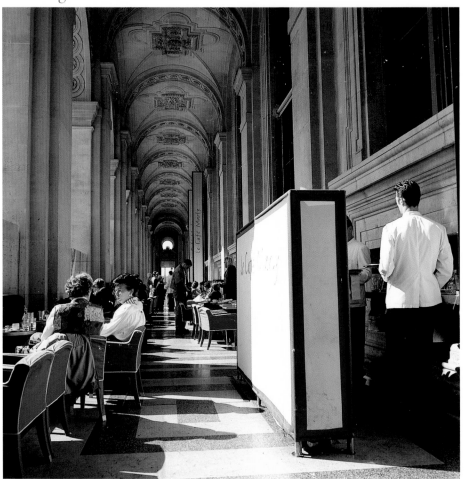

Café Marly at the Louvre, 1st arr.

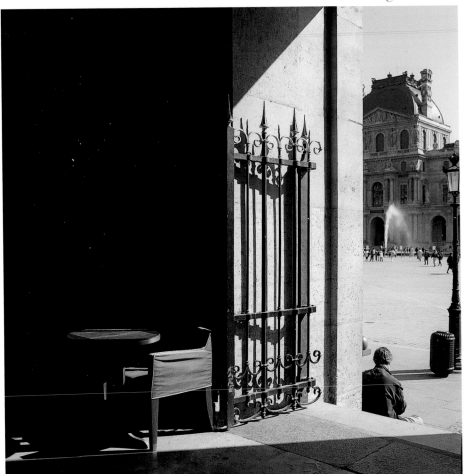

View of the cour Napoléon at the Louvre, from Café Marly, 1$^{st}$ arr.

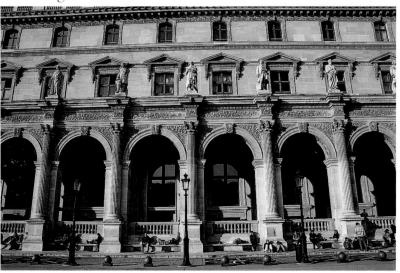

Façade of the Louvre, from the cour Napoléon, 1ˢᵗ arr.

Façade of the Louvre overlooking the quai du Louvre, 1ˢᵗ arr.

The cour Marly at the Louvre is covered by
a large skylight that
provides a view from Café Marly, 1ˢᵗ arr.

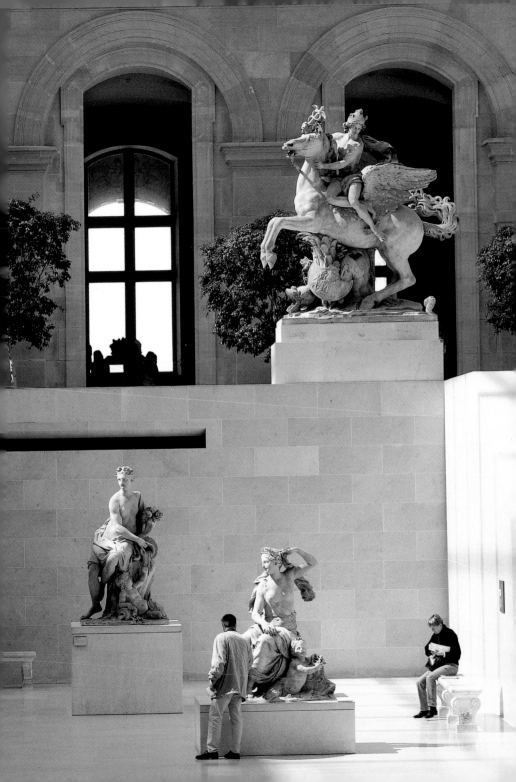

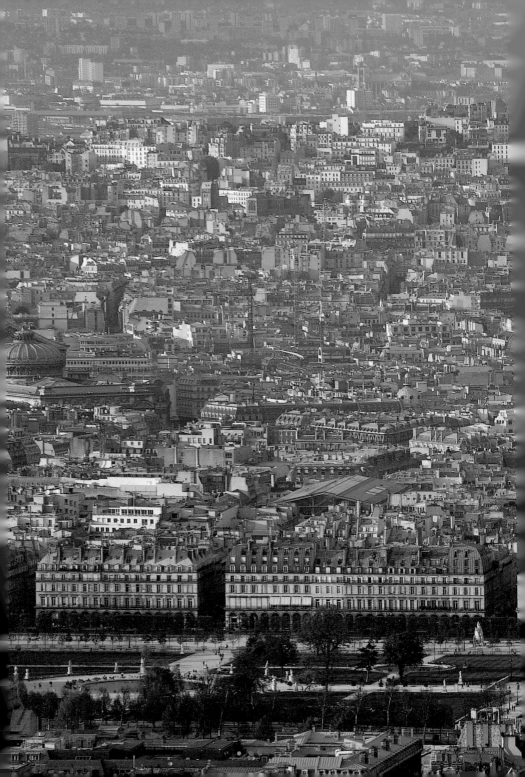

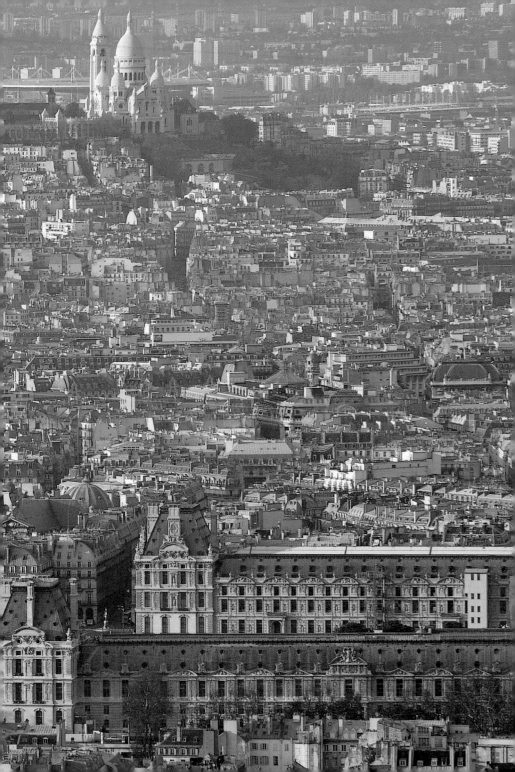

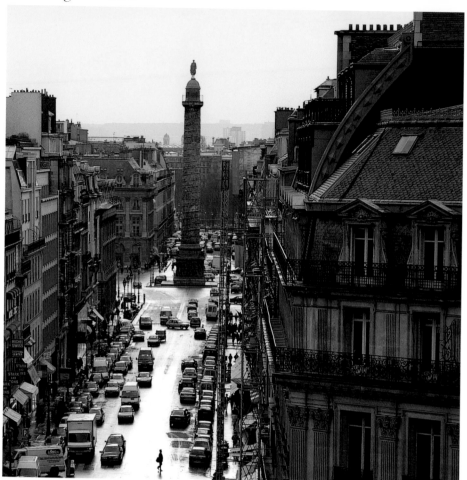

Rue de la Paix and the Vendôme Column, from the place de l'Opéra, 1$^{st}$ and 2$^{nd}$ arr.

*preceding double page*

The Right Bank, from the
Louvre and the Tuileries Gardens
to Montmartre and the Sacré-Coeur,
viewed from the Montparnasse Tower.

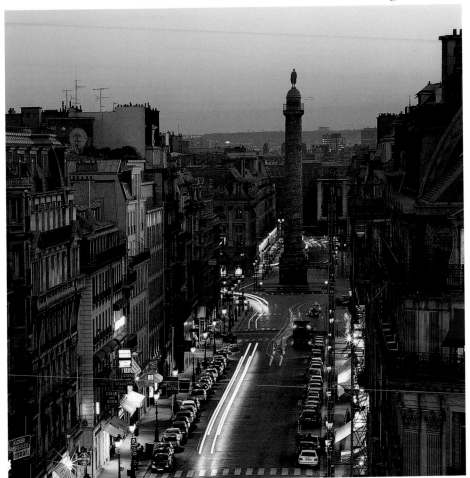

View at night of the Vendôme Column coming from the place de l'Opéra, 1$^{st}$ and 2$^{nd}$ arr.

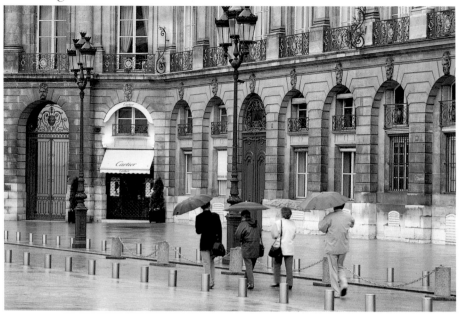

Cartier shop on place Vendôme, 1st arr.

The Vendôme Column
and the Ministry of Justice, 1st arr.

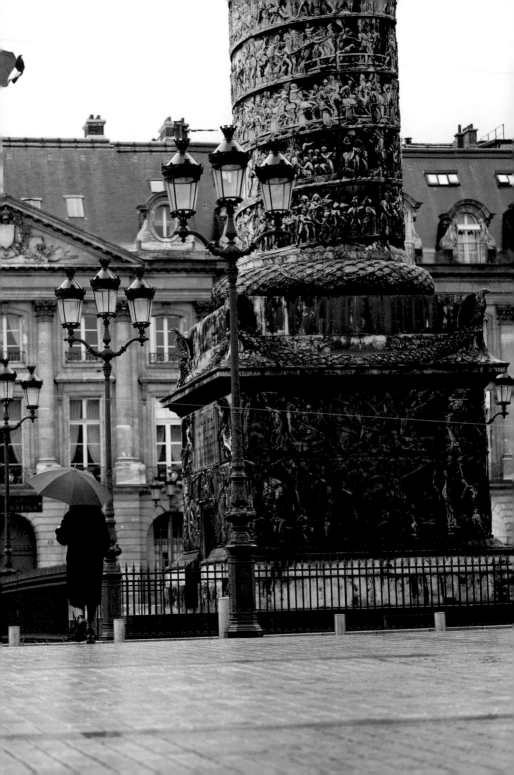

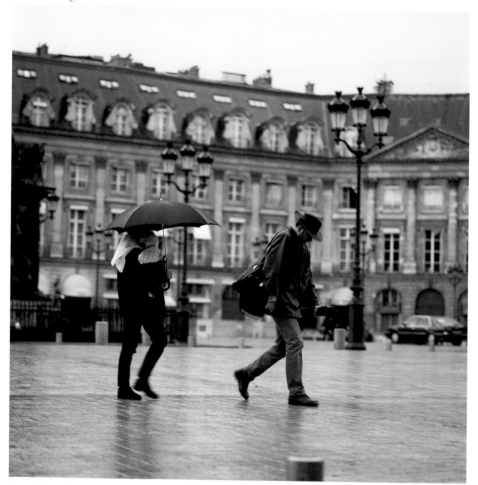

Place Vendôme, 1<sup>st</sup> arr.

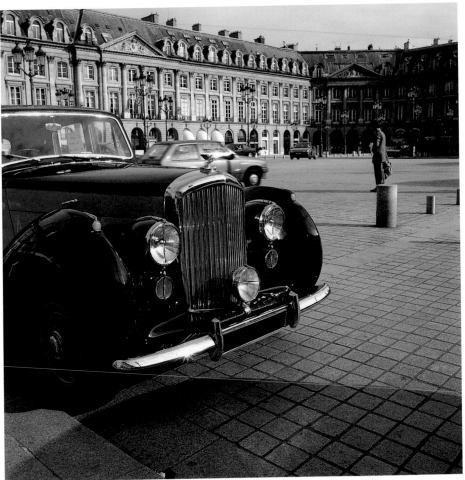

Bentley in front of the Ritz Hotel, place Vendôme, 1$^{st}$ arr.

*following double page*

Terrace café at Chez Georges,
the restaurant at the top of the Pompidou Center, 4$^{th}$ arr.

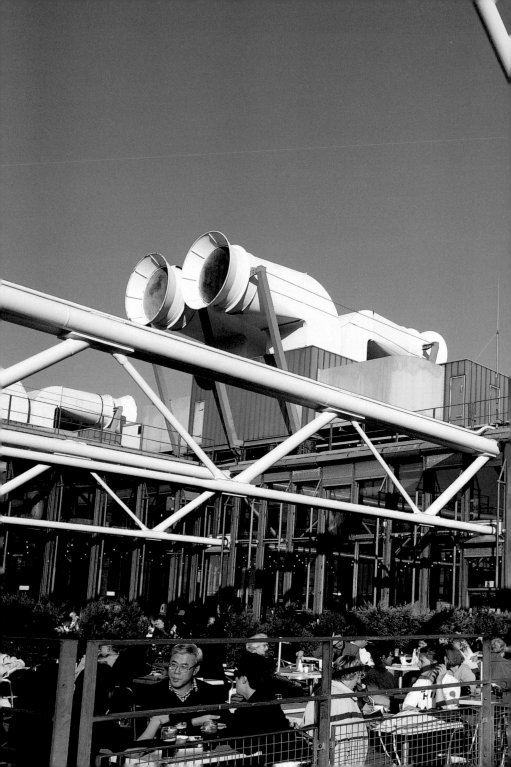

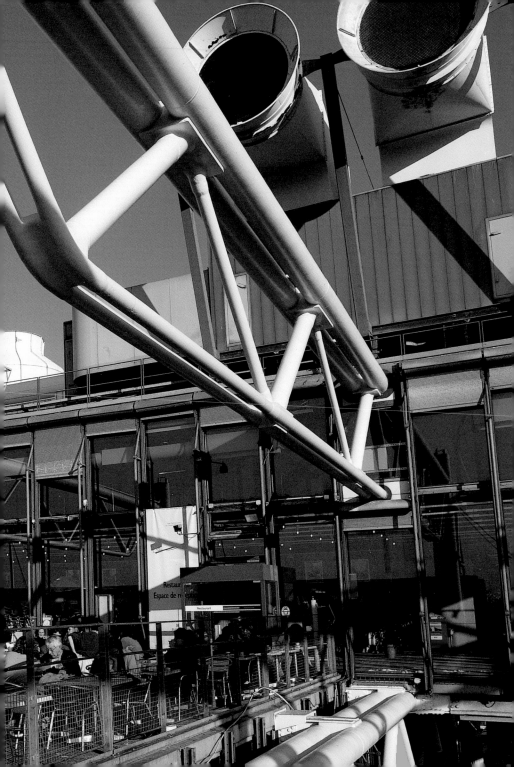

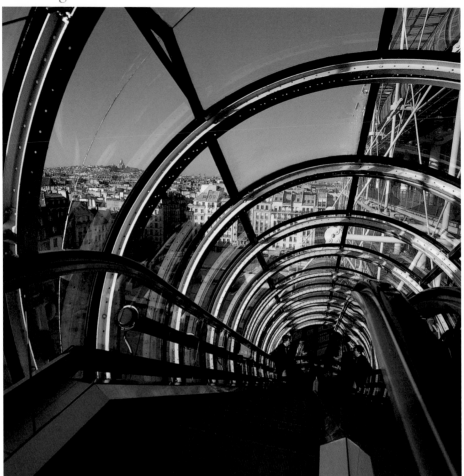

Escalators with a panoramic view at the Pompidou Center,
the work of architects Renzo Piano and Gianfranco Franchini, 4th arr.

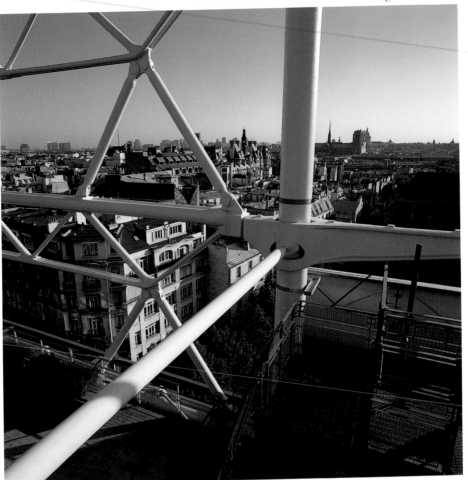

Spectacular view of Paris's old neighborhoods,
from the top floor of the Pompidou Center, 4th arr.

# The Right Bank

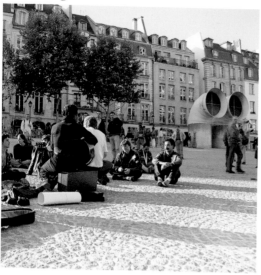

Square in front of the Pompidou Center, 4th arr.

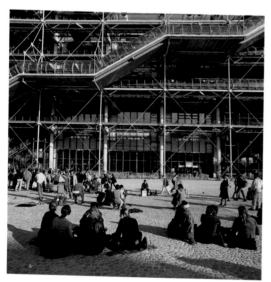

The façade and escalators
of the Pompidou Center, 4th arr.

The modern architecture of the Pompidou Center
dominates the mazelike streets
of the old neighborhood nearby, 4th arr.

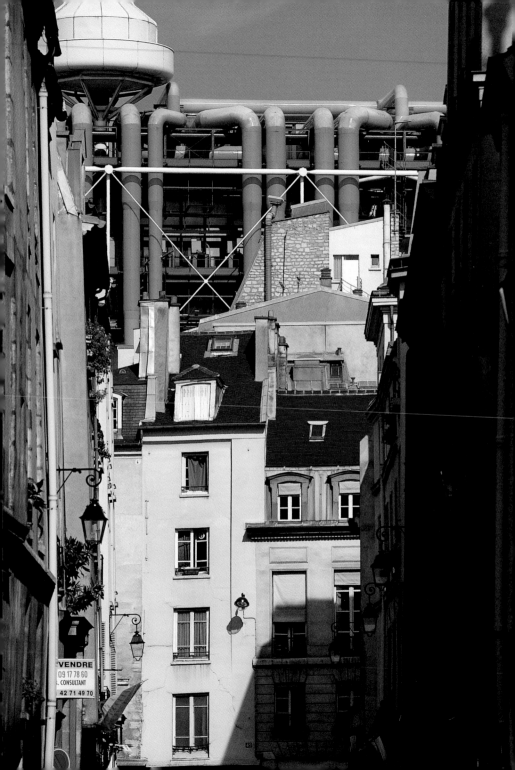

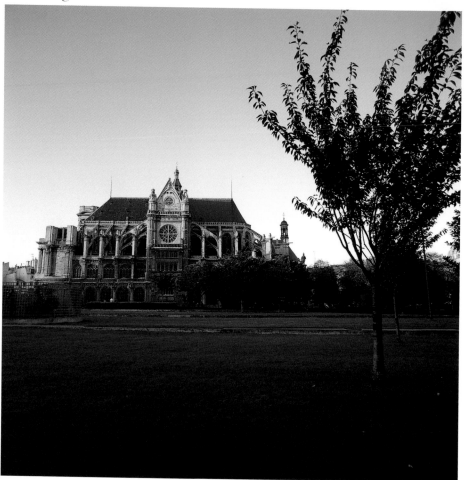

Saint-Eustache Church, from the gardens at the Forum des Halles, 1st arr.

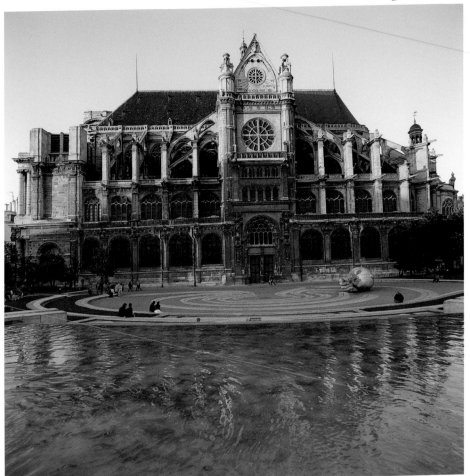

Henri de Miller's statue *L'Écoute*, in front of Saint-Eustache Church, 1ˢᵗ arr.

# The Right Bank

Café terrace at Les Halles, 1ˢᵗ arr.

Place du Châtelet,
the Fountain of Victory, 1ˢᵗ arr.

The Fountain of the Innocents,
place Joachim-du-Bellay,
near Les Halles, 1ˢᵗ arr.

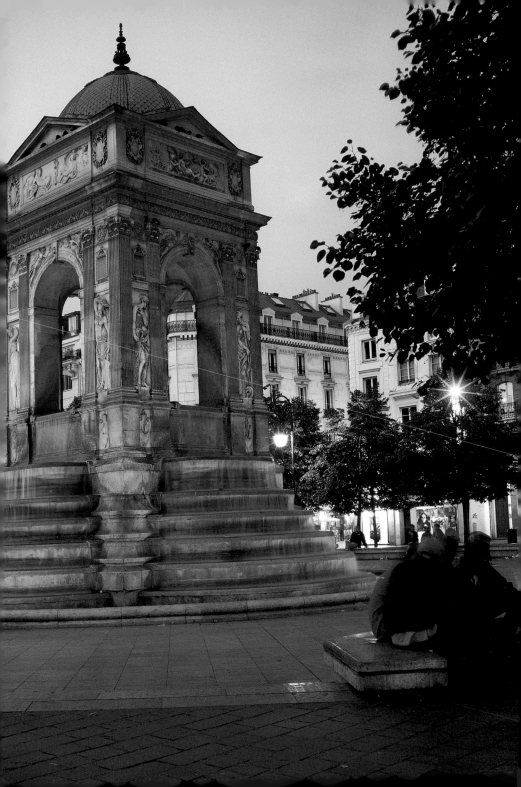

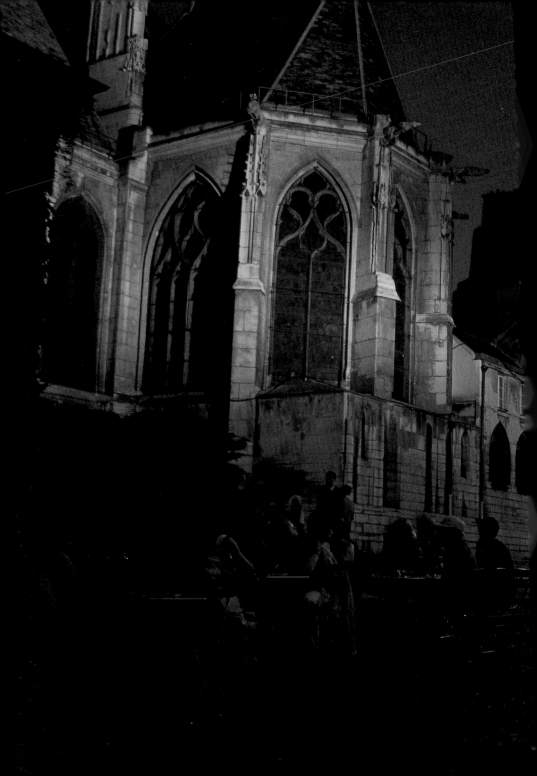

# The Right Bank

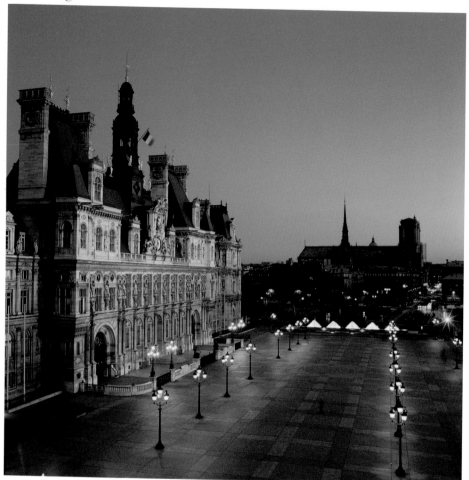

Place de l'Hôtel de Ville. In the background, l'île de la Cité and Notre-Dame, 4th arr.

*preceding double page*

Rue des Barres and the apse of Saint-Gervais Church in
the *marais*, 4th arr.

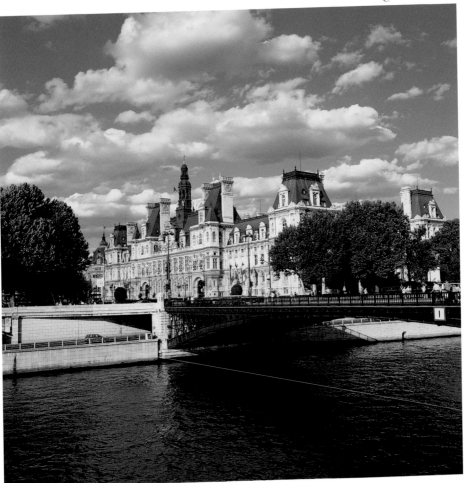

Pont d'Arcole and the Hôtel de Ville, 4ᵗʰ arr.

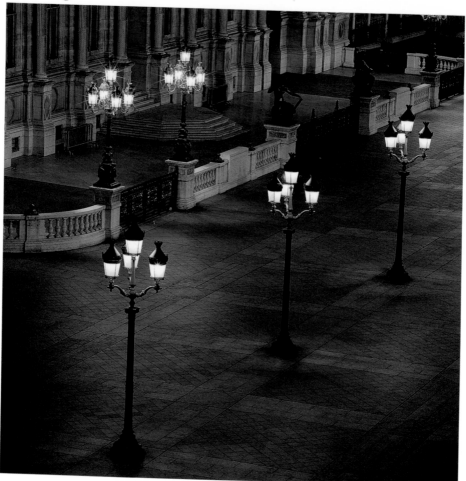

Place de l'Hôtel de Ville, 4th arr.

Detail of the roof of the Hôtel de Ville, 4th arr.

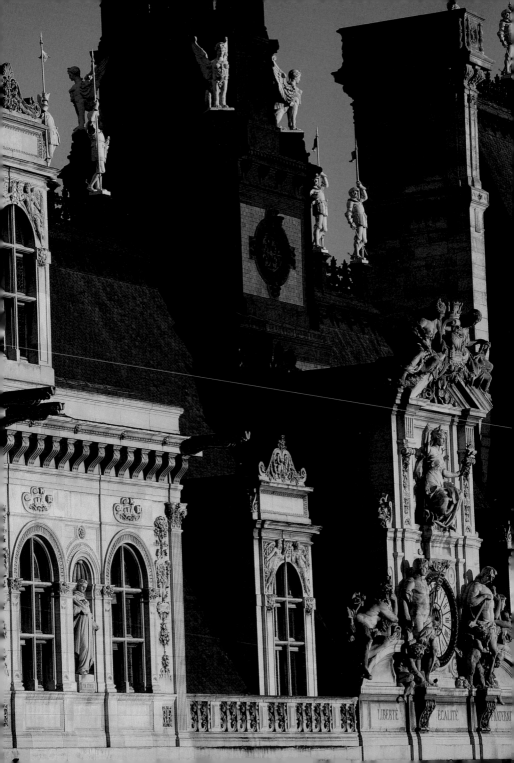

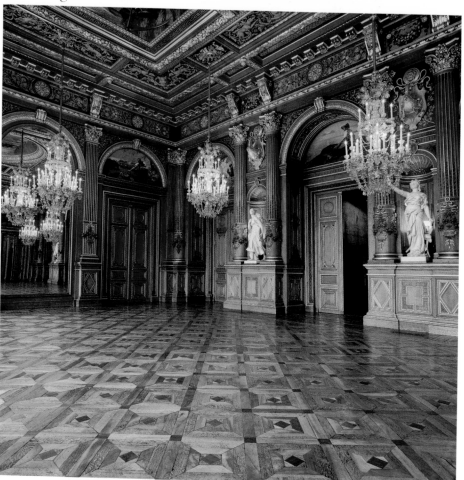

Reception hall, Hôtel de Ville, 4$^{th}$ arr.

The Salon des Arcades,
Hôtel de Ville, 4$^{th}$ arr.

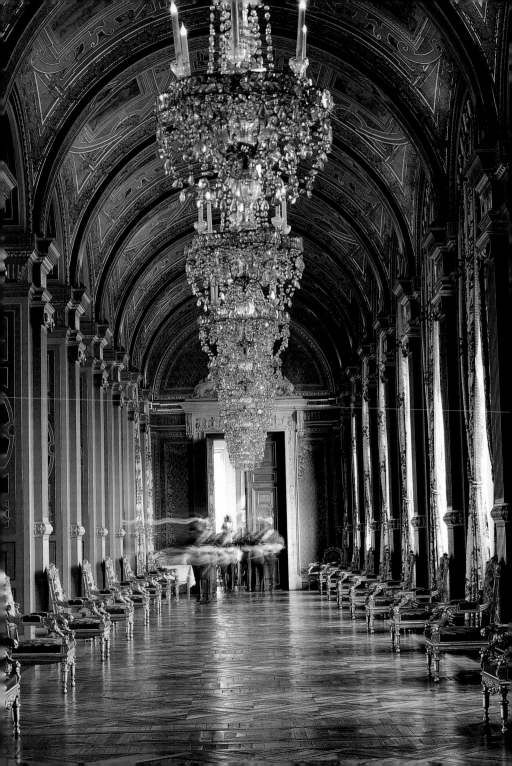

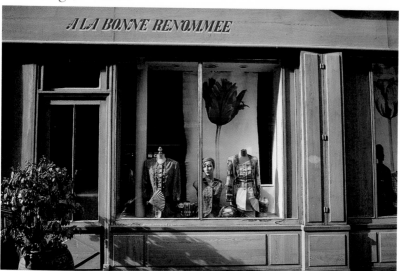

A la Bonne Renommée (Of Good Repute) boutique,
rue Vieille du Temple, 4th arr.

Many old storefronts line the small streets of the Marais, 4th arr.

The storefront of an old horse-butcher's shop in the Marais, 4th arr.

*following double page*

Hair salon on the rue de Rivoli, 4th arr.

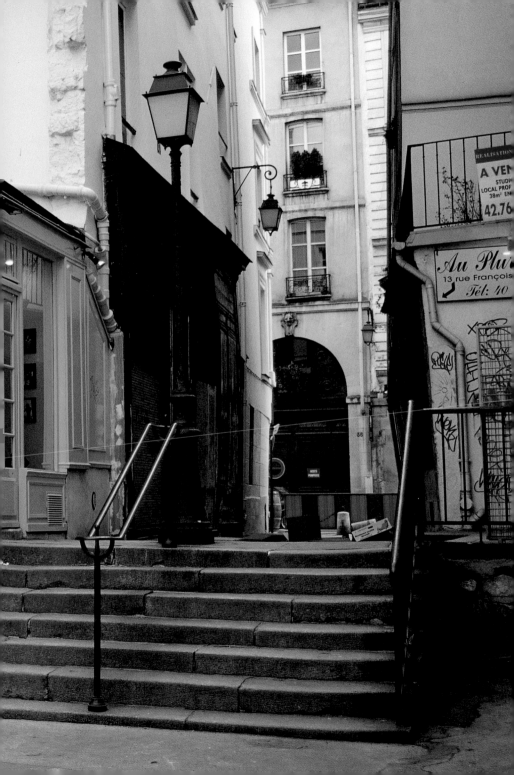

# The Right Bank

Café, rue des Lavandières-Sainte-Opportune, 1st arr.

A nostalgic storefront in the Marais, 4th arr.

Hôtel de Châtillon,
rue Payenne
in the Marais, 4th arr.

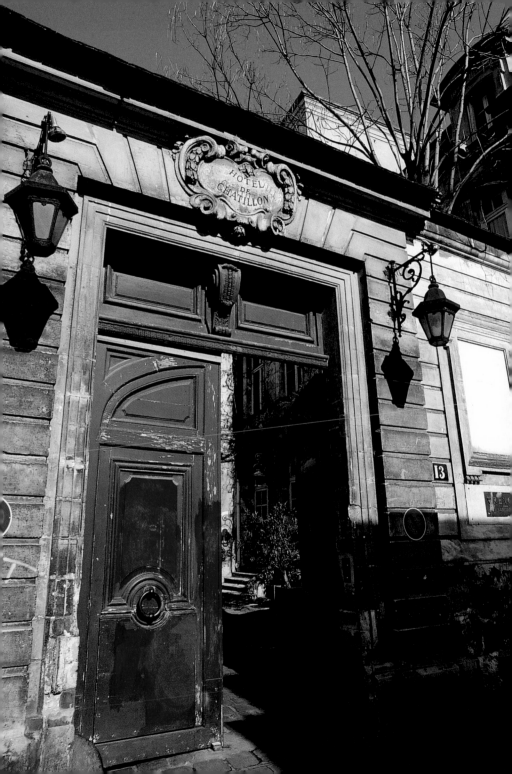

# The Right Bank

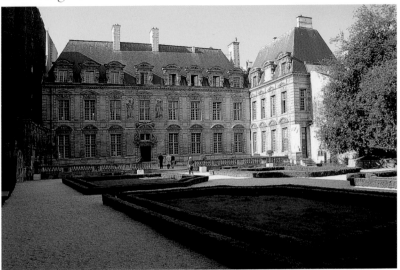

The Hôtel de Sully, home of the Treasury of Historical Monuments and Sites, 4th arr.

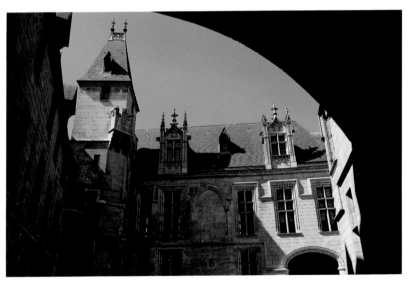

The Forney Library in the Hôtel de Sens, rue du Figuier, 4th arr.

The statue of Fame in the main courtyard of the Hôtel Carnavalet, Carnavalet Museum, 3rd arr.

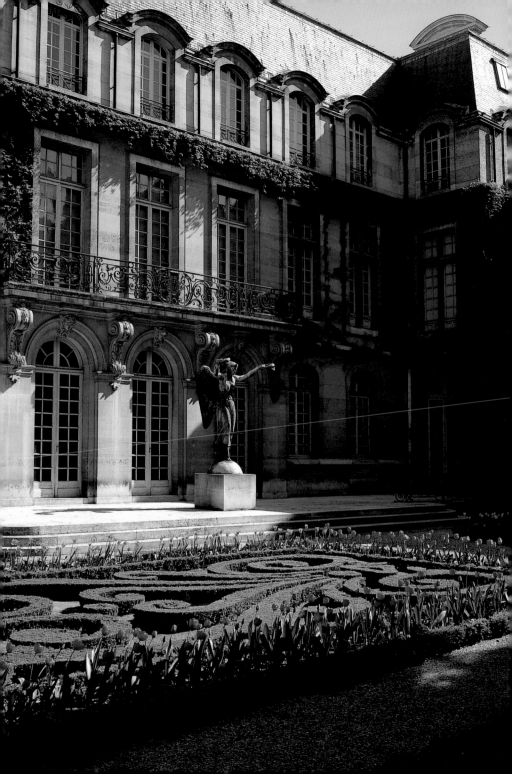

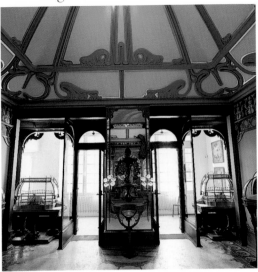

Fouquet's jewelry boutique,
Carnavalet Museum, 3rd arr.

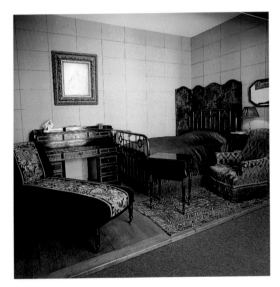

Author Marcel Proust's room,
Carnavalet Museum, 3rd arr.

The Luynes staircase and the statue of
Marie-Adélaïde de Savoie, duchess of Burgundy,
represented as Diana the Huntress,
by Antoine Coysevox, Carnavalet Museum, 3rd arr.

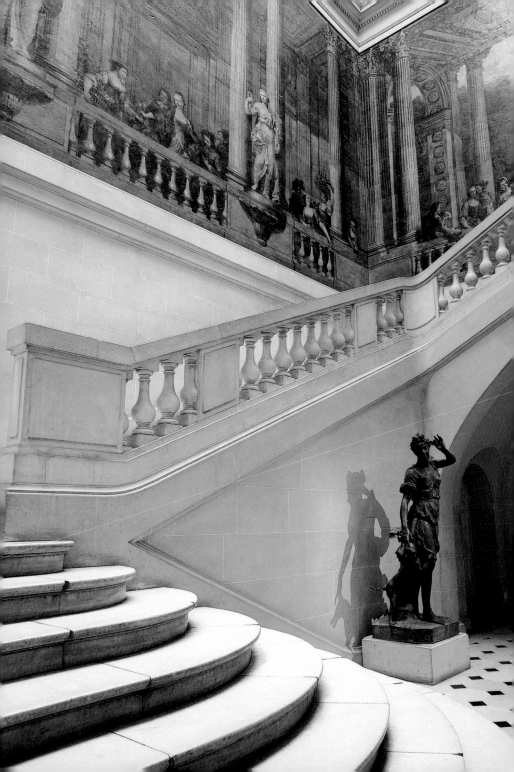

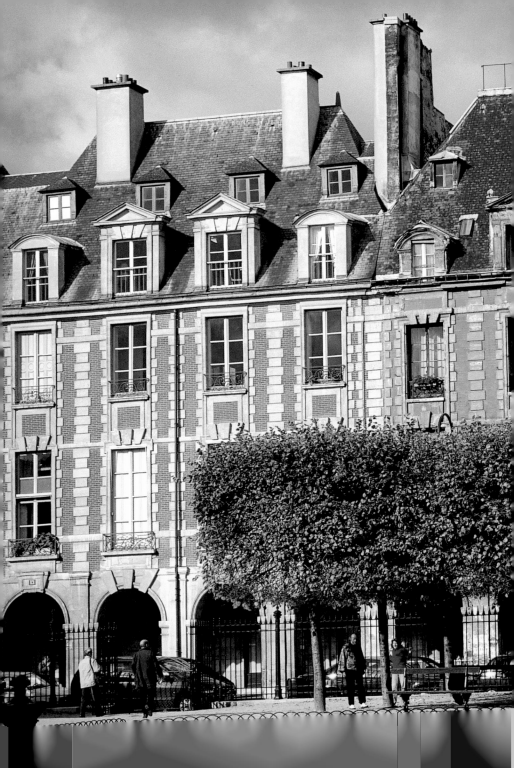

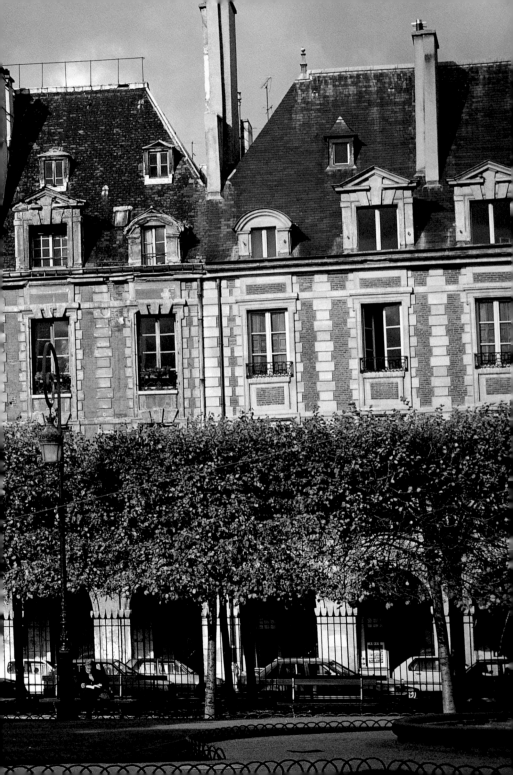

An antiques shop under the arcades of the place des Vosges, 4<sup>th</sup> arr.

*preceding double page*

Place des Vosges, 4<sup>th</sup> arr.

Statue of Louis XIII on horseback
Richelieu Square
place des Vosges, 4<sup>th</sup> arr

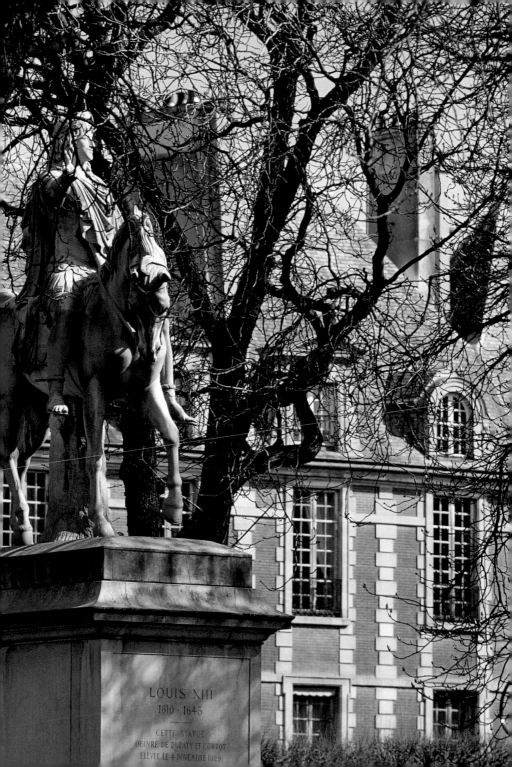

LOUIS XIII
1610 · 1643

CETTE STATUE
OEUVRE DE DUPATY ET CORTOT
ELEVEE LE 4 NOVEMBRE 1829

An old bakery, now a clothing shop, in the Marais, 4ᵗʰ arr.

Café du Trésor,
rue du Trésor, 4ᵗʰ arr.

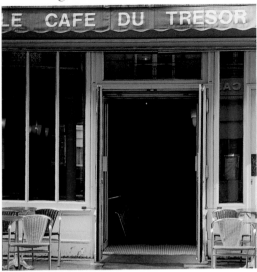

Café du Trésor, rue du Trésor, 4<sup>th</sup> arr.

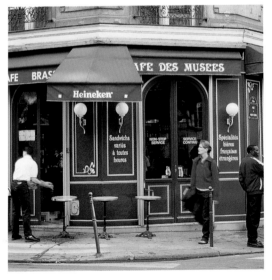

Café des Musées, rue de Turenne
near the Picasso Museum, 4<sup>th</sup> arr.

Halle du Carreau du Temple, 4<sup>th</sup> arr.

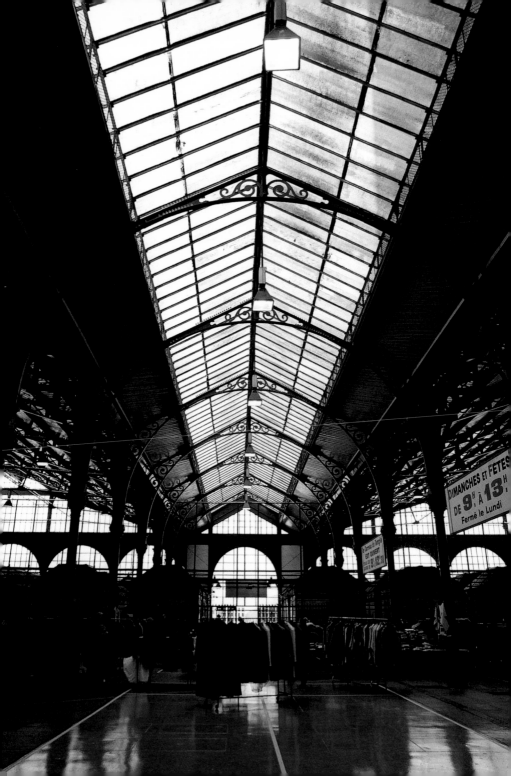

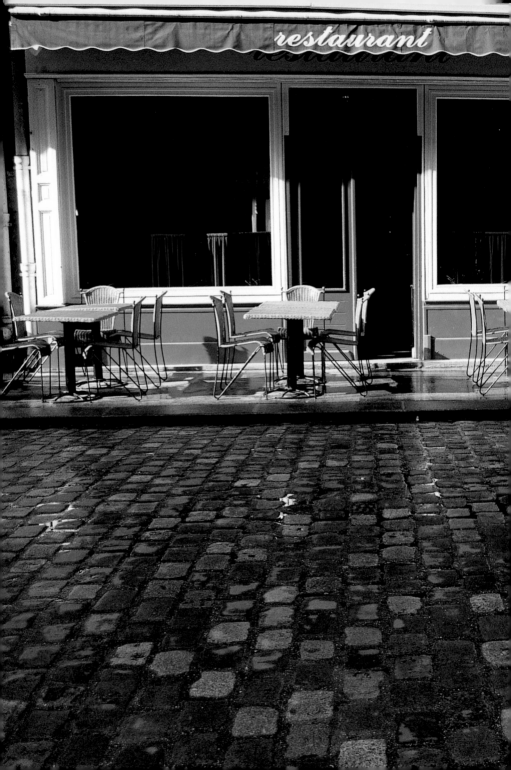

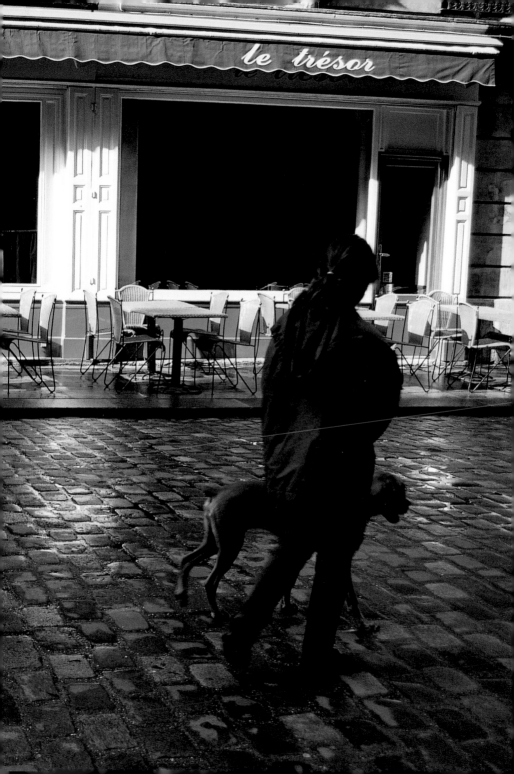

# The Right Bank

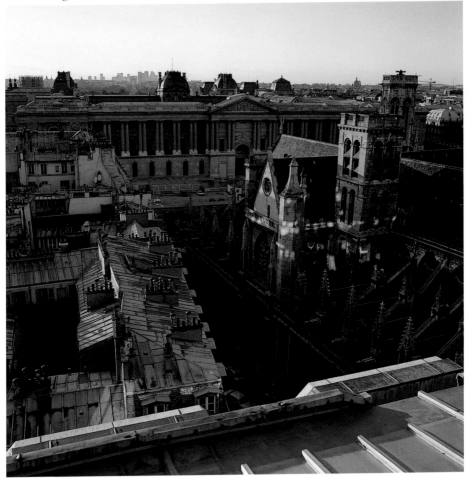

Saint-Germain-l'Auxerrois Church and the Louvre, from the
roof of Samaritaine, 1ˢᵗ arr.

*preceding double page*

Rue du Trésor, a quiet street opening onto the
much busier rue Vieille du Temple, 4ᵗʰ arr.

Saint-Gervais Church,
the Pompidou Center
and the Sacré-Coeur,
from the banks of the Seine.

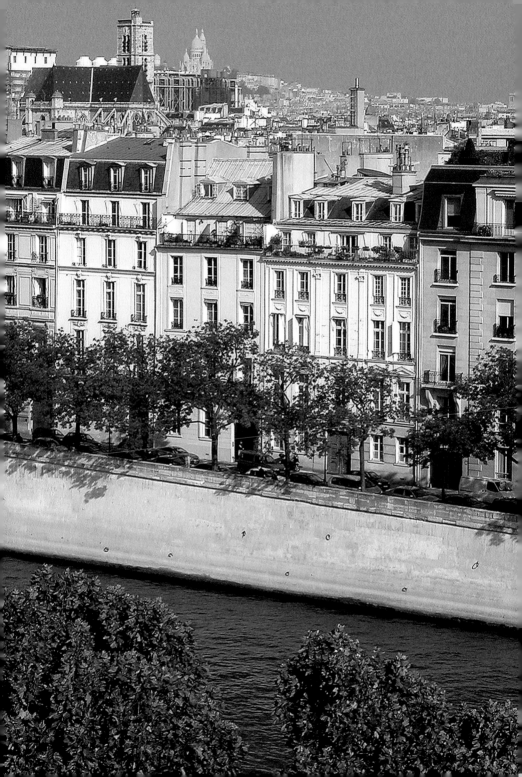

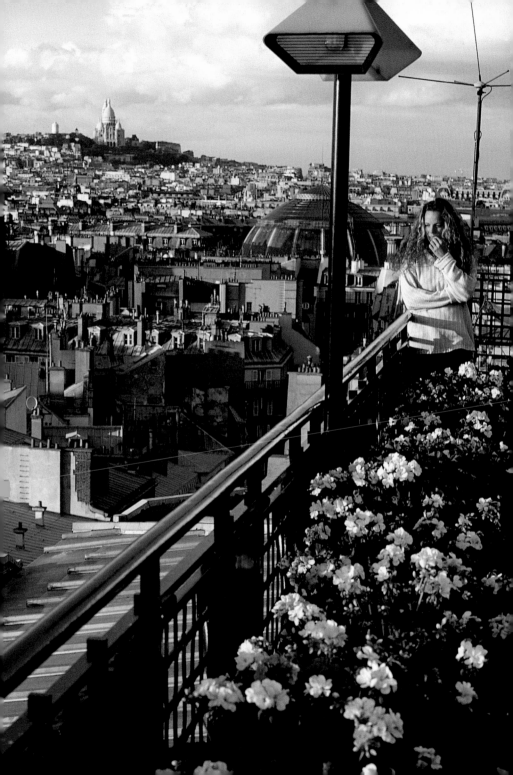

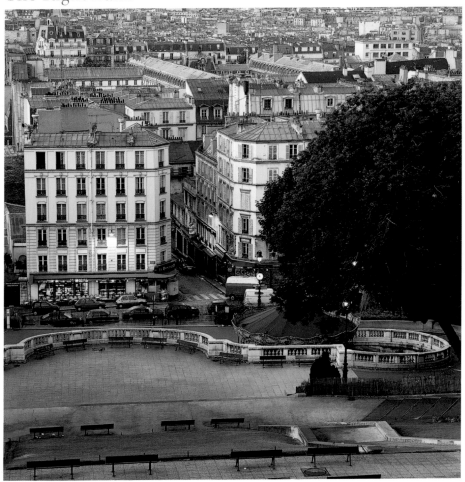

Montmartre, Willette Square, at the base of the Sacré-Coeur, 18th arr.

*preceding double page*

Montmartre Hill,
from the café terrace on top of
Samaritaine, 1st arr.

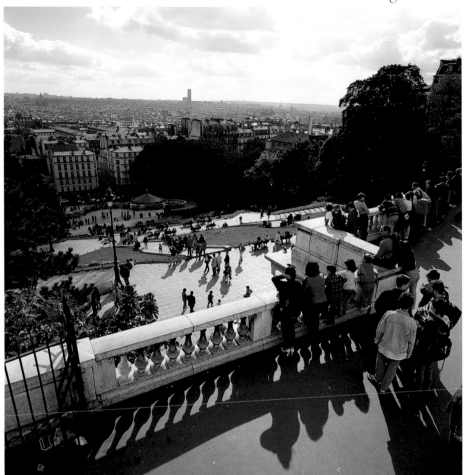

Paris and Montparnasse Tower, from the Sacré-Coeur, 18th arr.

Montmartre, rue Foyatier, 18th arr.

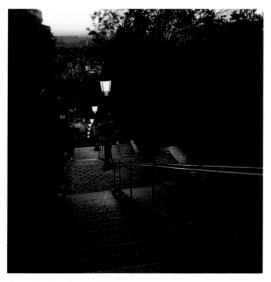

Evening by lamplight
in Montmartre, 18th arr.

A staircase leading up Montmartre,
rue Maurice-Utrillo, 18th arr.

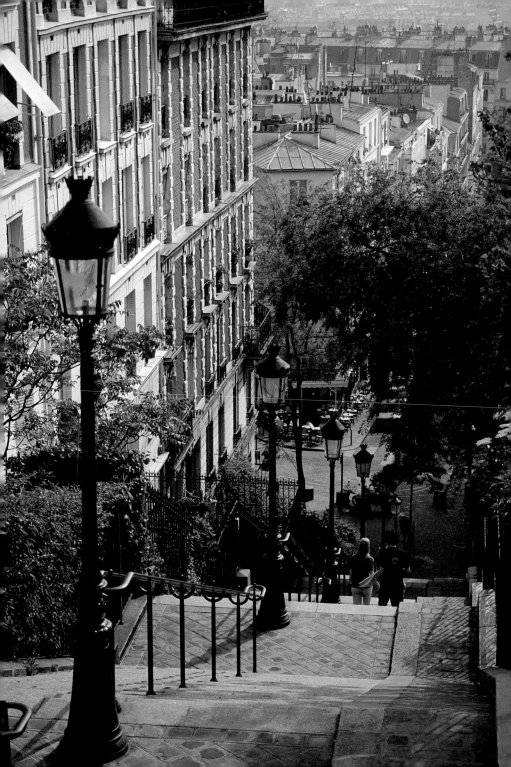

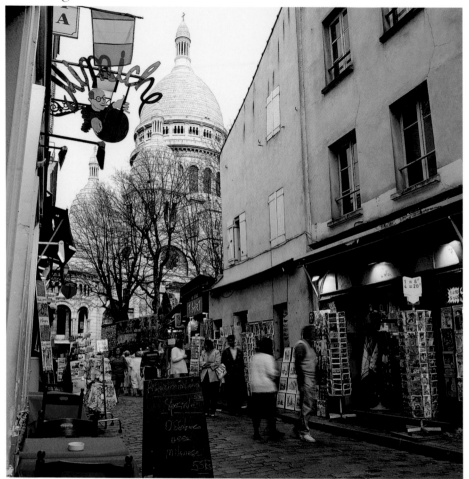

Rue du Chevalier-de-la-Barre and the Sacré-Coeur, 18th arr.

Rue de l'Abreuvoir
and the Sacré-Coeur, 18th arr.

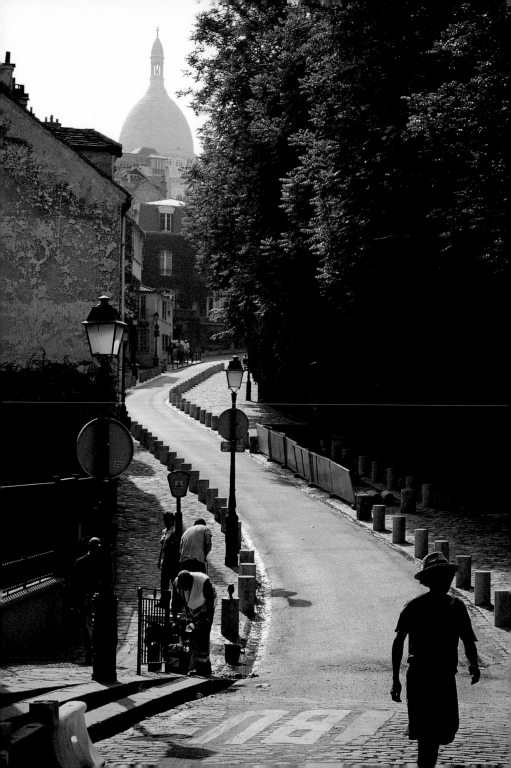

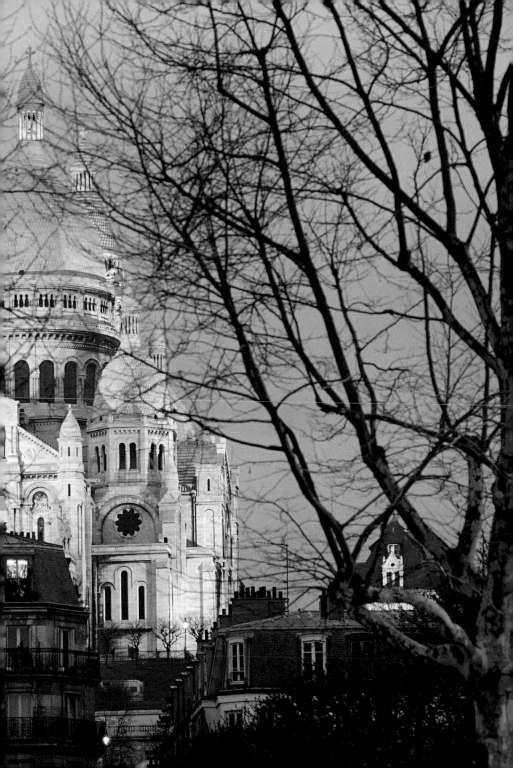

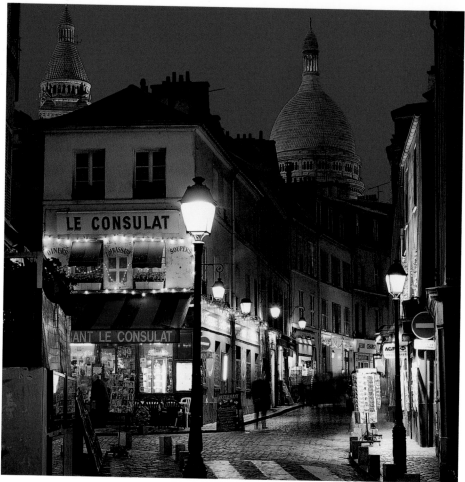

Rue Norvins runs toward the place du Tertre and the Sacré-Cœur, 18th arr.

*preceding double page*

The Sacré-Coeur of Montmartre,
from the Square d'Anvers, 18th arr.

An alleyway in old Montmartre,
the rue Saint-Rustique, 18th arr.

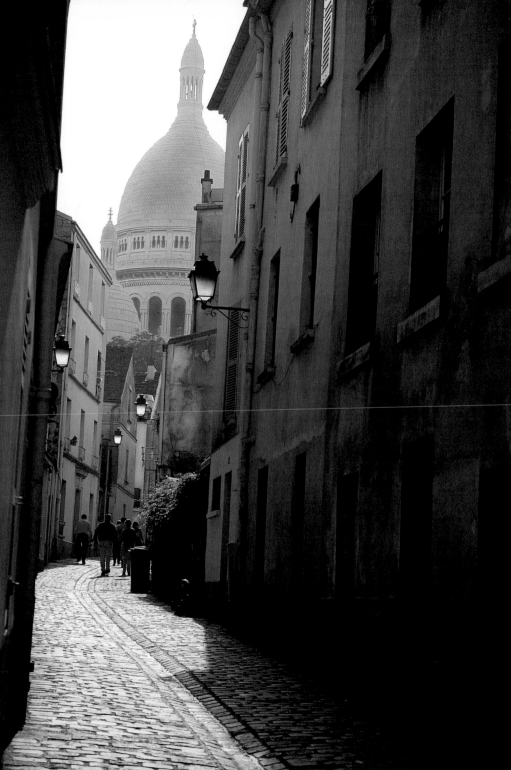

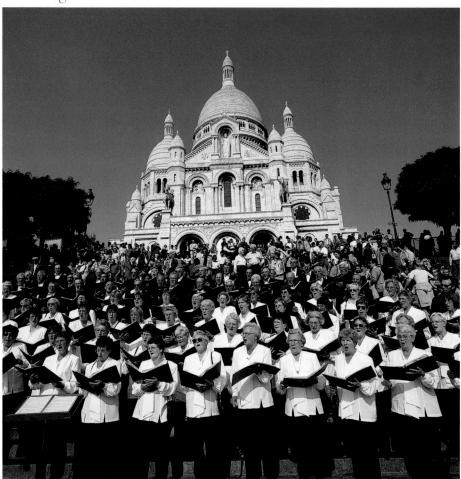

Choir in front of the Sacré-Coeur, 18th arr.

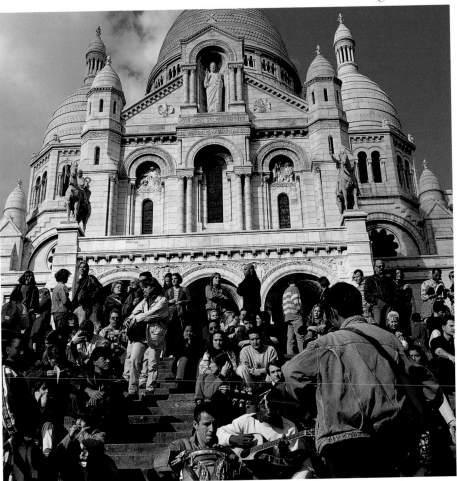

Day of the Harvest Festival on Montmartre, 18th arr.

*following double page*
Place du Tertre, 18th arr.

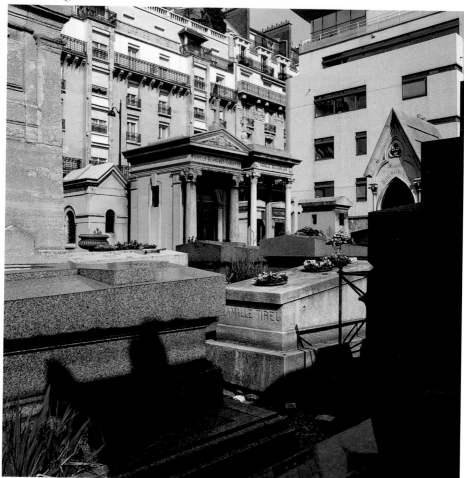

Montmartre Cemetery, near the place de Clichy, 18th arr.

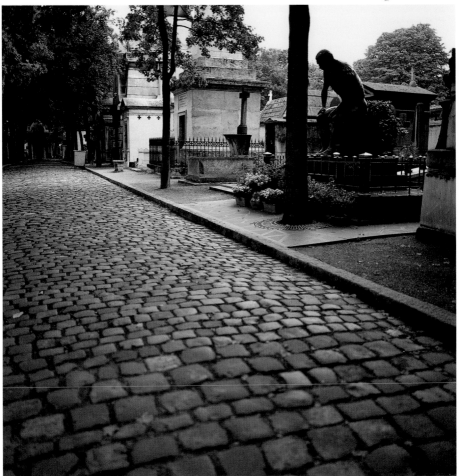

Rue Caulaincourt overlooking Montmartre Cemetery, 18th arr.

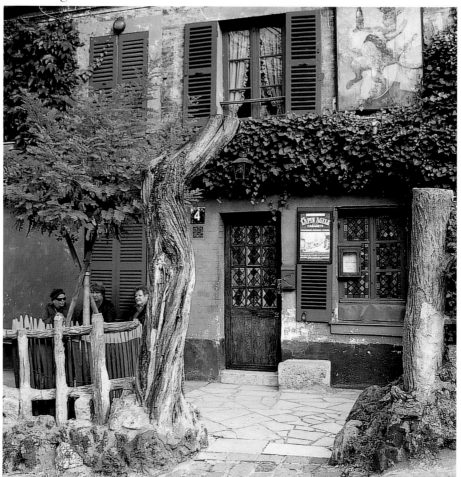

The old cabaret Au Lapin Agile, Montmartre, 18th arr.

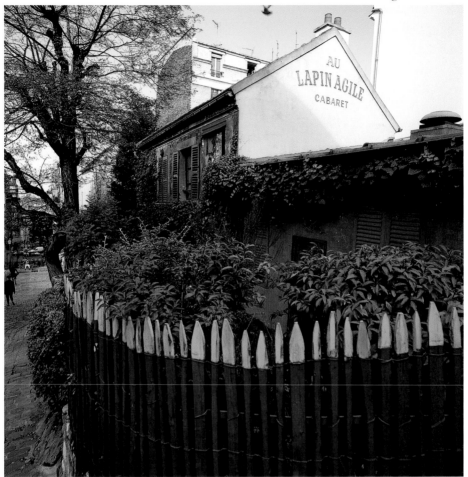

Rue des Saules, intersection with the rue Saint-Vincent,
one of the most picturesque corners of Montmartre, 18th arr.

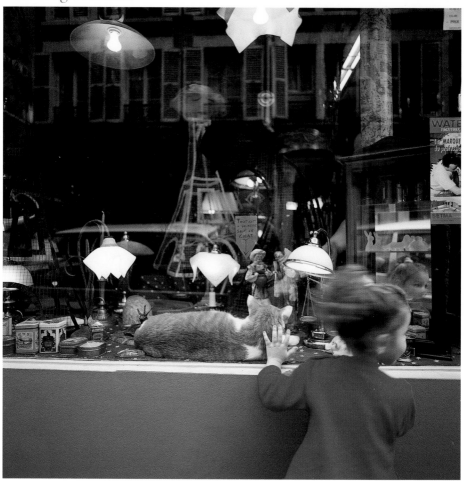

Secondhand goods store in the Barbès neighborhood,
rue André-Del-Sarte, 18th arr.

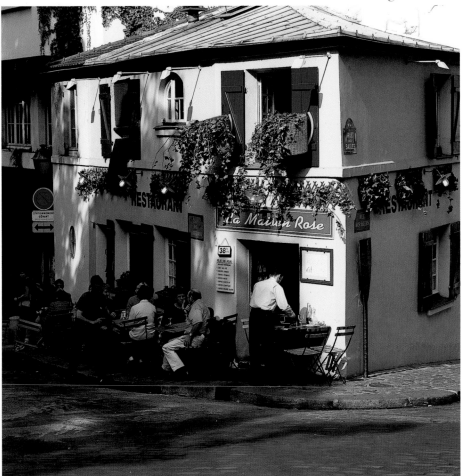

Restaurant on Montmartre Hill, rue de l'Abreuvoir, 18th arr.

# The Right Bank

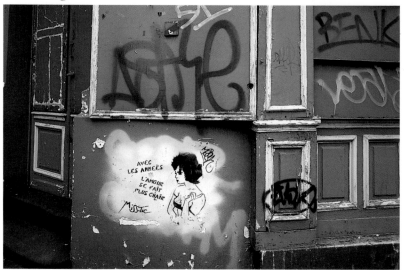

Graffiti in the 18th arr.

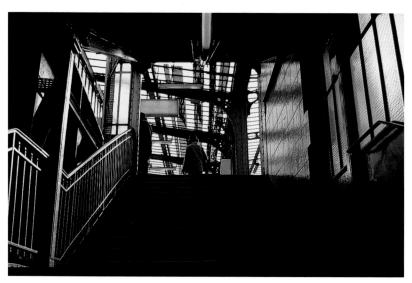

Barbès-Rochechouart metro station, 18th arr.

Romanès Circus, passage Lathuille, near the place de Clichy, 17th arr.

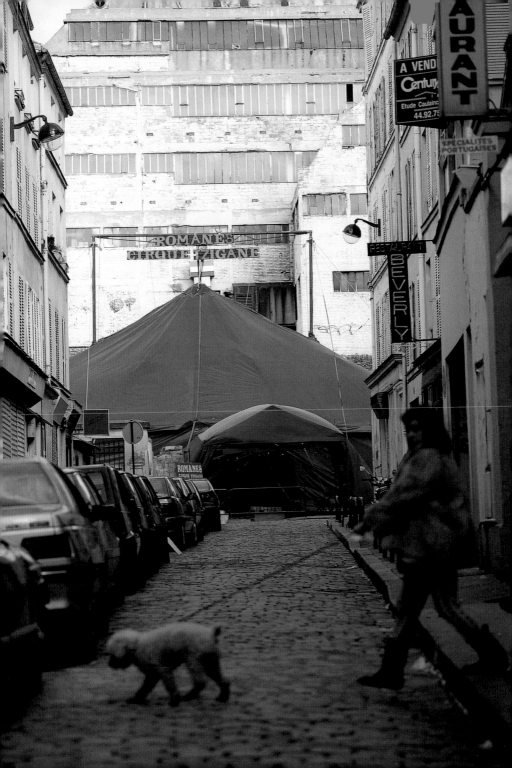

Gare Saint-Lazare, 8th arr.

Suburban railway trains at the Gare de l'Est,
10th arr.

Skylights on top of the Gare de l'Est,
from the rue d'Alsace, 10th arr.

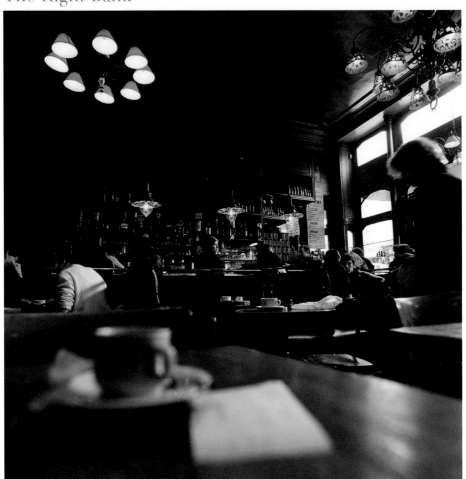

Café Charbon, rue Oberkampf, 11th arr.

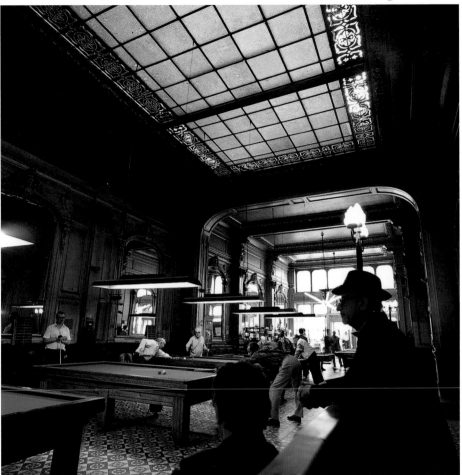

The Billiards Academy at Clichy-Montmartre, 17ᵗʰ arr.

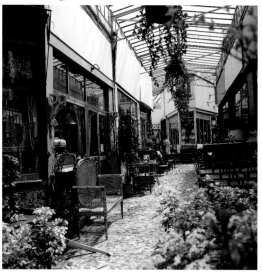

Antiques stores at Auteuil.

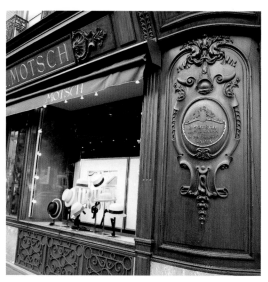

Motsch hatshop storefront,
place de l'Alma, 7$^{th}$ arr.

One of the flea markets at Saint-Ouen, 18$^{th}$ arr.

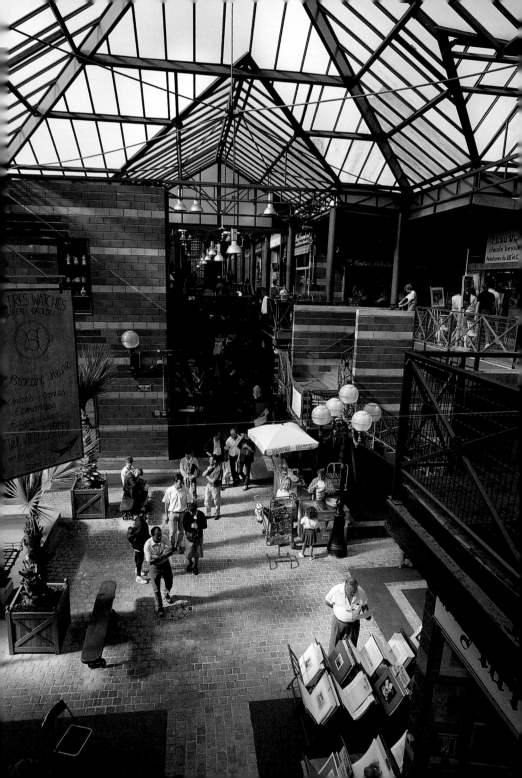

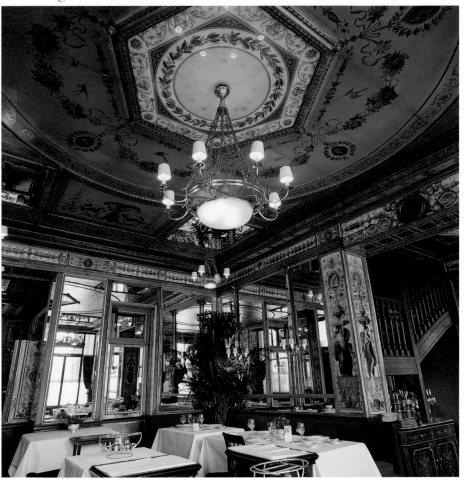

Le Grand Véfour restaurant, under the arcades bordering
the gardens of the Palais-Royal, 1st arr.

Reflected decor of Le Grand Véfour,
one of the most beautiful
restaurants in Paris, 1st arr.

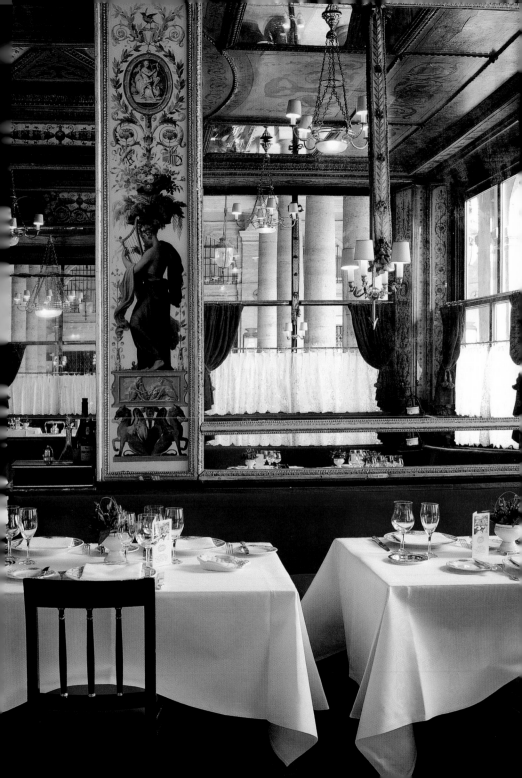

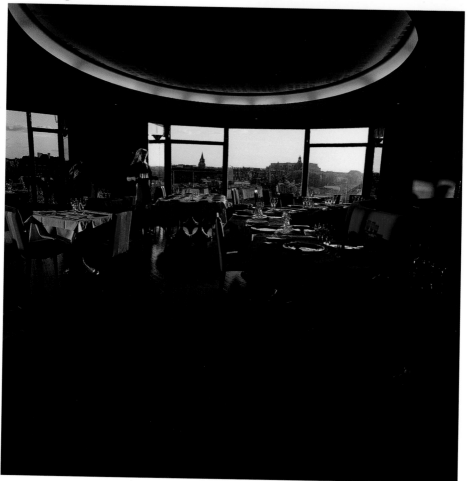

Salle du Toupary, restaurant decorated by renowned interior designer
Hilton MacConnico, 1st arr.

The view overlooking the Pont-Neuf and
the banks of the Seine from the
Toupary restaurant, on the
sixth floor of Samaritaine, 1st arr.

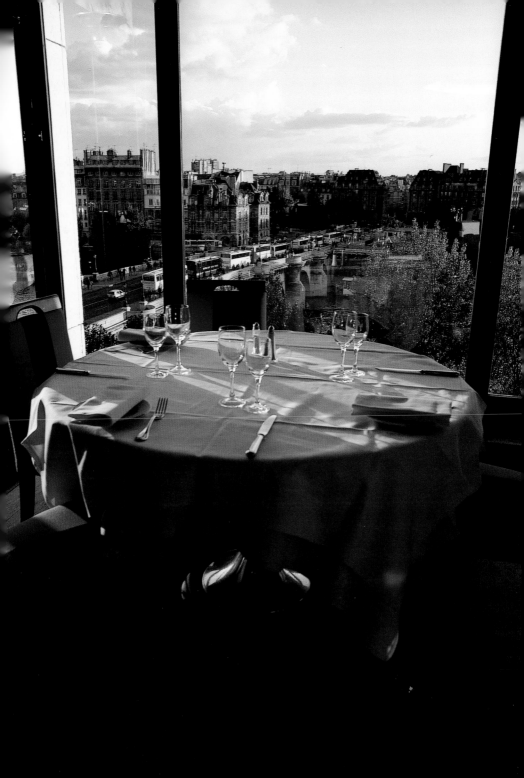

Bosio's statue of Louis XIV, place des Victoires, 2nd arr.

Rue d'Aboukir, place des Victoires,
and the Bank of France, 2nd arr.

Place de la Bastille, from the steps of the nearby opera house, 12th arr.

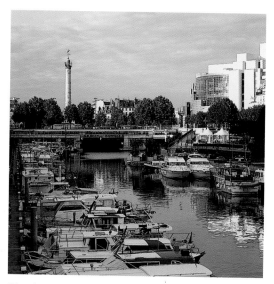

The Arsenal basin, a port for pleasure boats, 12th arr.

*Spirit of the Bastille,*
from the rue du Faubourg-Saint-Antoine, 12th arr.

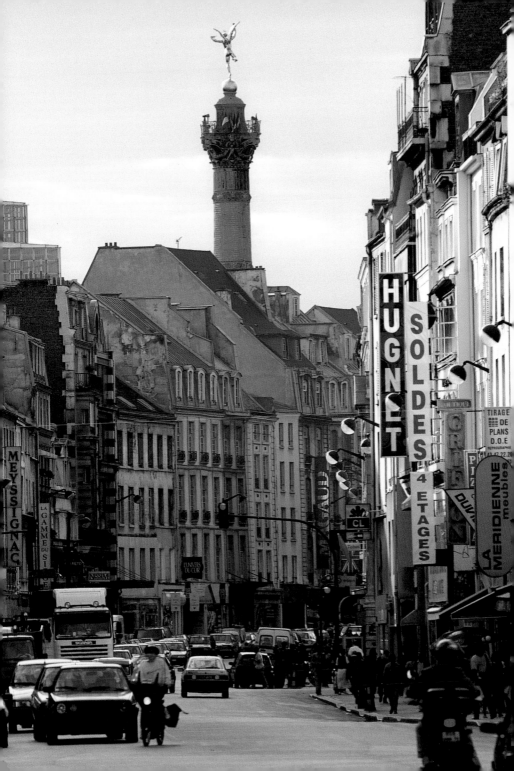

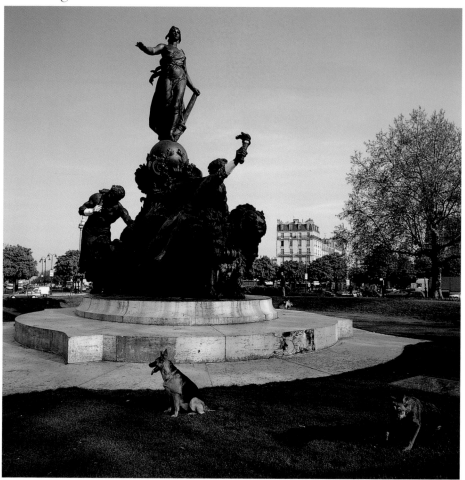

*The Triumph of the Republic*, by Jules Dalou, place de la Nation, 12th arr.

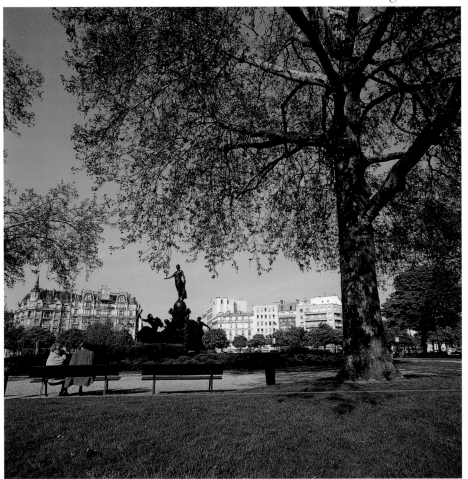

Garden at the center of the place de la Nation, 12th arr.

*following double page*

Upscale buildings in the 8th arrondissement,
bordering the parc Monceau.

243

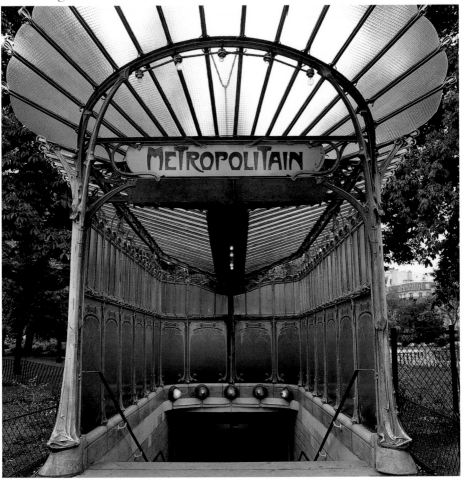

The art nouveau Porte-Dauphine
metro station designed by Hector Guimard, 16th arr.

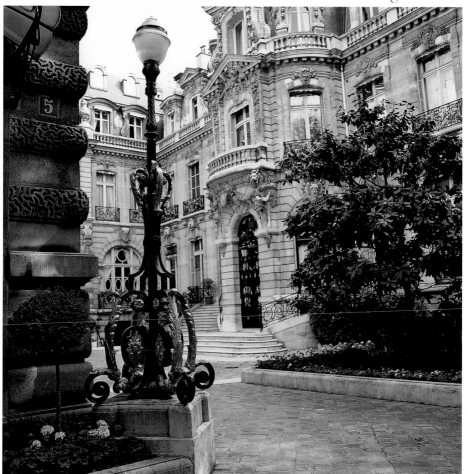

Home of the Menier family, built by architect H. Parent, parc Monceau, 8th arr.

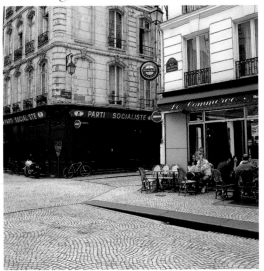

Montorgueil neighborhood, 2<sup>nd</sup> arr.

Façade in the 2<sup>nd</sup> arr.

Montorgueil neighborhood, 2<sup>nd</sup> arr.

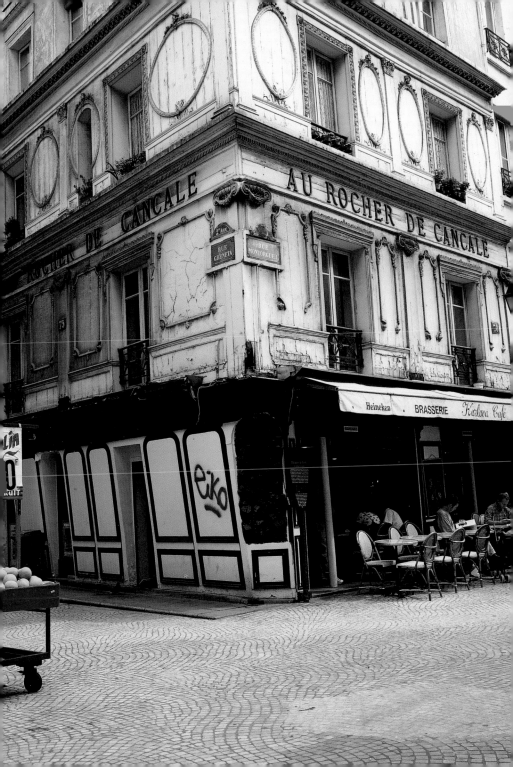

RESTAU

BRASSERIE DU PONT LOUIS PHILIPPE

RESTAURANT

Chez
Louis-Philippe
Restaurant
Salle panoramique
RESERVATIONS
01.42.72.29.42

LIQUEURS                    DE LUXE

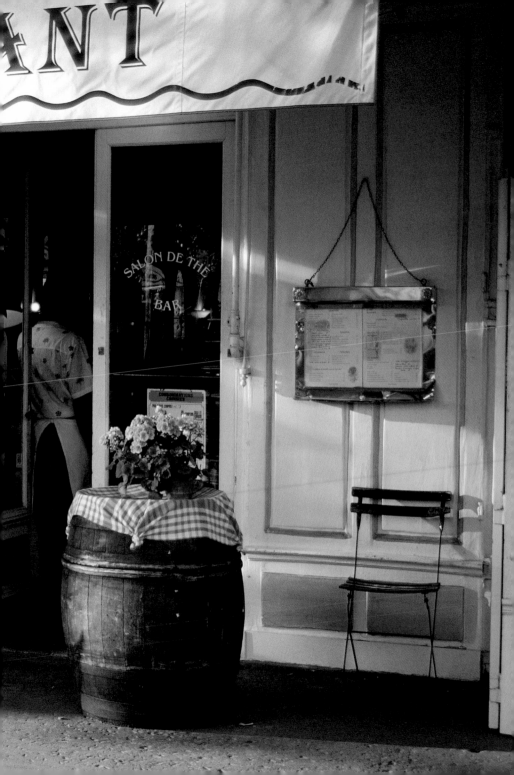

Restaurant in the 16th arr.

Boutique, rue Vieille du Temple, 4th arr.

*preceding double page*

Le Pont-Louis-Philippe restaurant,
quai de l'Hôtel-de-Ville, 4th arr.

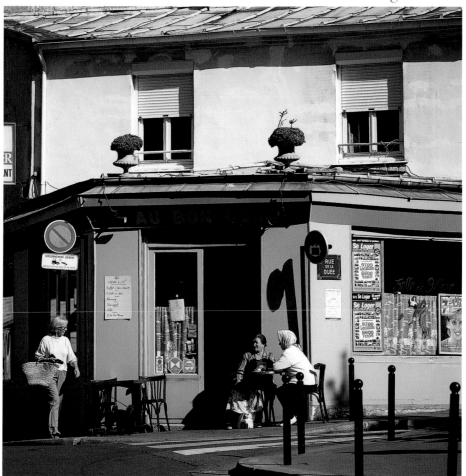

Belleville neighborhood, 20th arr.

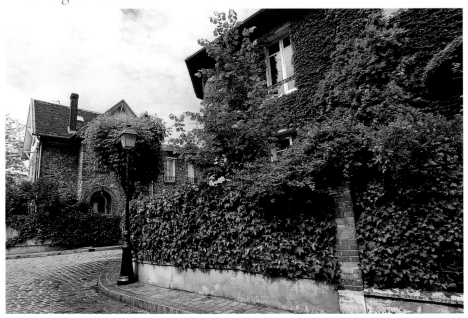

Parisian countryside, rue Irénée-Blanc, 20<sup>th</sup> arr.

Interior courtyard of the
Hôtel de Châtillon
rue Payenne
in the Marais, 4<sup>th</sup> arr

The hidden entrance to author Honoré de Balzac's house,
rue Berton, 16<sup>th</sup> arr.

Old artists' workshops, 11<sup>th</sup> arr.

Old artists' workshops, 11<sup>th</sup> arr.

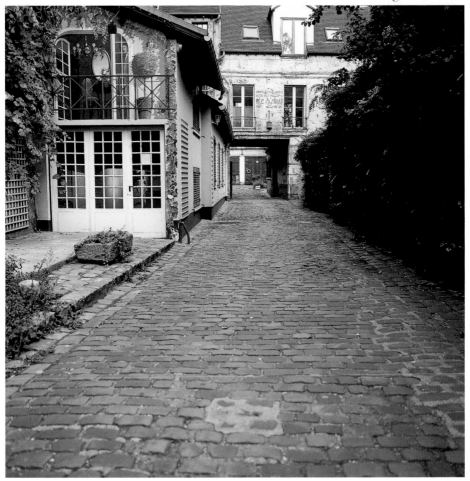

Courtyard of the Étoile-d'Or, Faubourg-Saint-Antoine, 11th arr.

*following double page*

Old artists' workshops,
Bastille neighborhood, 11th arr.

# The Right Bank

Building on the rue Raynouard, 16th arr.

Passage on the rue du Faubourg-Saint-Antoine, 11th arr.

Footbridge over the canal de l'Ourcq, 19th arr.

Interior courtyard
near the place de la République, 10th arr.

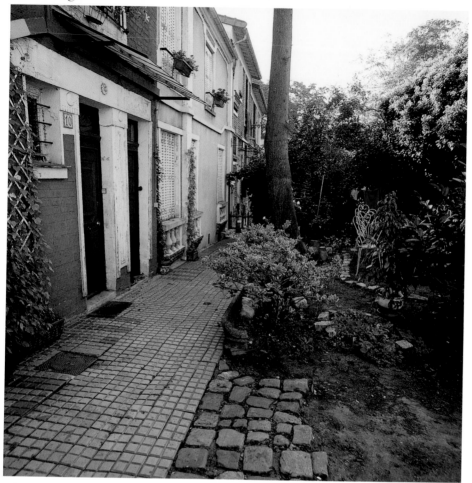

Villa de l'Ermitage, Ménilmontant, 20th arr.

Villa Castel, Ménilmontant, 20th arr.

The tomb of French poet Guillaume Apollinaire,
Père Lachaise Cemetery, 20ᵗʰ arr.

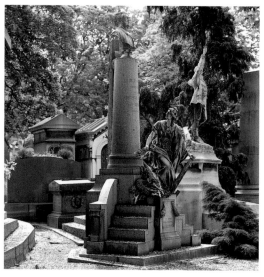

A veritable museum of funerary sculptures
within Père Lachaise Cemetery, 20ᵗʰ arr.

Located on a wooded hill,
Père Lachaise Cemetery is the perfect
place for an afternoon stroll, 20ᵗʰ arr.

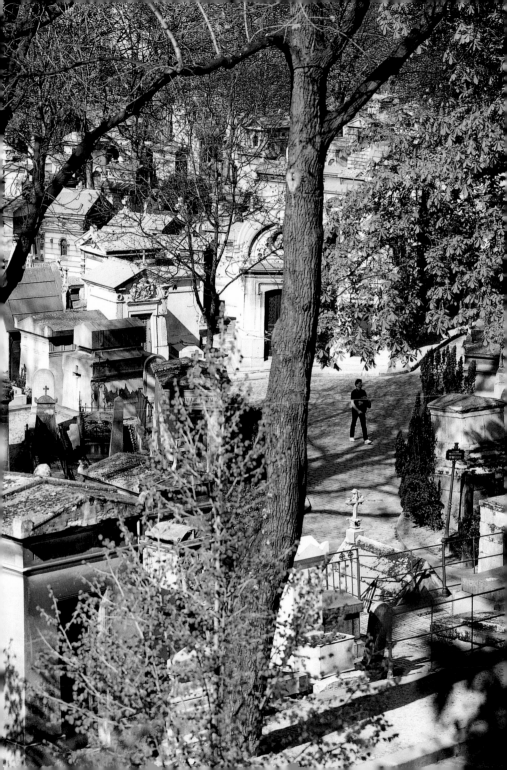

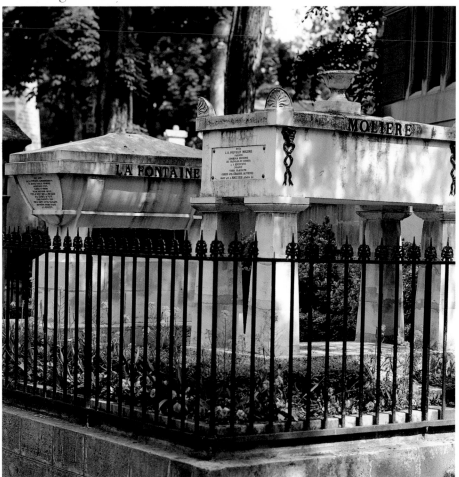

The tombs of authors La Fontaine and Molière, Père Lachaise Cemetery, 20th arr.

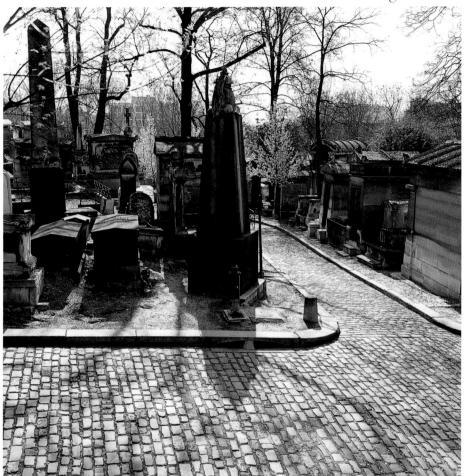

Thousands of trees provide shade for the Père Lachaise Cemetery, the largest park in the city, 20th arr.

# The Right Bank

Passage, rue du Faubourg-Saint-Antoine, 11th arr.

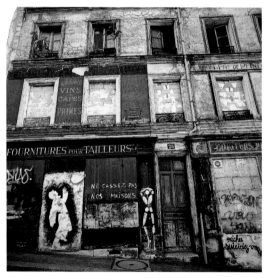

Vestiges of old Paris, Ménilmontant, 20th arr.
To the left of the door, a white body
by the painter Jérôme Mesnager.

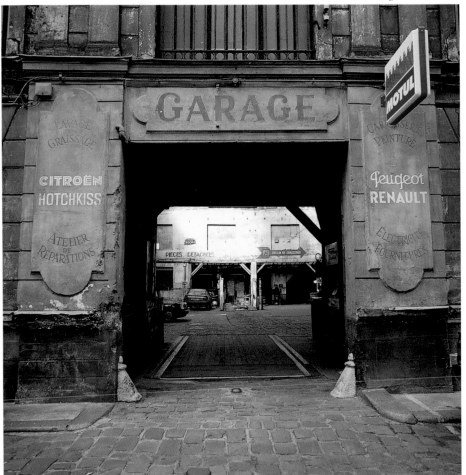

Passage, rue du Faubourg-Saint-Antoine, 11ᵗʰ arr.

Fashion boutique, place du Marché-Saint-Honoré, 1ˢᵗ arr.

Nicolas Flamel's house (1407), the oldest house in Paris,
rue de Montmorency, 3$^{rd}$ arr.

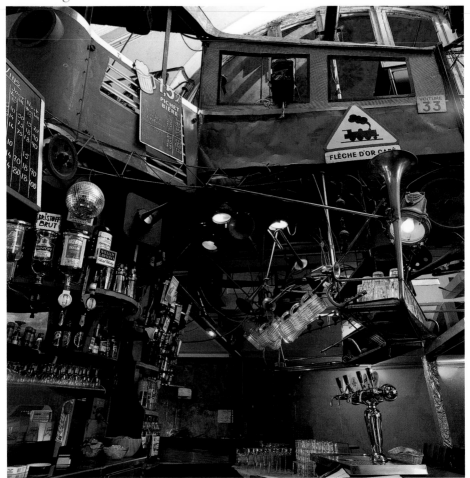

The Flèche d'Or (Golden Spire) Café, rue de Bagnolet, 20th arr.

Sun merchant, rue Oberkampf, 11th arr.

*following double page*
Christmas in Paris on the Champs-Élysées, 8th arr.

279

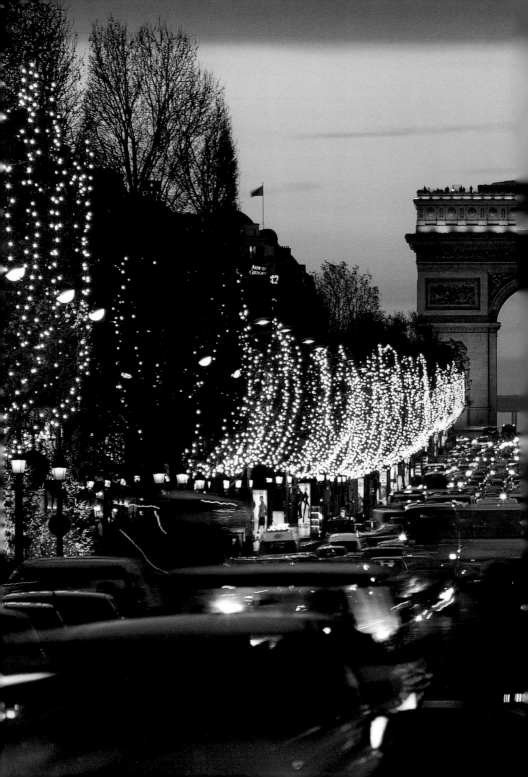

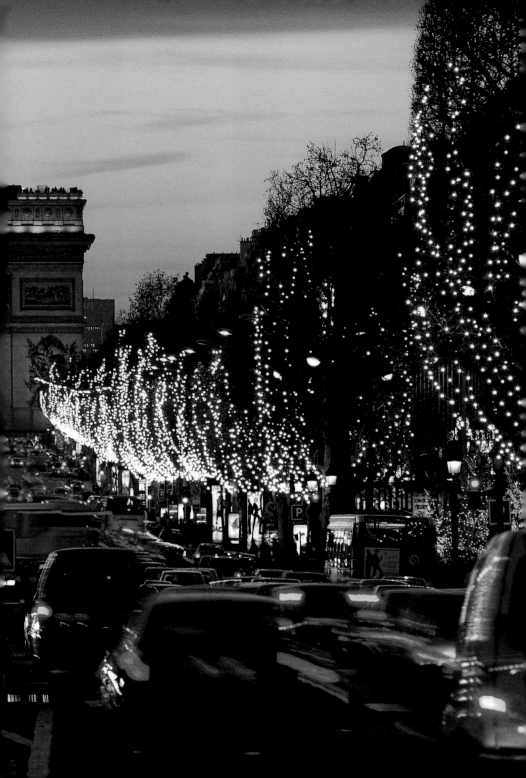

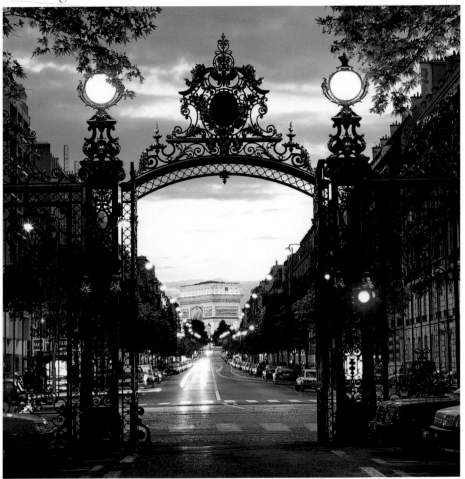

Avenue Hoche and the Arc de Triomphe, from the gate at the parc Monceau, 8th arr.

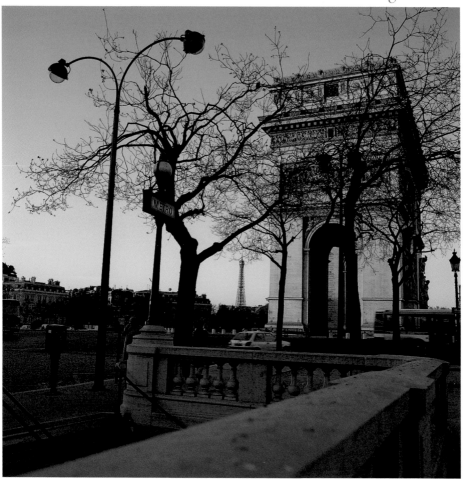

Place Charles-de-Gaulle and the Arc de Triomphe, 8th arr.

Café terrace on the Champs-Élysées, 8th arr.

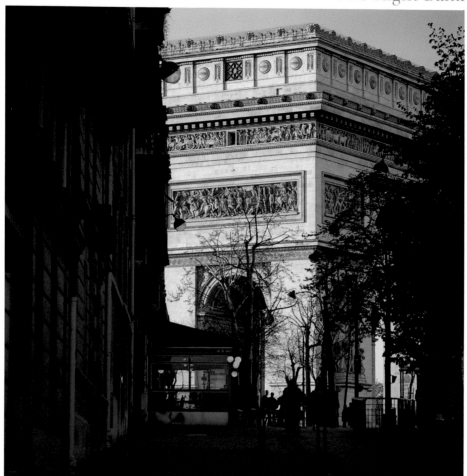

The Arc de Triomphe, from the avenue Mac-Mahon, 8th arr.

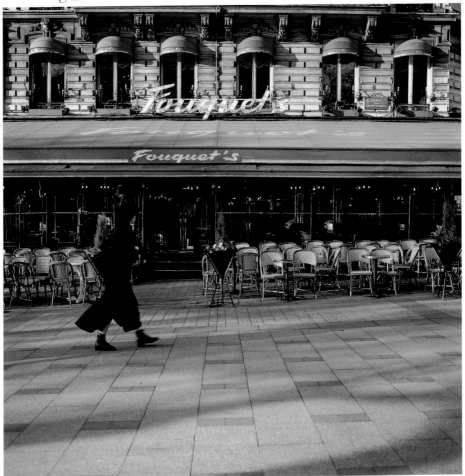

Fouquet's restaurant on the Champs-Élysées, 8th arr.

Springtime at the Ledoyen restaurant, Champs-Élysées, 8ᵗʰ arr.

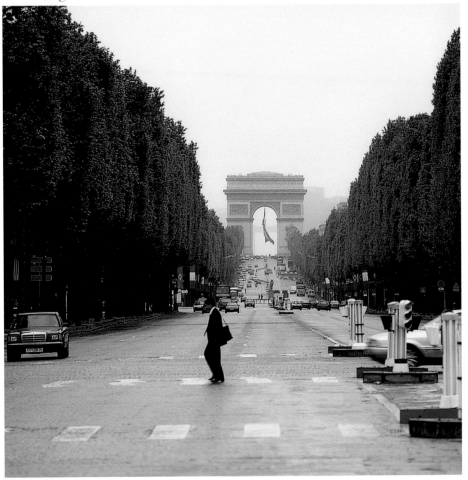

The Champs-Élysées, Paris's triumphal avenue,
rising on a gentle incline from the Concorde to l'Étoile, 8ᵗʰ arr.

Paris's most famous street, the Champs-Élysées,
an ideal place for the parades and celebrations
to which it often plays host, 8ᵗʰ arr.

*following double page*
Avenue Foch and the avenue de la Grande-Armée
near the towers of la Défense, 8ᵗʰ arr.

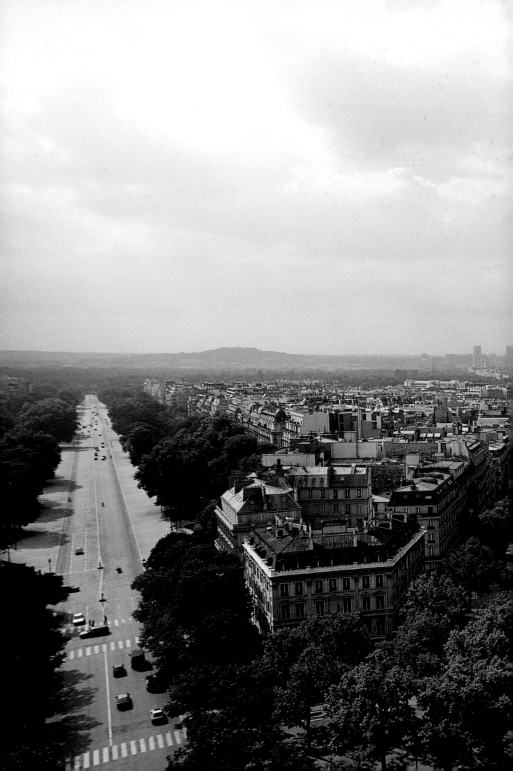

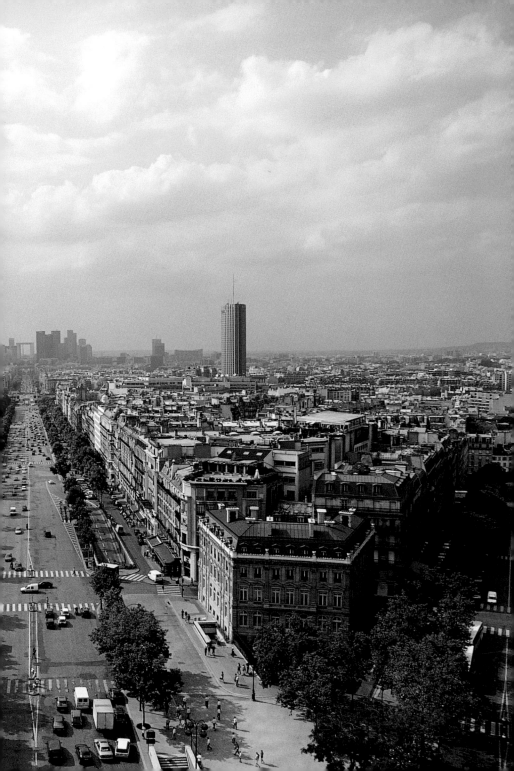

# The Right Bank

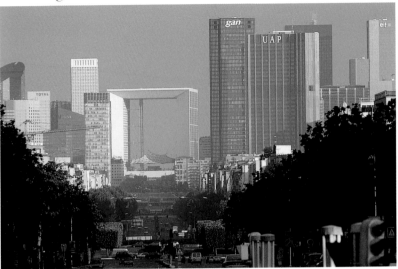

The neighborhood around la Défense and the Grande Arche,
near the Seine and l'île de Puteaux.

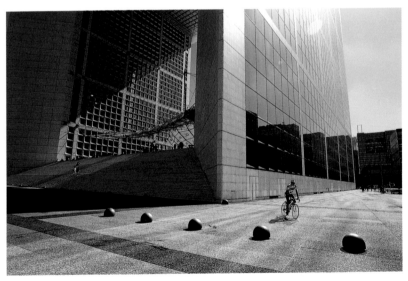

People taking a stroll at the base of the Grande Arche,
la Défense neighborhood.

The *Mobile de Calder*, a modern
sculpture on the square in front of the
Grande Arche, la Défense neighborhood.

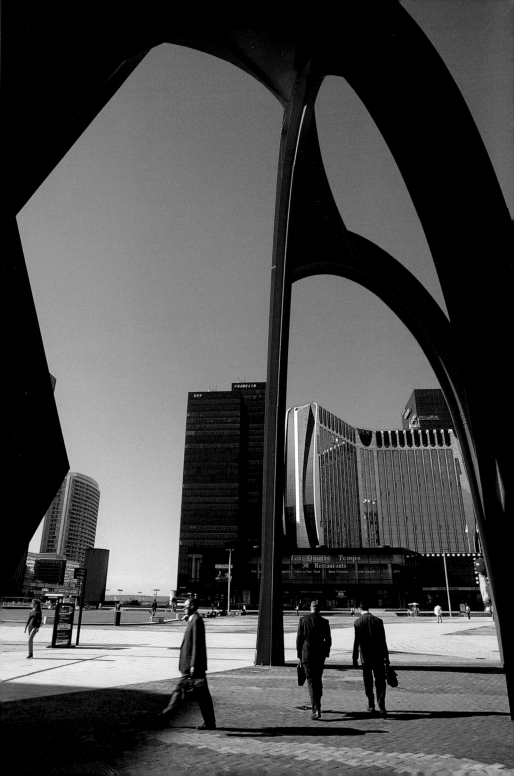

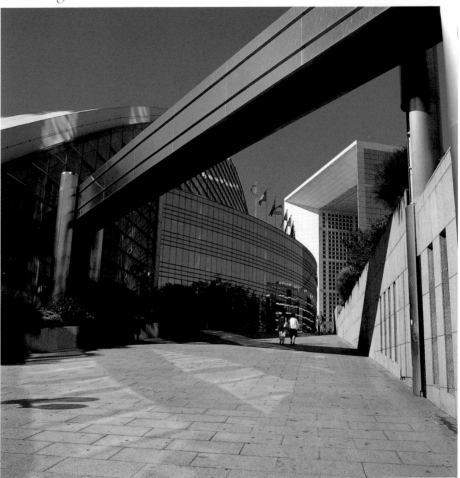

The CNIT Conference and Exhibition Center of Paris and the Grande Arche, la
Défense neighborhood, beyond the pont de Neuilly.

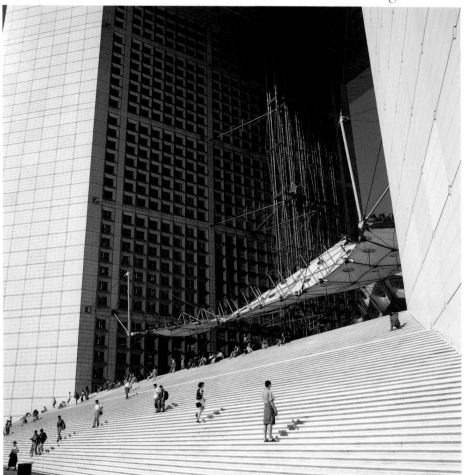

The Grande Arche de la Défense, designed by the Danish architect Otto von Spreckelsen.

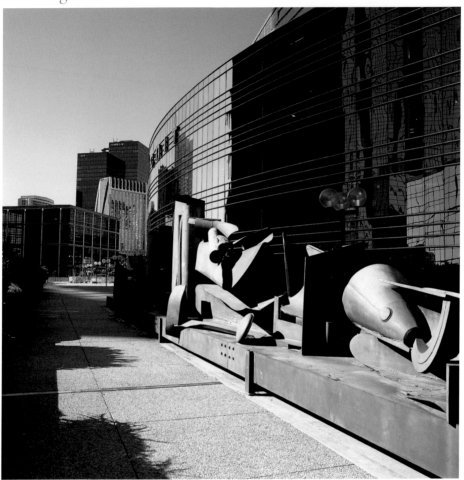

Outside of Paris but along the same axis that connects L'Etoile
and the Champs-Élysées, in la Défense neighborhood.

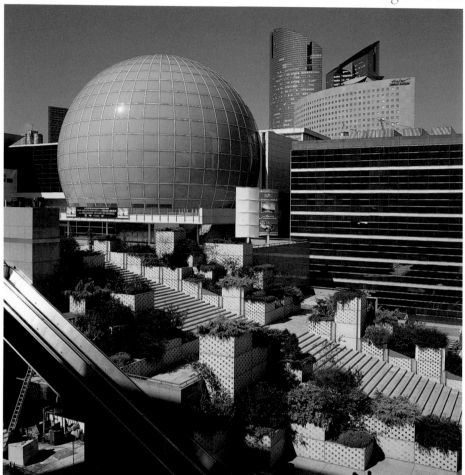

Near the Museum of the Automobile,
the cinema dome in la Défense neighborhood.

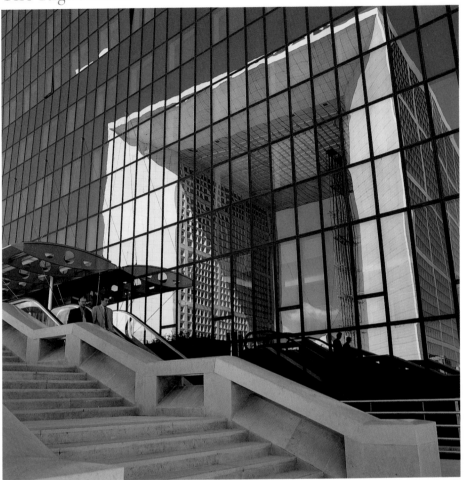

Reflection of the Grande Arche on one of the towers of la Défense.

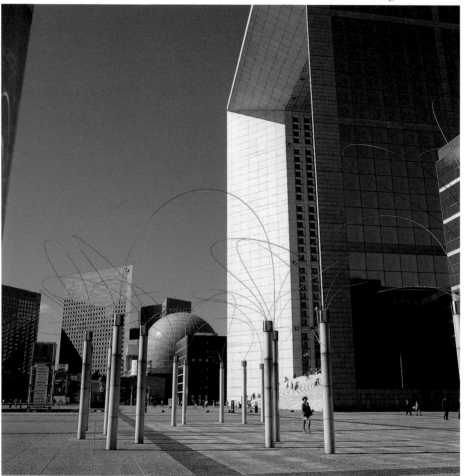

Square in front of the Grande Arche de la Défense.

*following double page*

The Grande Arche, the third triumphal arch of the
Grande Axe connecting la Défense,
the Arc de Triomphe, and the smaller
triumphal arch near the Louvre on a single axis.

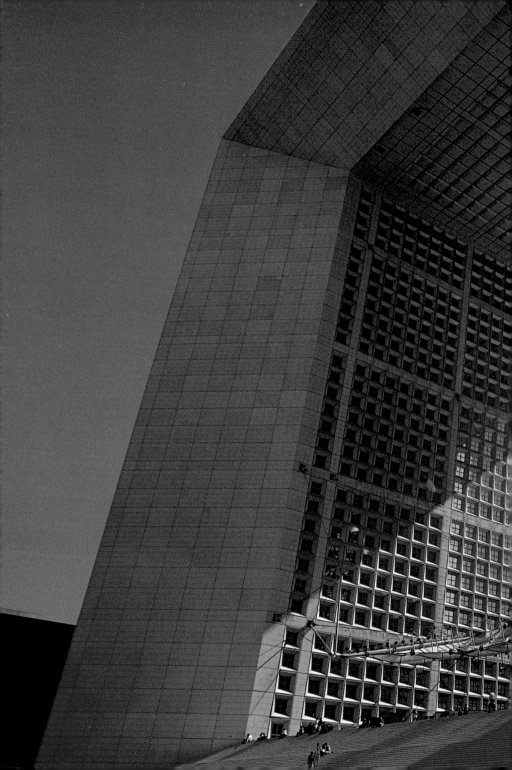

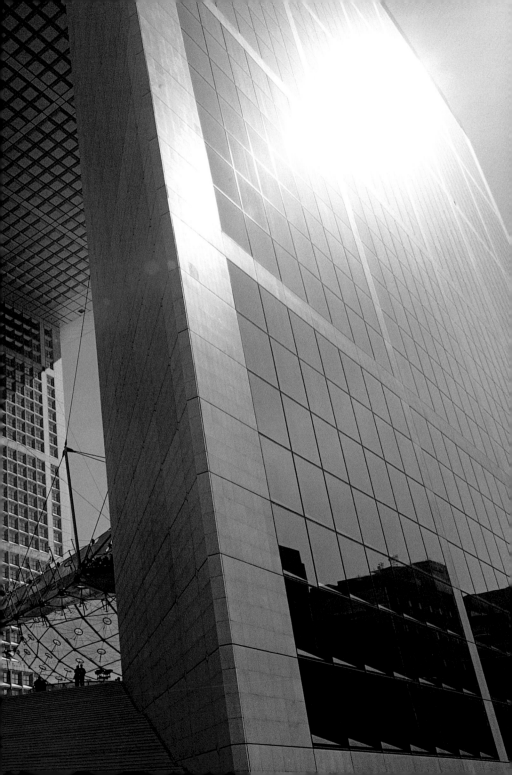

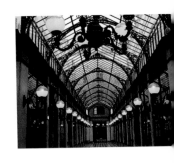

# Passageways

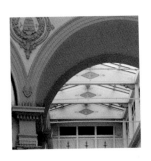
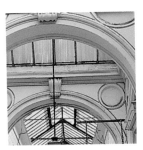
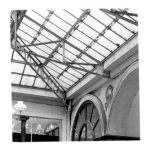

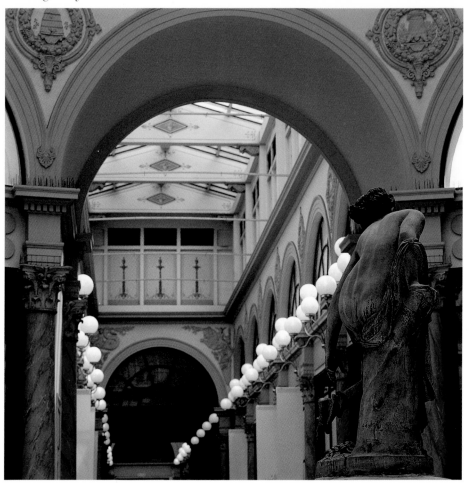

Statue of Eurydice, Galerie Colbert, 2nd arr.

The large rotunda inside
the Galerie Colbert,
6, rue des Petits-Champs, 2nd arr.

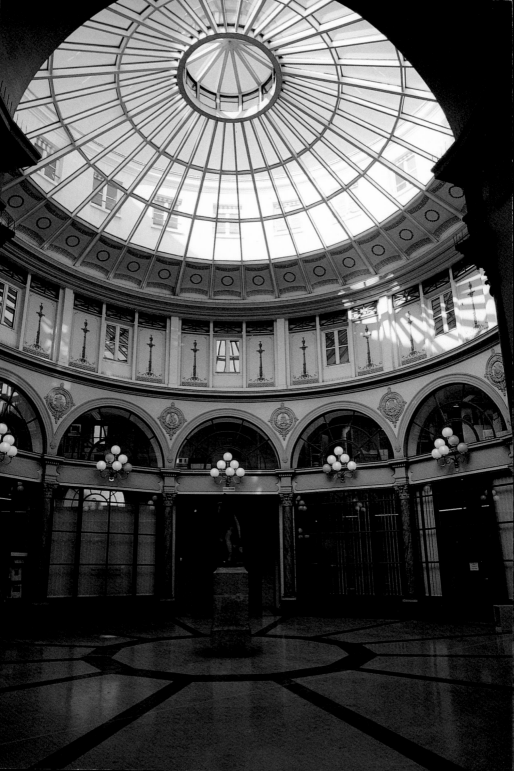

# Passageways

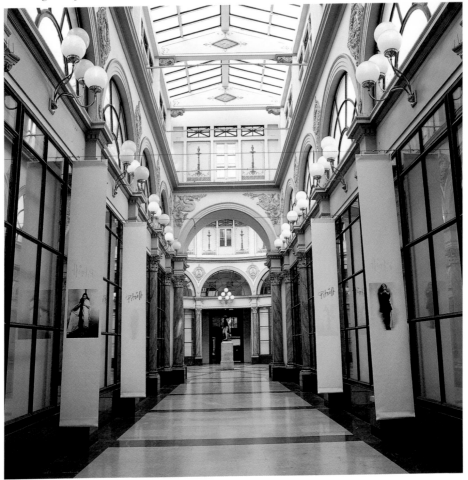

Galerie Colbert, near the stock exchange, 2<sup>nd</sup> arr.

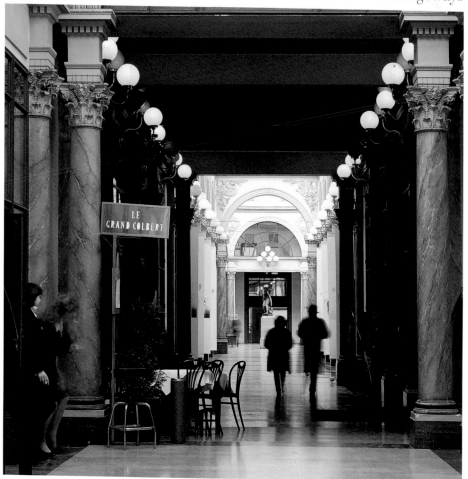

Le Grand Colbert, a famous restaurant inside the Galerie Colbert, 2<sup>nd</sup> arr.

Galerie Véro-Dodat, 1$^{st}$ arr.

The Galerie Véro-Dodat opens onto the
rue Jean-Jacques-Rousseau, 1$^{st}$ arr.

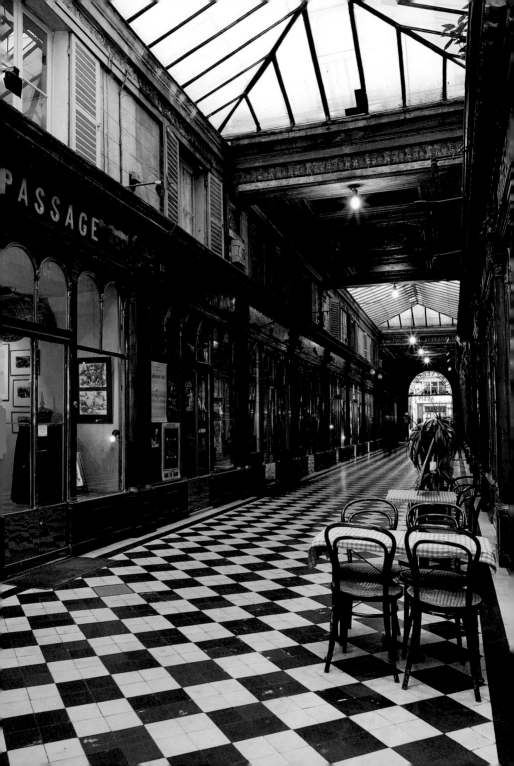

Luthier, selling guitars inside the Galerie Véro-Dodat, 1st arr.

Not far from the Palais-Royal, the Galerie Véro-Dodat is home to a number of antiques shops, 1st arr.

Bistrot 1900, at the cour du
Commerce-Saint-André, near Odéon, 6ᵗʰ arr.

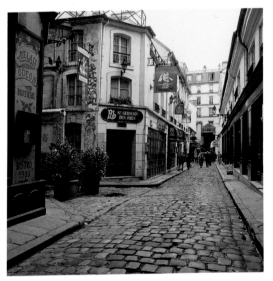

Cour du Commerce-Saint-André,
intersecting the cour de Rohan, 6ᵗʰ arr.

Cour du Commerce-Saint-André,
between the rue Saint-André-des-Arts and
the boulevard Saint-Germain, 6ᵗʰ arr.

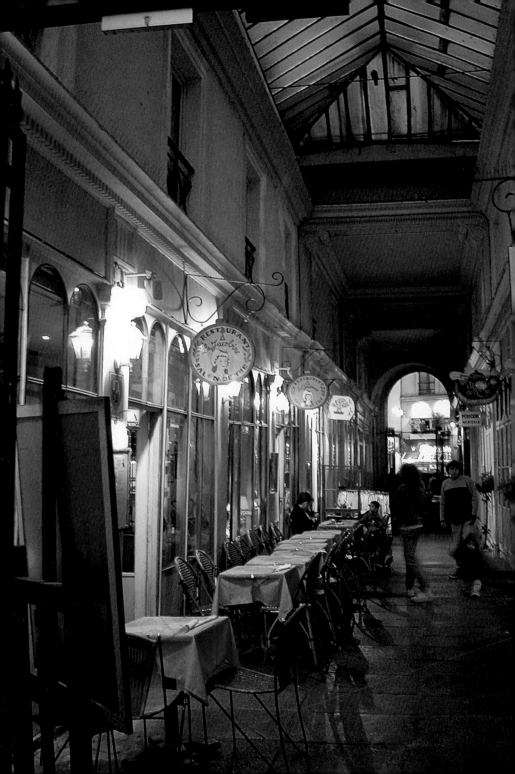

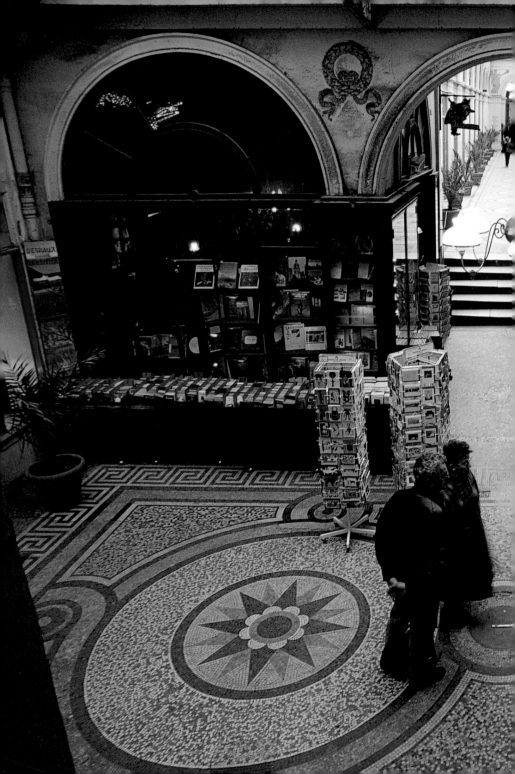

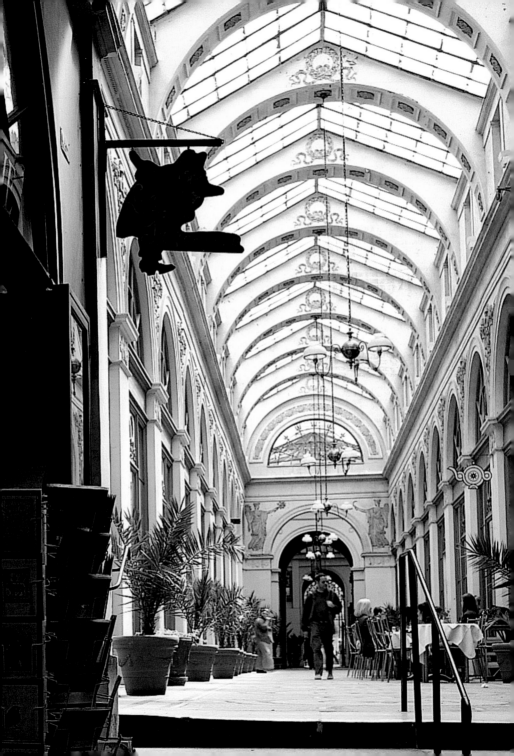

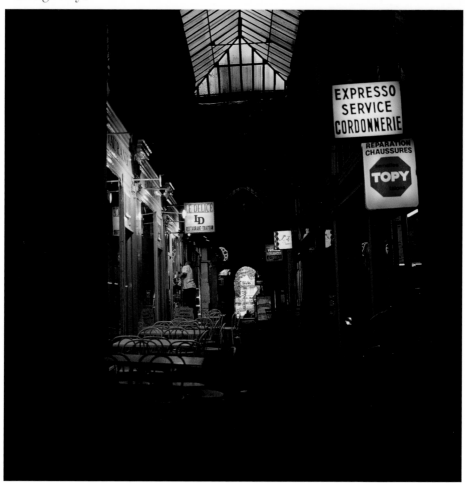

Passage Vendôme, between the place de la République and the rue Béranger, 3rd arr.

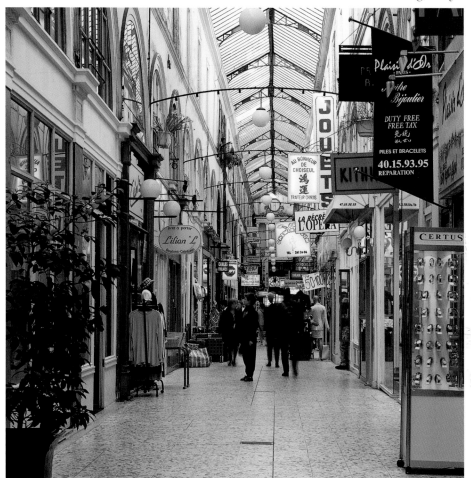

Passage de Choiseul, between the rue des Petits-Champs and
the rue Saint-Augustin, 2nd arr.

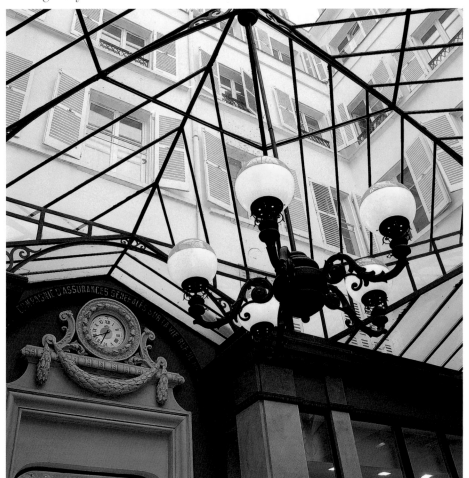

Passage des Princes, between the boulevard des Italiens and the rue de Richelieu, 2$^{nd}$ arr.

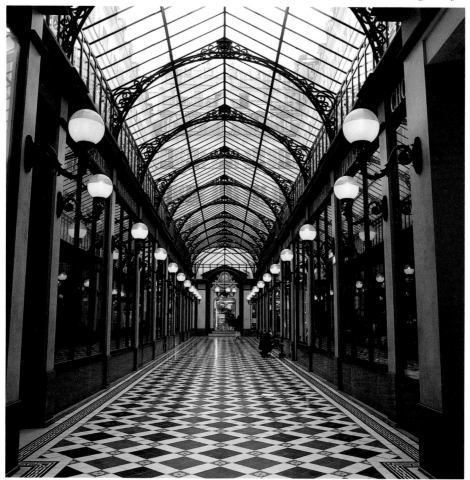

Recently renovated, the Passage des Princes is located very close to the Opéra, 2$^{nd}$ arr.

*following double page*

Spice shops and Indian restaurants in the Passage Brady
between the rue du Faubourg-Saint-Martin
and the rue du Faubourg-Saint-Denis, 10$^{th}$ arr.

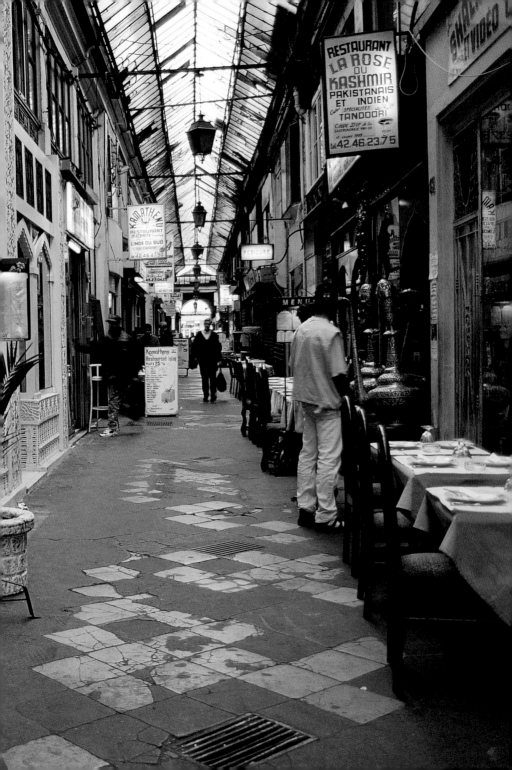

# Passageways

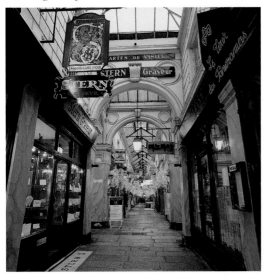

The storefront of the famous Stern engravers in the Passage des Panoramas, 2nd arr.

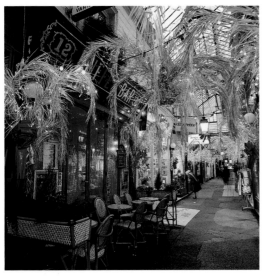

Passage des Panoramas between rue Saint-Marc and boulevard Montmartre, 2nd arr.

Passage Jouffroy between the boulevard Montmartre and the rue de la Grange-Batelière. Skylights provide a view from the Musée Grévin, Paris's famous wax museum, 9th arr.

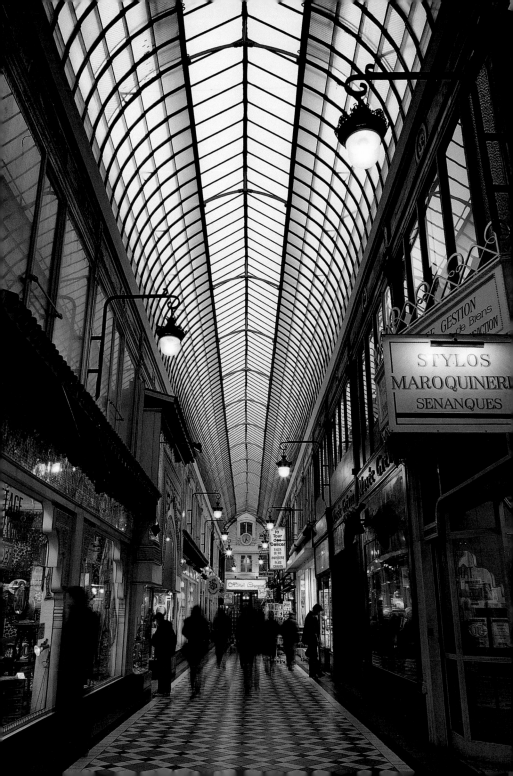

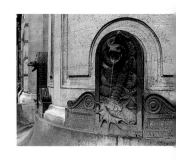

# The Left Bank

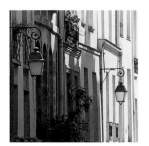

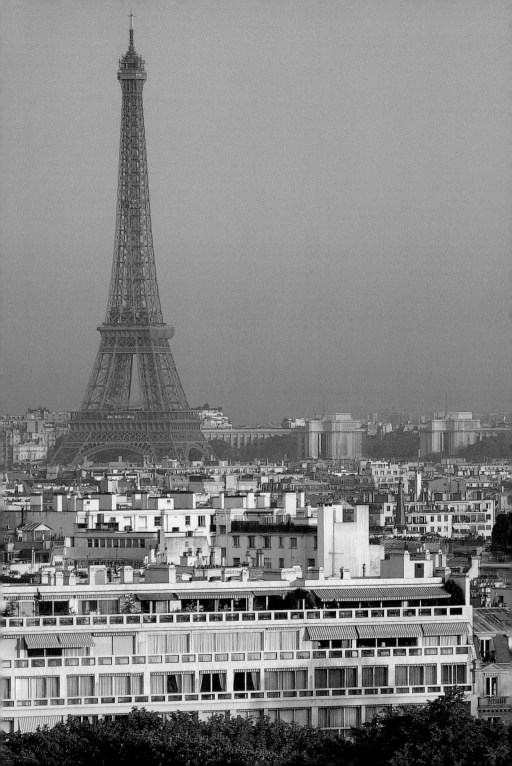

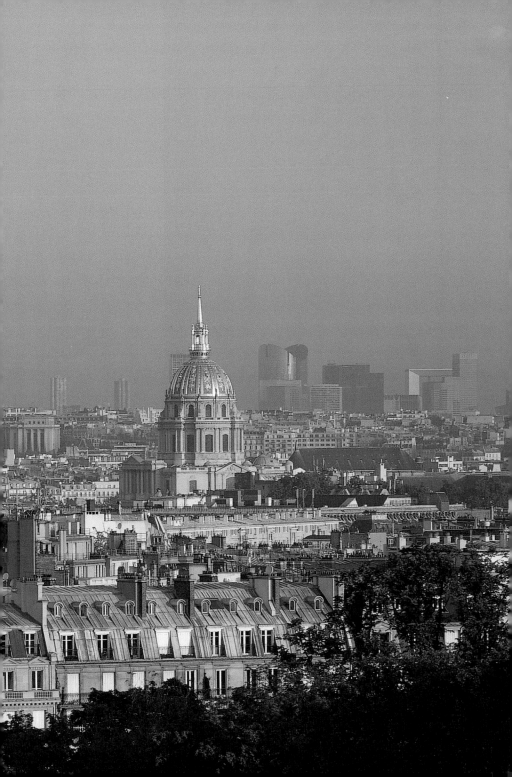

# The Left Bank

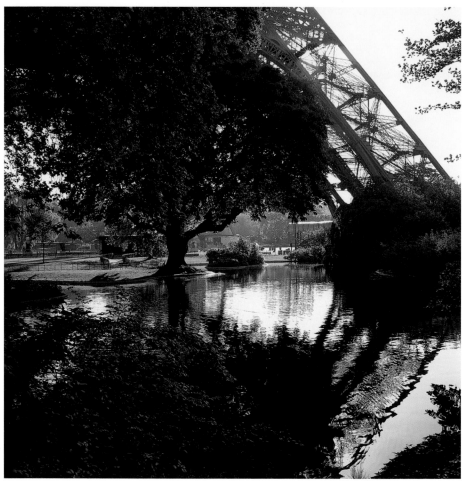

Reflecting pool at the base of the Eiffel Tower, 7th arr.

*preceding double page*

The Eiffel Tower, the Invalides dome,
and la Défense neighborhood.

View of the Eiffel Tower, 7th arr.,
through the trees in the
Trocadéro Garden, 16th arr.

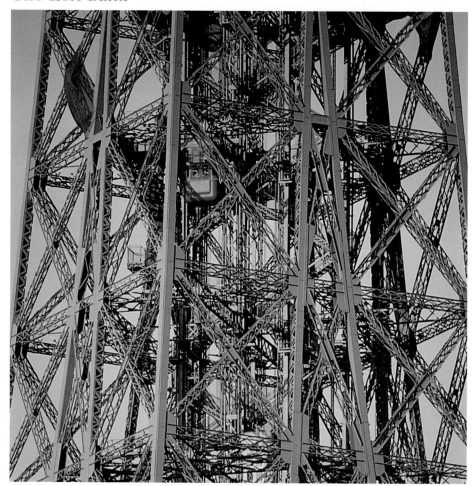

Elevators climbing the Eiffel Tower, 7th arr.

The Eiffel Tower, from the Champ-de-Mars, 7th arr.

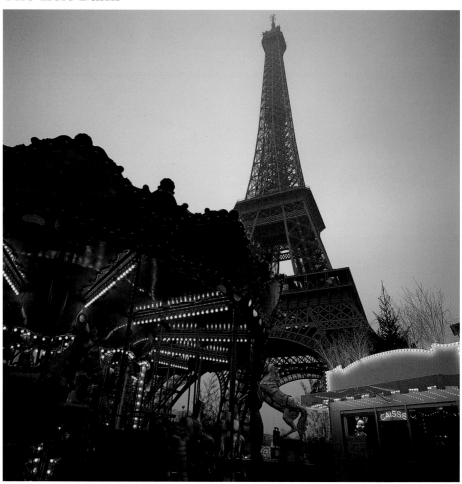

A carousel in the parc du Champ-de-Mars, 7ᵗʰ arr.

View of the Eiffel Tower from the
carousel at the parc du Champs-de-Mars, 16ᵗʰ arr

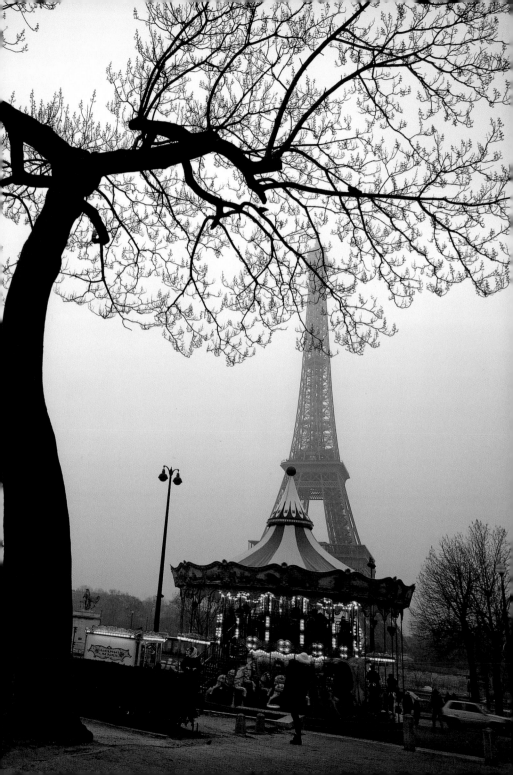

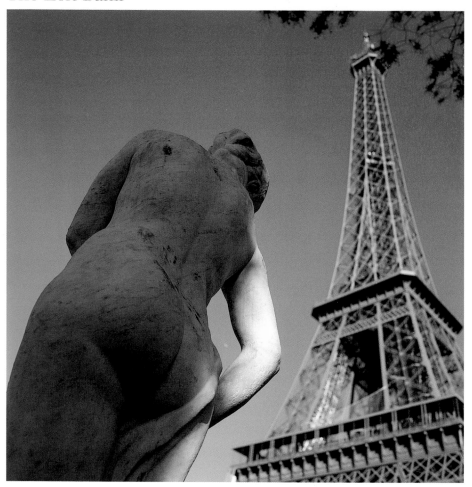

*La Femme au bain* (*Woman Bathing*) statue in the parc du
Champ-de-Mars, 7<sup>th</sup> arr.

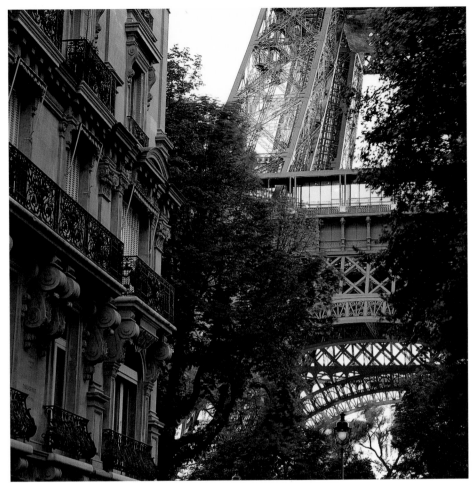

The Eiffel Tower, from the rue l'Université, 7ᵗʰ arr.

*following double page*

The dome of the church inside the Invalides, 7ᵗʰ arr.,
from the top of the Montparnasse Tower, 14ᵗʰ arr.

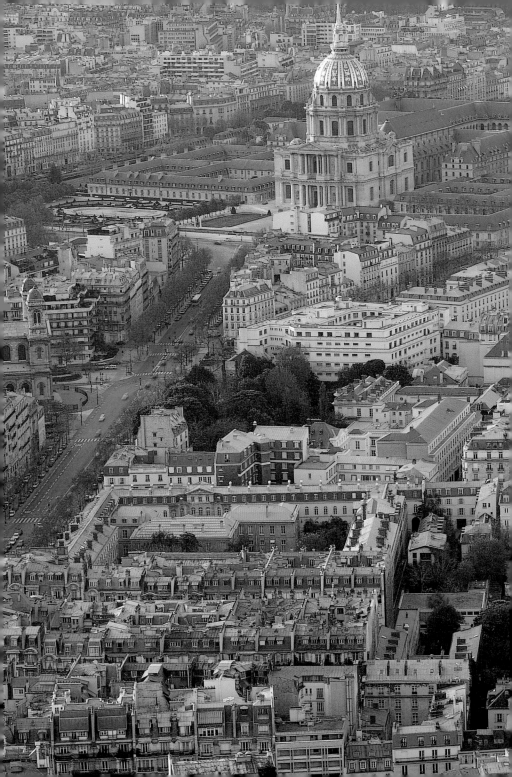

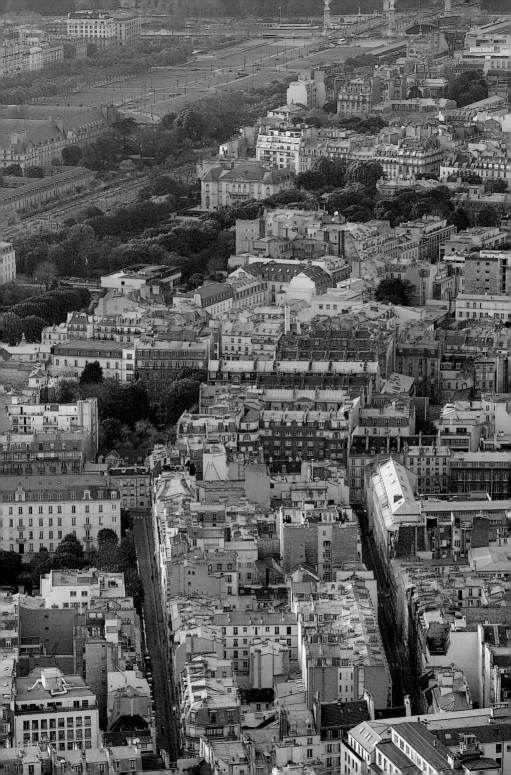

Interior courtyard, 7<sup>th</sup> arr.

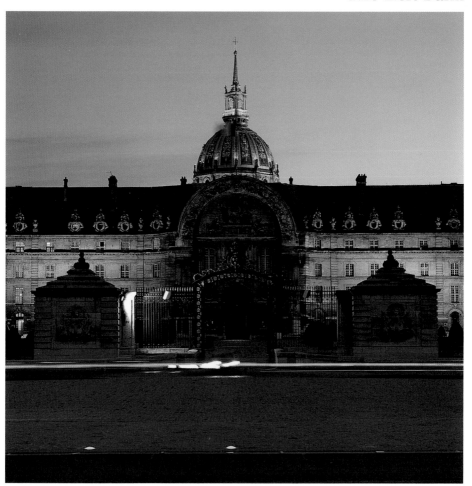

The Hôtel des Invalides, 7th arr.

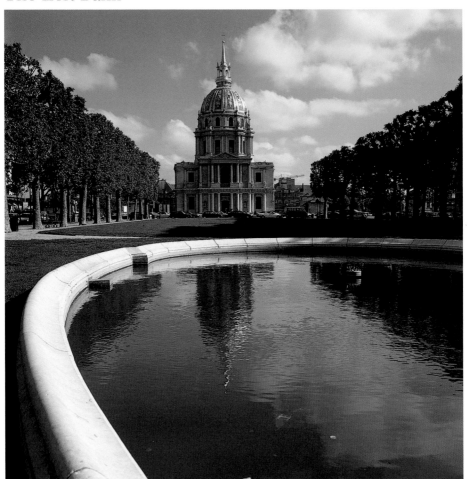

Elliptical reflecting pool, avenue de Breteuil, behind the Invalides, 7th arr.

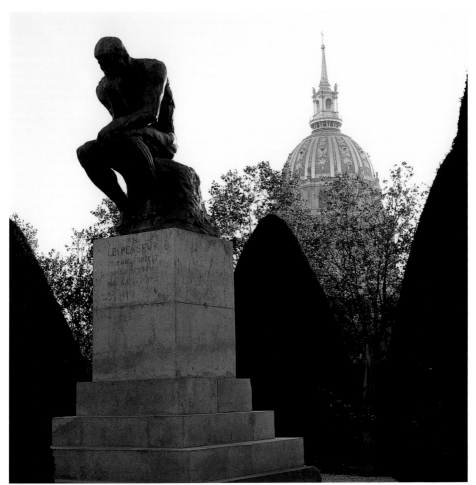

*The Thinker* by Auguste Rodin, in bronze, in the garden at the Rodin Museum.
In the background, the Invalides dome, 7th arr.

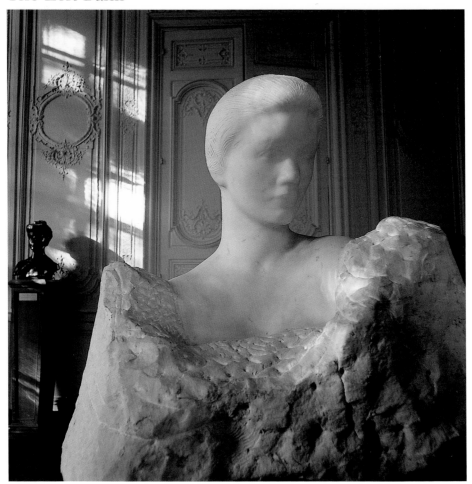

*Study of a Slavic Woman,* in marble by Auguste Rodin,
at the Rodin Museum, rue de Varenne, 7$^{th}$ arr.

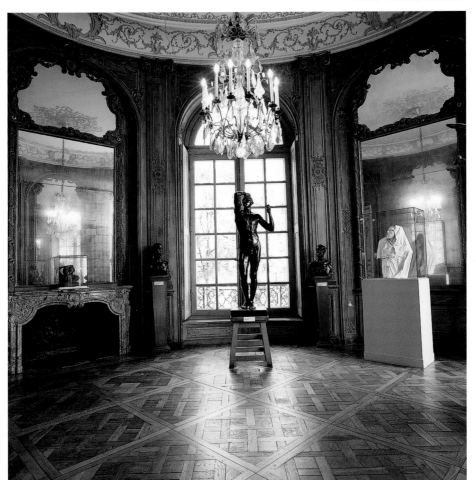

*The Bronze Age*, in bronze by Rodin. The halls of the Rodin Museum overlook a beautiful public garden, 7th arr.

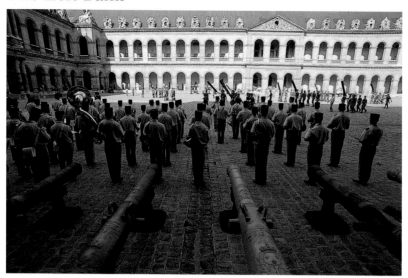

Military ceremony in the courtyard of the Invalides, 7th arr.

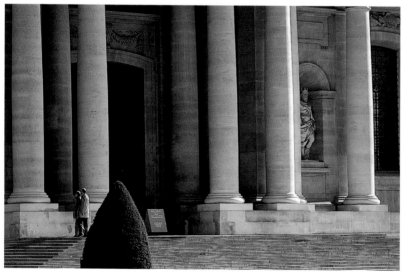

Columns of the church under the dome inside the Invalides, 7th arr.

The church under the dome of the
Invalides, from the courtyard, 7th arr.

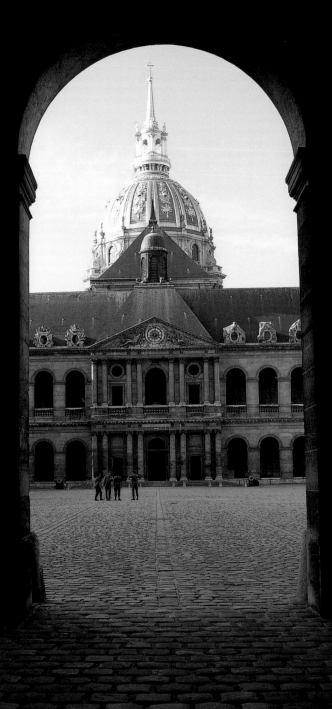

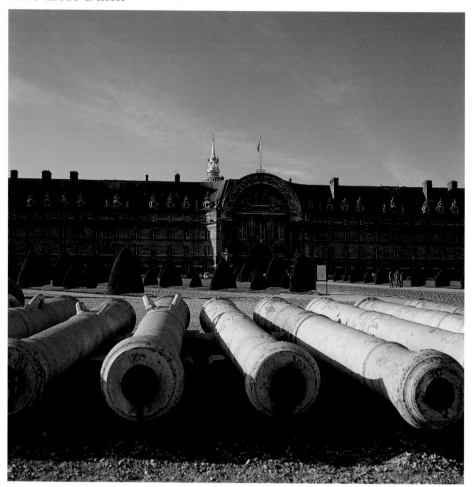

Façade of the Hôtel des Invalides facing the Esplanade
and the Seine, 7th arr.

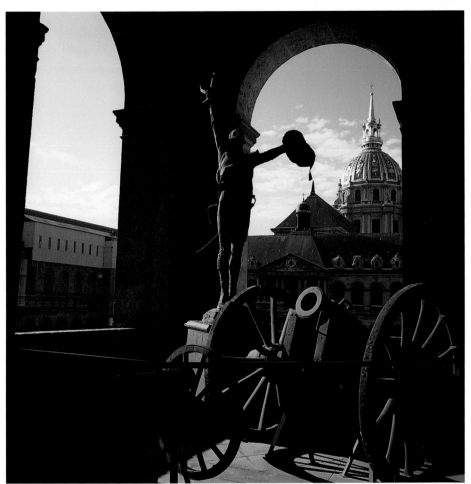

Interior gallery of the Hôtel des Invalides, 7th arr.

# The Left Bank

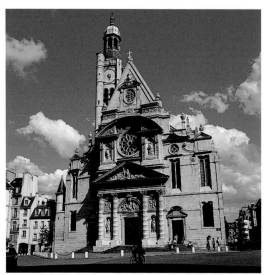

Saint-Étienne-du-Mont Church,
place du Panthéon, 5ᵗʰ arr.

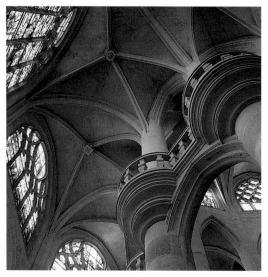

Vaulted ceiling inside the Saint-Étienne-du-Mont
Church, 5ᵗʰ arr.

The nave of th
Saint-Étienne-du-Mont Church, 5ᵗʰ arr

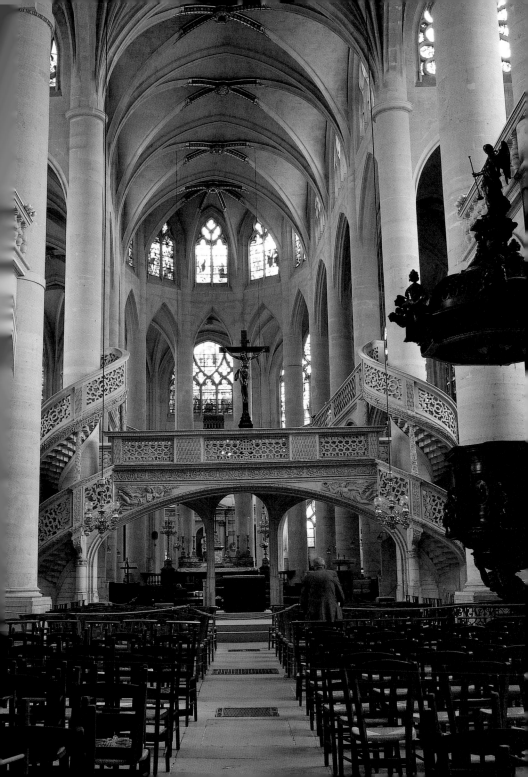

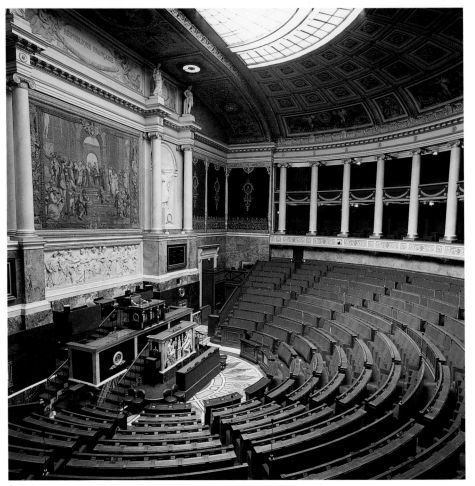

Semicircular chamber of the National Assembly, Palais-Bourbon, 7<sup>th</sup> arr.

Façade of the National Assembly and
the Ministry of Foreign Services, 7<sup>th</sup> arr.

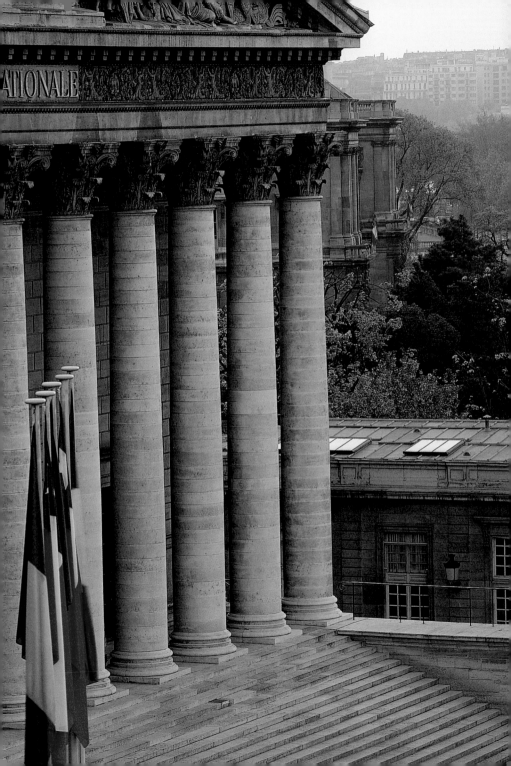

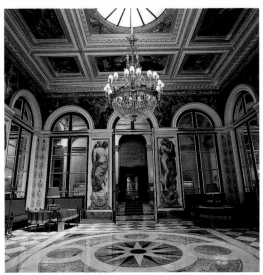

Salle des Pas Perdus in the Salon of Peace,
National Assembly, 7th arr.

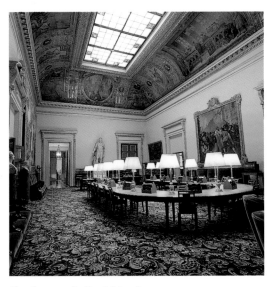

Conference hall within the
National Assembly, 7th arr.

Magnificent ceiling decorations
in the library of the
National Assembly, Palais-Bourbon, 7th arr.

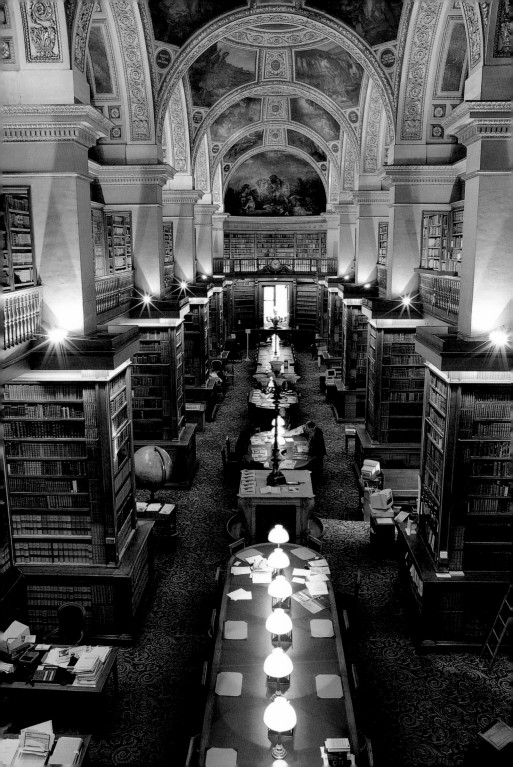

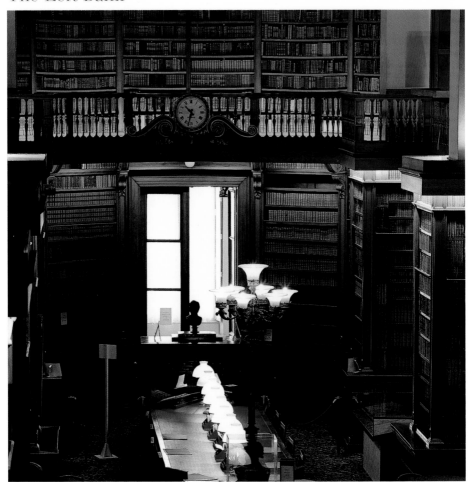

A quiet reading corner at the library of the National Assembly, 7th arr.

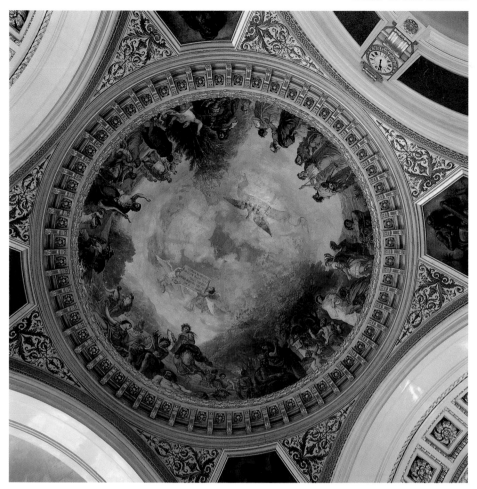

Detail of the ceiling in the library of the National Assembly,
painted by Eugène Delacroix, 7ᵗʰ arr.

*following double page*

Façade of the restaurant Le Procope,
rue de l'Ancienne-Comédie, 6ᵗʰ arr.

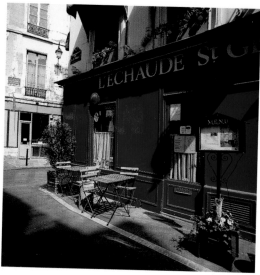

Restaurant terrace, rue de l'Échaudé, 6th arr.

The house where Ernest Hemingway lived,
rue du Cardinal-Lemoine, 5th arr.

Terrace of the café Les Deux Magots
and the Saint-Germain-des-Prés belltower, 6th arr.

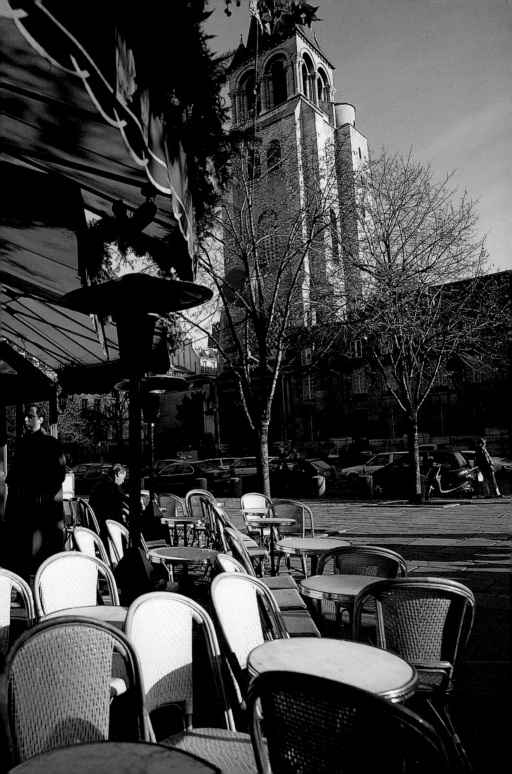

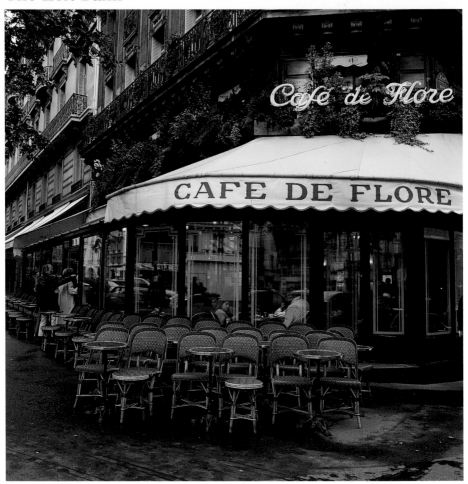

At the corner of the rue Saint-Benoît and the boulevard Saint-Germain, the Café de Flore, 6<sup>th</sup> arr.

Table at the Café de Flore, boulevard Saint-Germain, 6<sup>th</sup> arr.

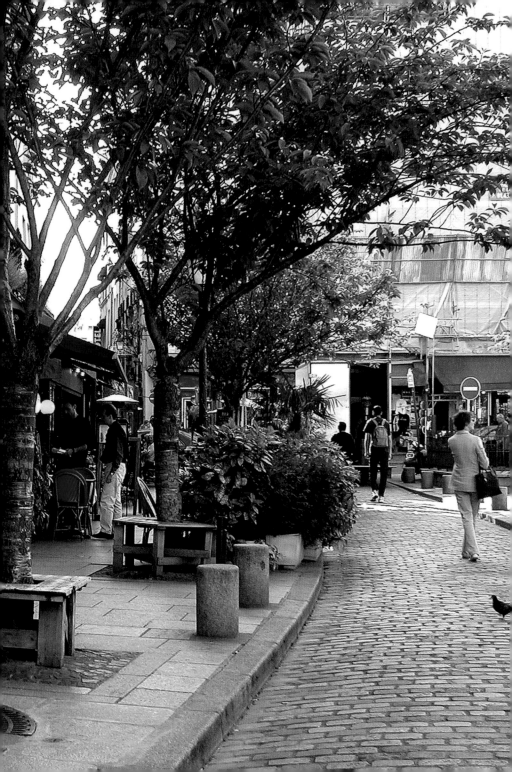

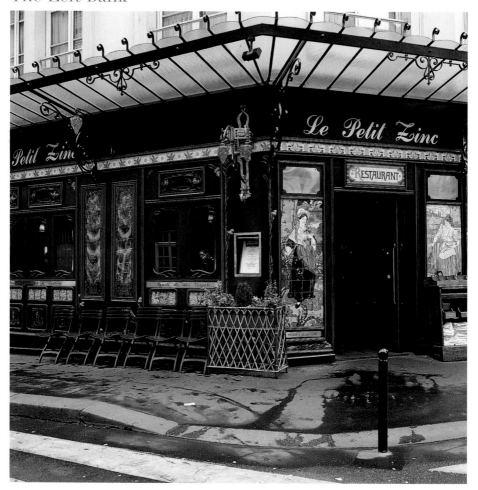

Rue Saint-Benoît at Saint-Germain-des-Prés, 6th arr.

*preceding double page*

Wallace Fountain in front of Paris's famous Shakespeare & Company,
an English-language bookstore, on the quai de Montebello, 5th arr.

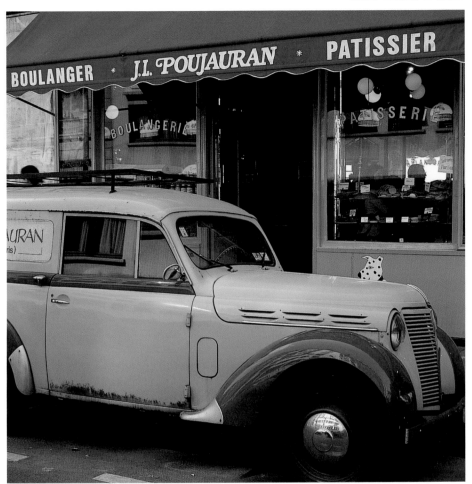

Poujauran bakery, rue Jean-Nicot, 7<sup>th</sup> arr.

# The Left Bank

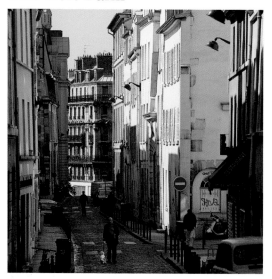

Rue Tournefort, 5ᵗʰ arr.

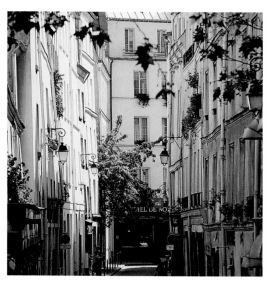

Rue Maître-Albert, 5ᵗʰ arr.

The dome of the Panthéon,
from rue de Bièvre, 5ᵗʰ arr.

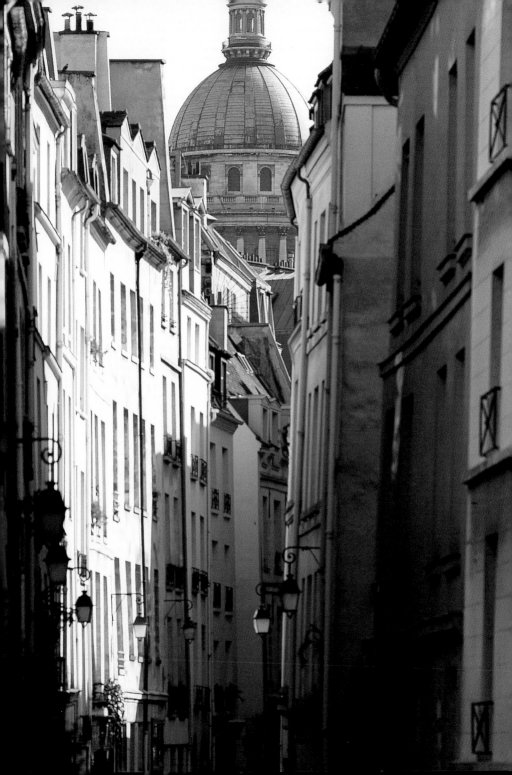

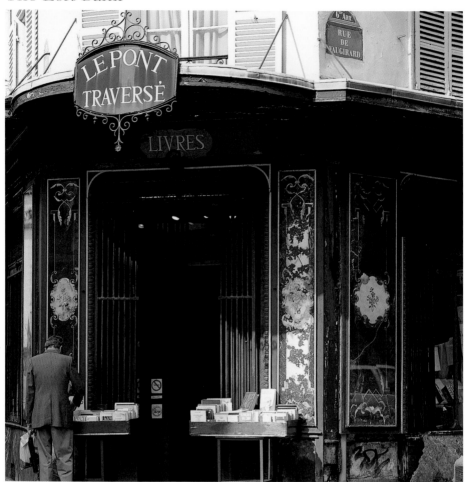

Librairie Le Pont Traversé, in front of Luxembourg Gardens at the corner of
rue Madame, 6th arr.

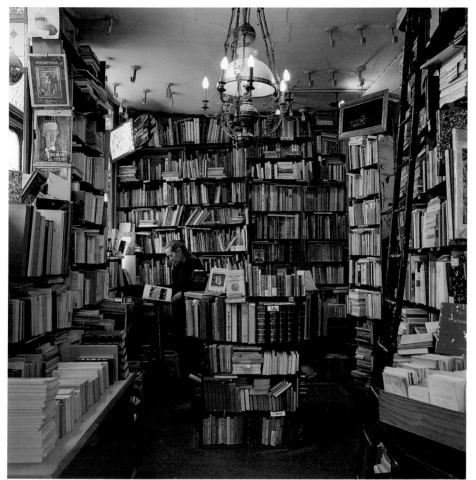

Inside the Pont Traversé bookstore, which specializes in poetry, 6th arr.

# The Left Bank

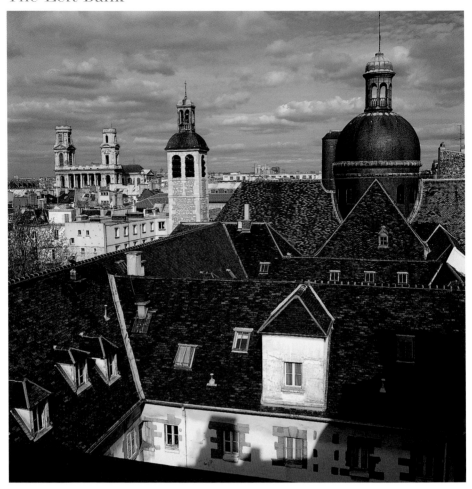

The rooftop of the Catholic Institute of Paris, rue d'Assas.
In the background, the belltowers of Saint-Sulpice, 6th arr.

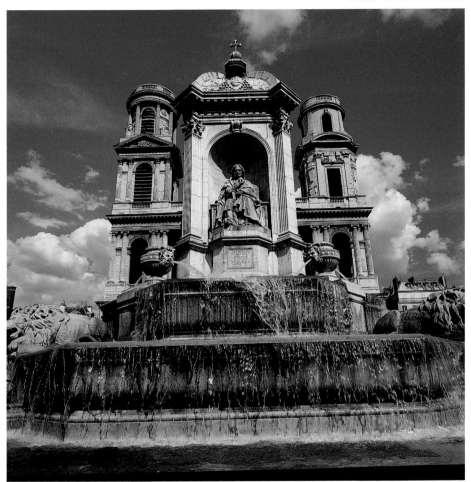

Fountain at the place Saint-Sulpice, 6th arr.

# The Left Bank

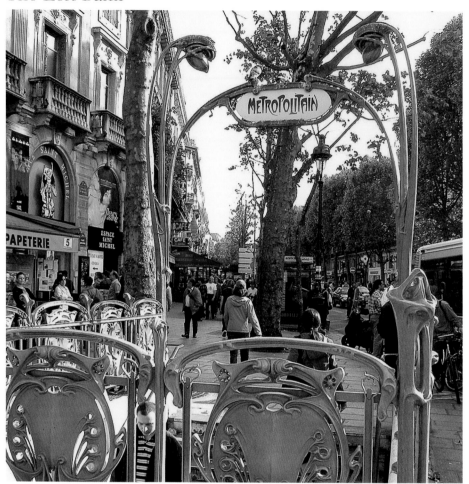

Saint-Michel metro station, the work of Hector Guimard,
at the end of the boulevard Saint-Michel, 5th arr.

Rue de la Huchette,
Latin Quarter, 5th arr.

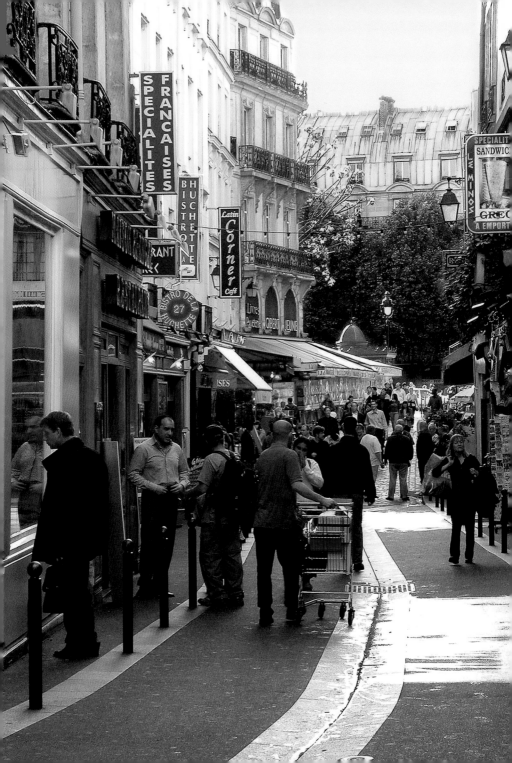

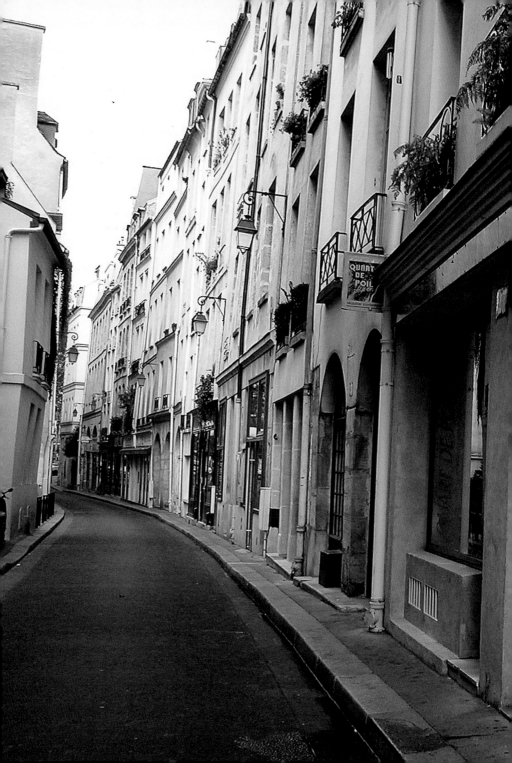

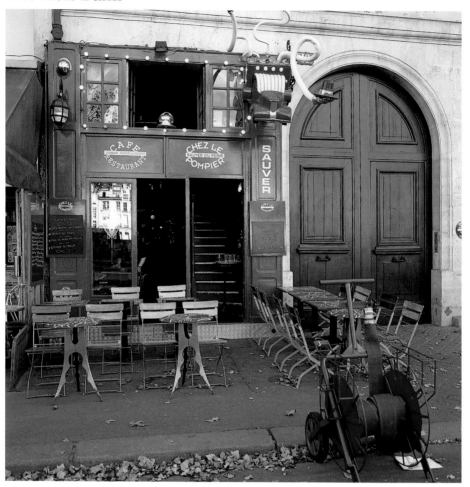

The café Chez le Pompier, quai de la Tournelle, 5<sup>th</sup> arr.

*preceding double page*

Rue de Bièvre, with a drawing by
Jérôme Mesnager, 5<sup>th</sup> arr.

A café in the Odéon
neighborhood, 6<sup>th</sup> arr.

MAISON
MEUBLÉE
CONFORT MODERNE

MAISON
MEUBLÉE
CONFORT MODERNE

BAR     LE CONDE     STELLA ARTOIS

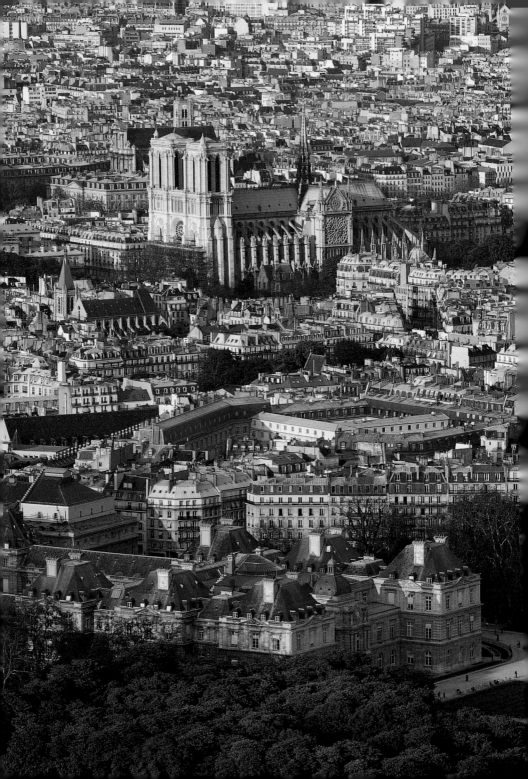

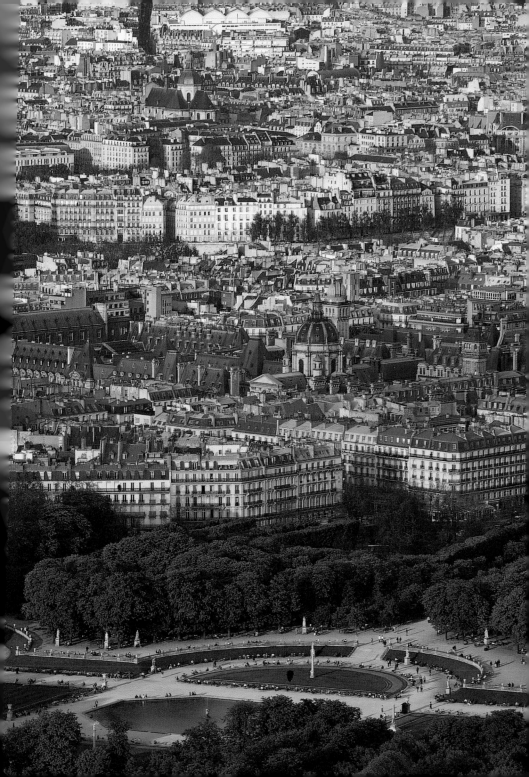

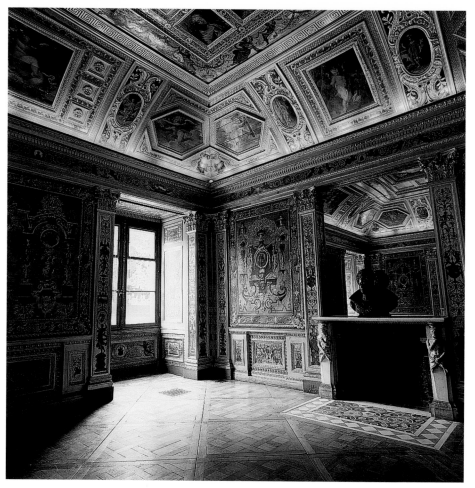

Salle du Livre d'Or (Guestbook Room), Palais du Luxembourg, 6ᵗʰ arr.

*preceding double page*

The Luxembourg Palace and Gardens,
Notre-Dame Cathedral, and l'île Saint-Louis,
from the top of the Montparnasse Tower.

The main staircase, designed by
architect Jean-François Chalgrin,
in the Palais du Luxembourg, 6ᵗʰ arr.

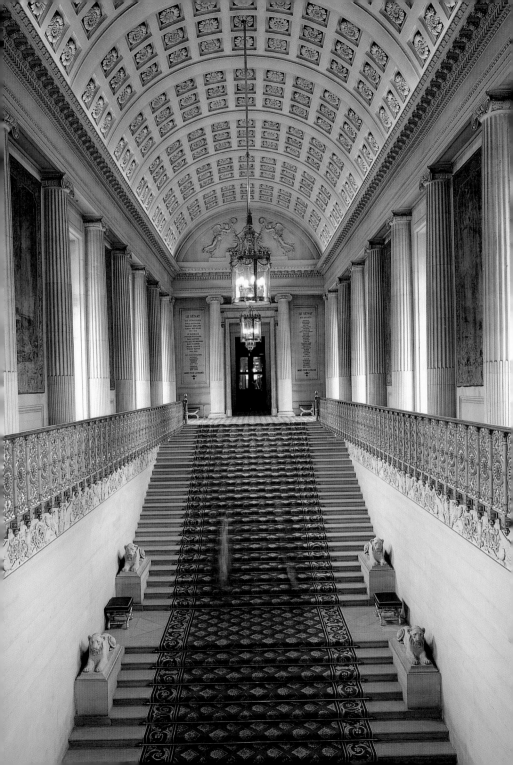

# The Left Bank

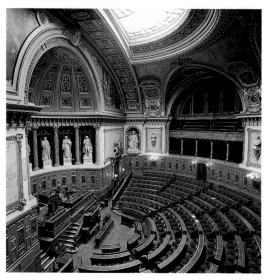

The semicircular chamber in the Senate, Palais du Luxembourg, 6th arr.

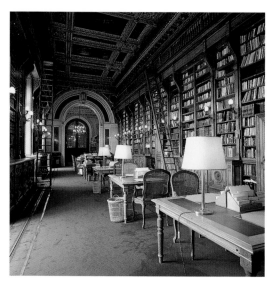

The library inside the Palais du Luxembourg, 6th arr.

The conference room inside the Palais du Luxembourg, 6th arr.

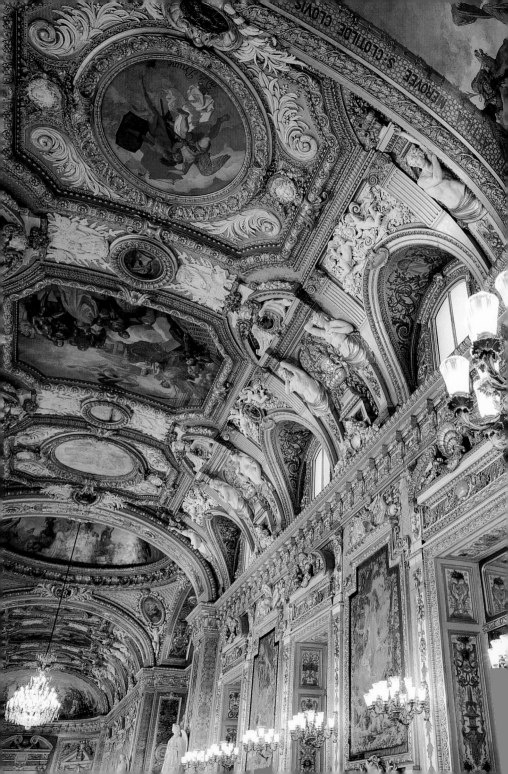

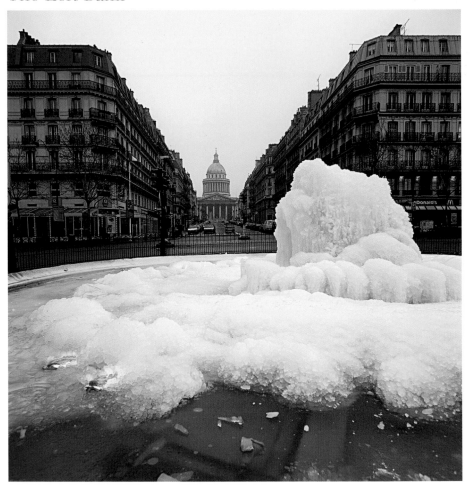

The Edmond-Rostand fountain, rue Soufflot, with the Panthéon
in the background, on a particularly cold day, 5ᵗʰ arr.

Place de Furstemberg, 6ᵗʰ ar

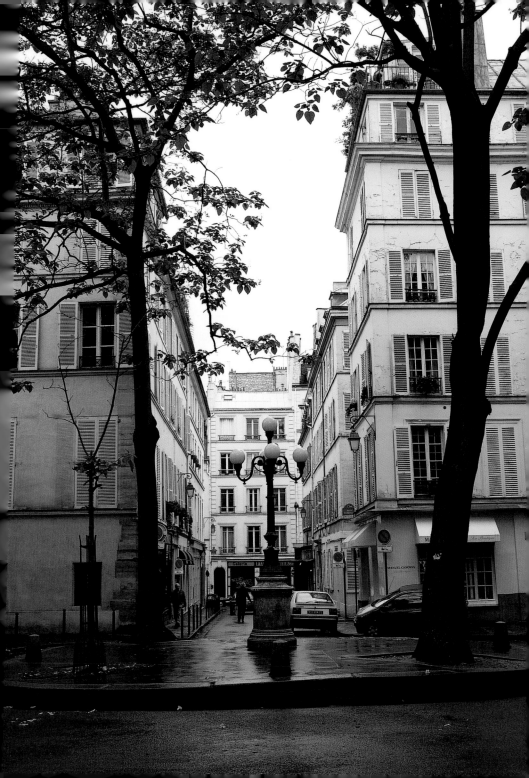

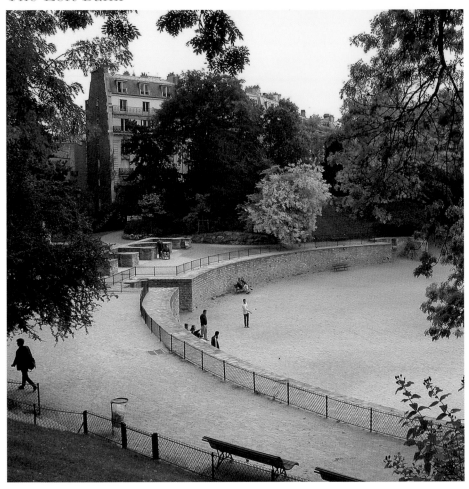

Lutèce Arena, 5<sup>th</sup> arr.

*preceding double page*

Square René Le Gall
in the Gobelins neighborhood, 13<sup>th</sup> arr.

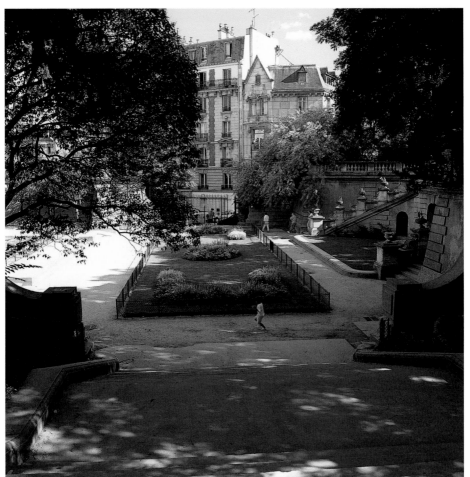

Square Capitan, behind the Lutèce Arena, 5<sup>th</sup> arr.

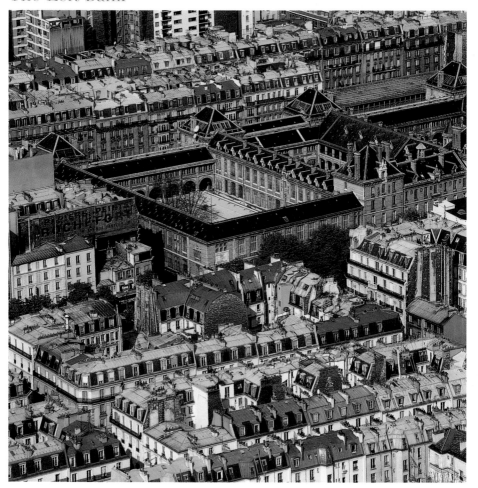

Lycée Buffon, boulevard Pasteur, 15th arr.

The School of Pharmacy, near the Luxembourg Gardens, 5th arr.

Statue of Neptune, rue du Cherche-Midi, 6th arr.

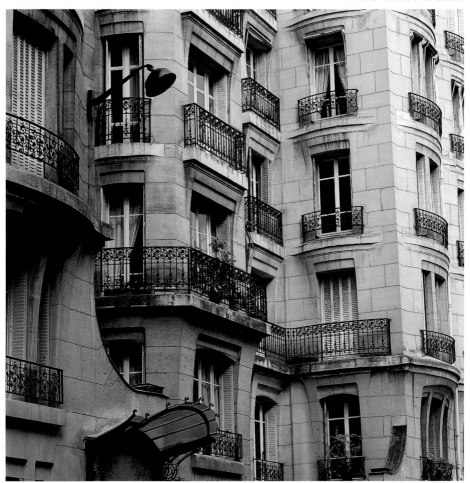

Façades in the 5th arr.

*following double page*

Secondhand-book market,
parc Georges-Brassens, 15th arr.

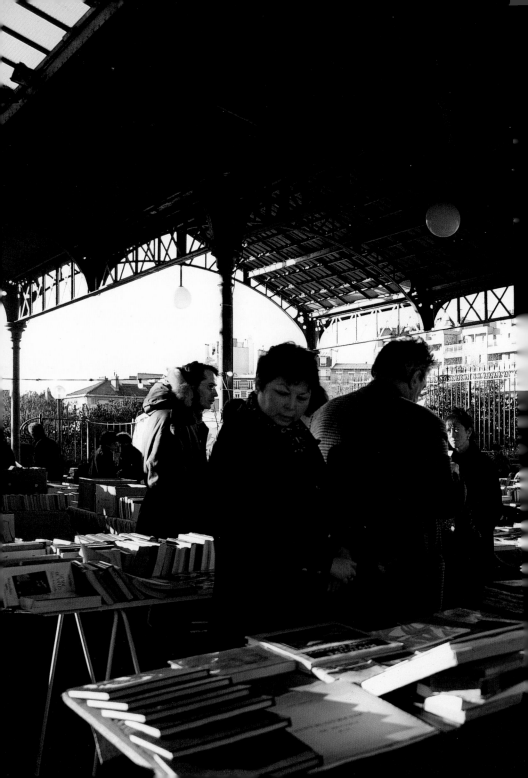

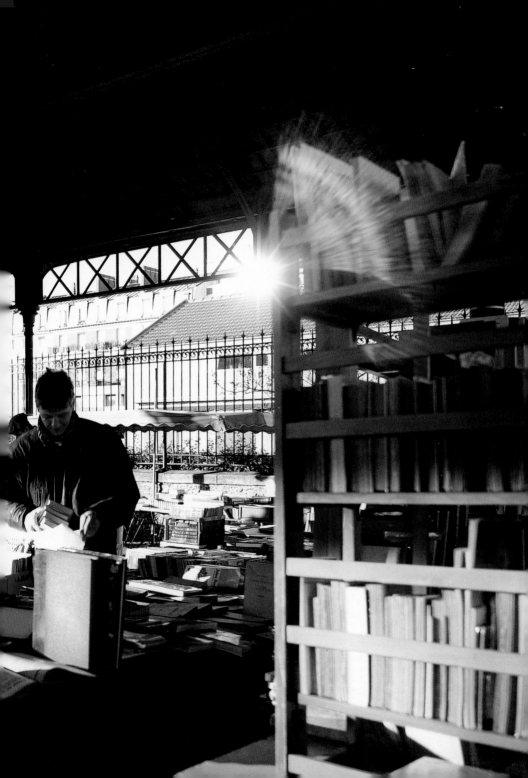

Secondhand-book market, rue Brancion,
at the edge of parc Georges-Brassens, 15th arr.

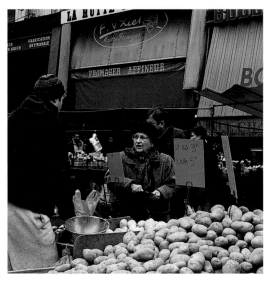

Bargaining at the produce market,
rue Mouffetard, 5th arr.

Goods for sale at one of
Paris's famous produce markets
on the rue Mouffetard, 5th arr.

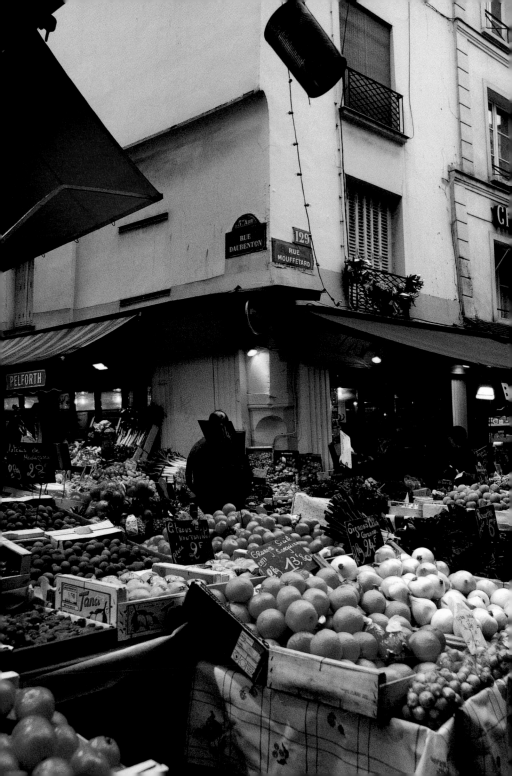

Café Parisien, rue d'Assas, 6<sup>th</sup> arr.

Newsstand, rue Saint-Benoît, 6th arr.

# The Left Bank

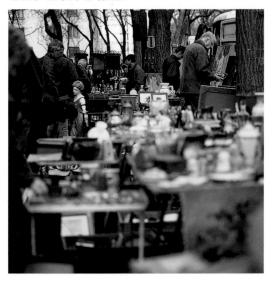

Vanves flea market, 14ᵗʰ arr.

Vanves flea market, 14ᵗʰ arr.

The Vanves flea market, 14ᵗʰ arr., in the
south of Paris competes with the
Saint-Ouen market, located in the north.

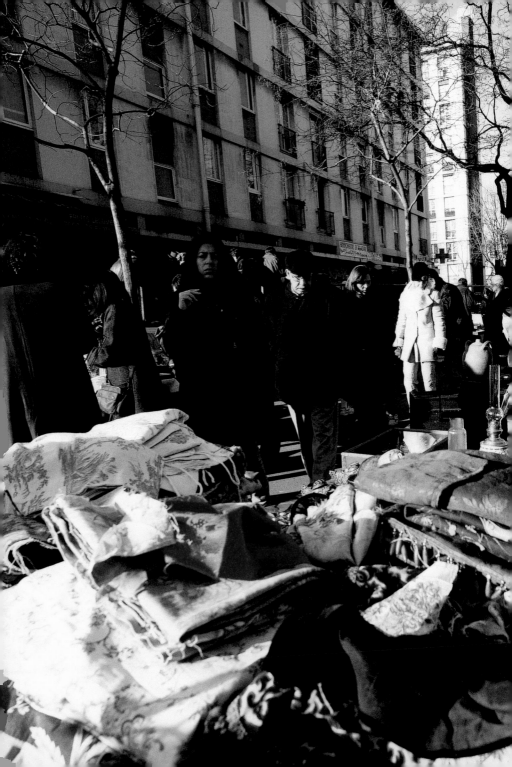

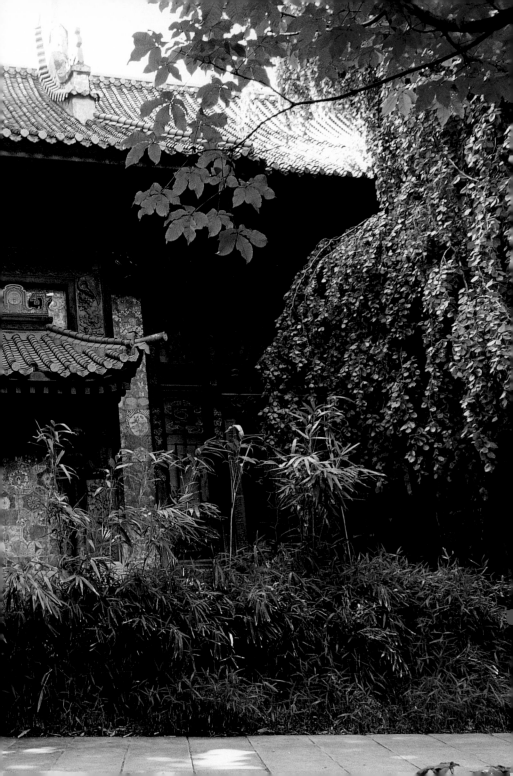

# The Left Bank

Chinese New Year in the 13<sup>th</sup> arr.

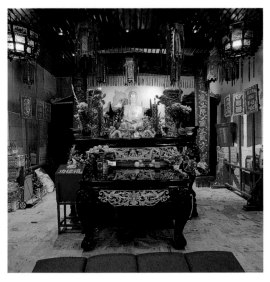

Altar dedicated to Buddha,
avenue de Choisy, 13<sup>th</sup> arr.

*preceding double page*

The Pagoda Cinema,
rue de Babylone, 7<sup>th</sup> arr.

Celebrating the
Chinese New Year in the 13<sup>th</sup> arr.

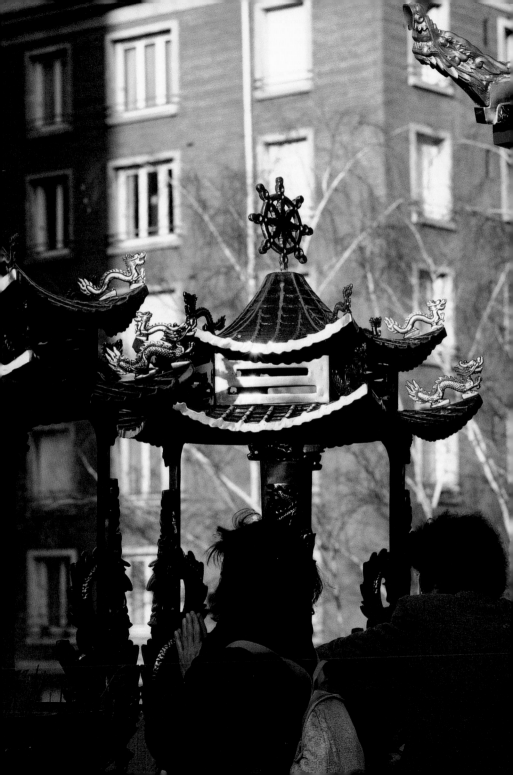

# The Left Bank

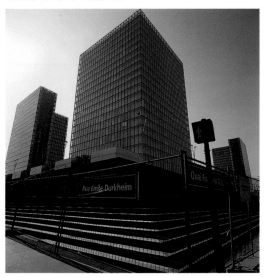

The Towers of the François-Mitterrand National Library in the 13th arr.

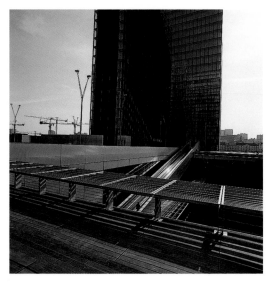

The square in front of the National Library opens onto a garden below, 13th arr.

The National Library, designed by architect Dominique Perrault, located on the banks of the Seine, 13th arr.

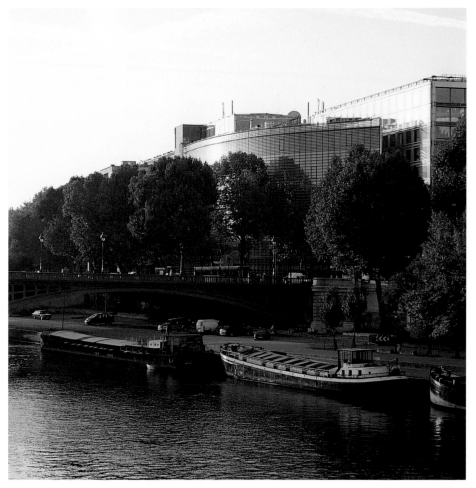

The Institute of the Arab World, designed by architect Jean Nouvel, 5th arr.

Entrance to the Institute of the Arab World,
opening onto the Faubourg Saint-Germain, 5th arr.

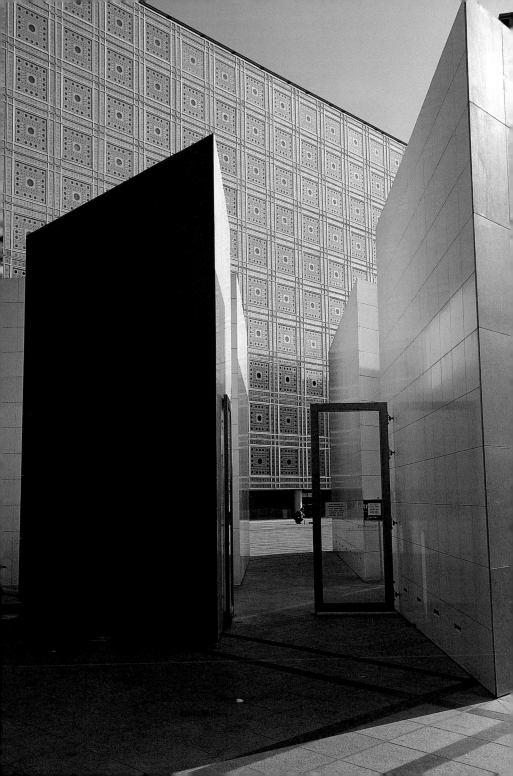

# Gardens

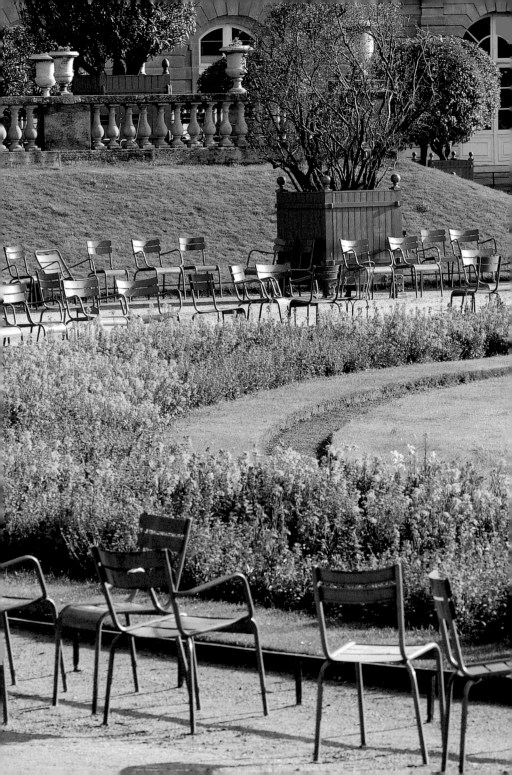

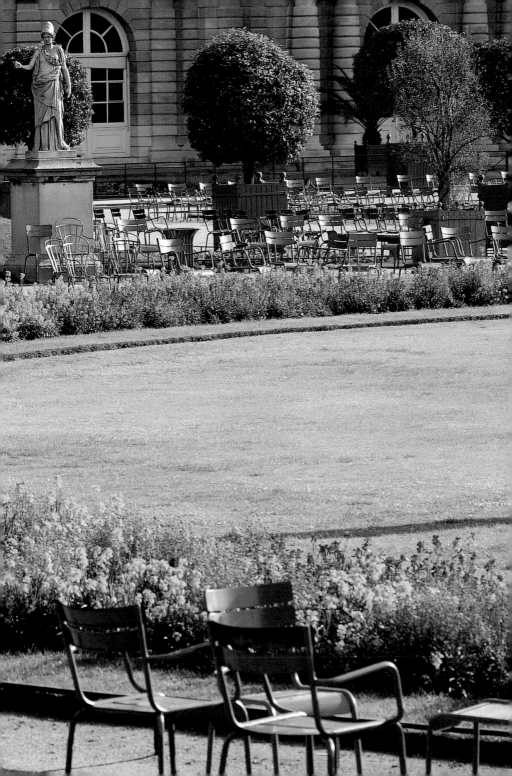

# Gardens

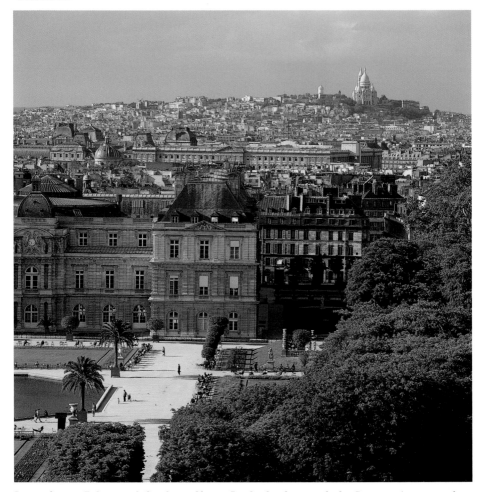

Luxembourg Palace and Gardens, 6<sup>th</sup> arr. In the background, the Louvre, 1<sup>st</sup> arr., and the Sacré-Coeur, 18<sup>th</sup> arr., are both visible.

*preceding double page*

Orange trees, pomegranate trees, and rose laurels abound in the Luxembourg Gardens, 6<sup>th</sup> arr.

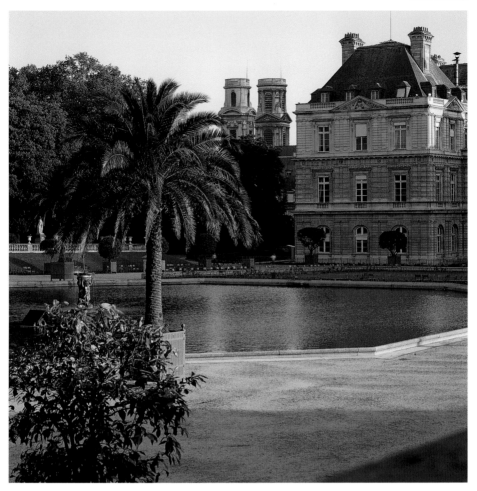

Pool at the Luxembourg Gardens, with the belltowers of Saint-Sulpice
in the background, 6th arr.

# Gardens

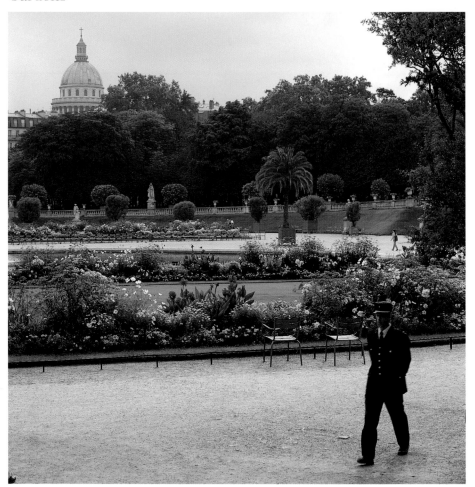

Luxembourg Gardens, 6th arr., with the dome of the Panthéon
in the background, 5th arr.

Lawns with flower beds shaded by thick foliage,
at the Luxembourg Gardens, 6th arr.

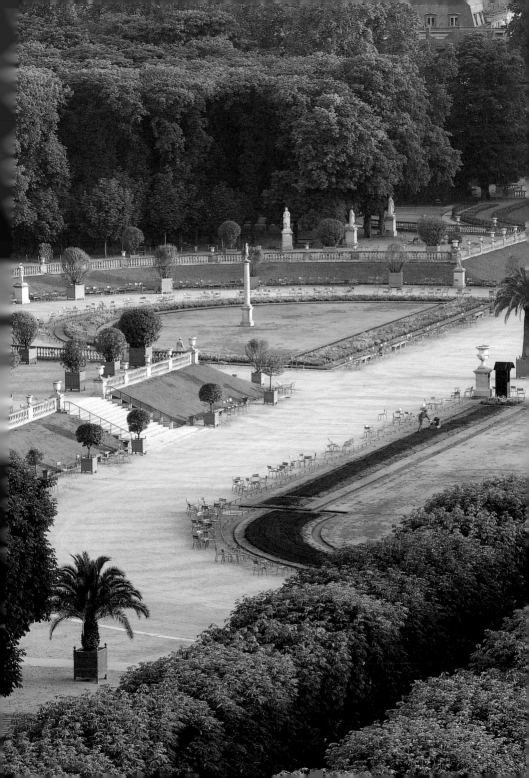

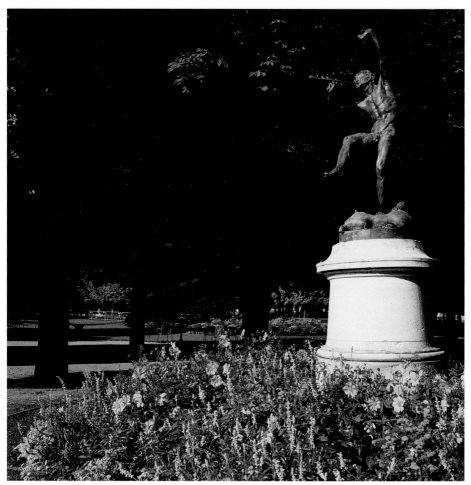

Dancing faun in Luxembourg Gardens, 6<sup>th</sup> arr.

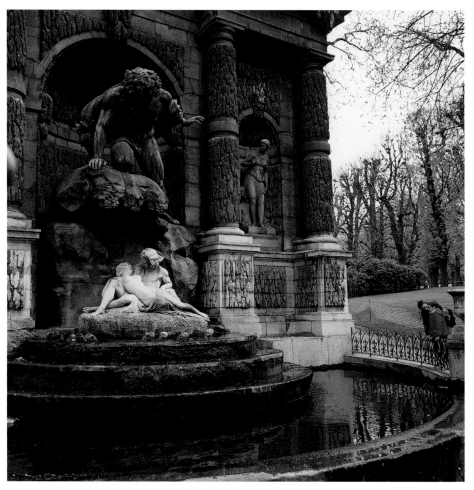

The Médicis Fountain, Luxembourg Gardens, 6th arr.

# Gardens

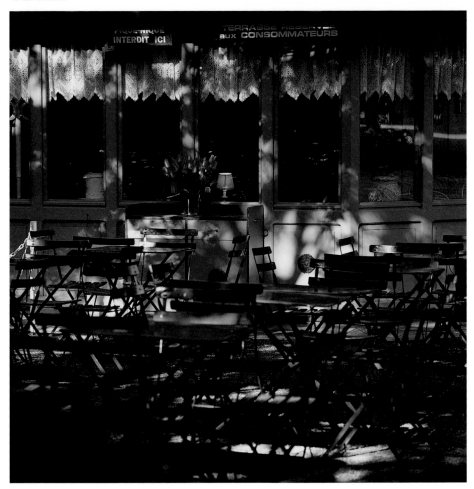

A terrace café at the Luxembourg Gardens, 6<sup>th</sup> arr.

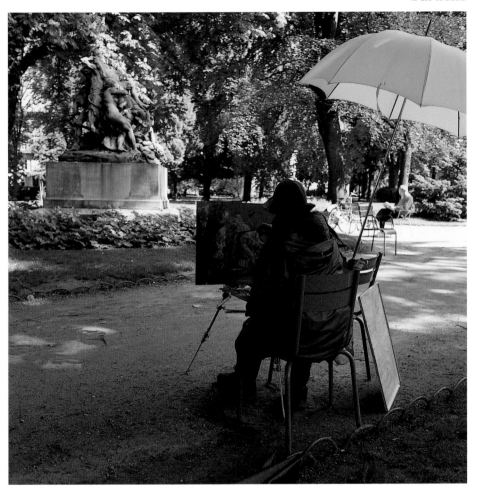

An artist in the shade at the Luxembourg Gardens, 6<sup>th</sup> arr.

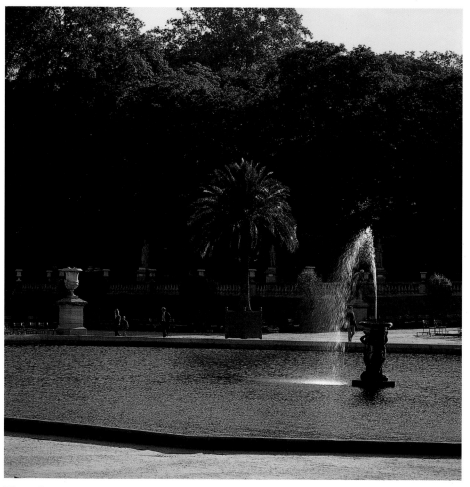

The palm trees in the Luxembourg Gardens spend the winter in the garden's orangerie, 6<sup>th</sup> arr.

The center of the Luxembourg Gardens is surrounded by a slope adorned with balustrades, statues, and marble urns, 6<sup>th</sup> arr.

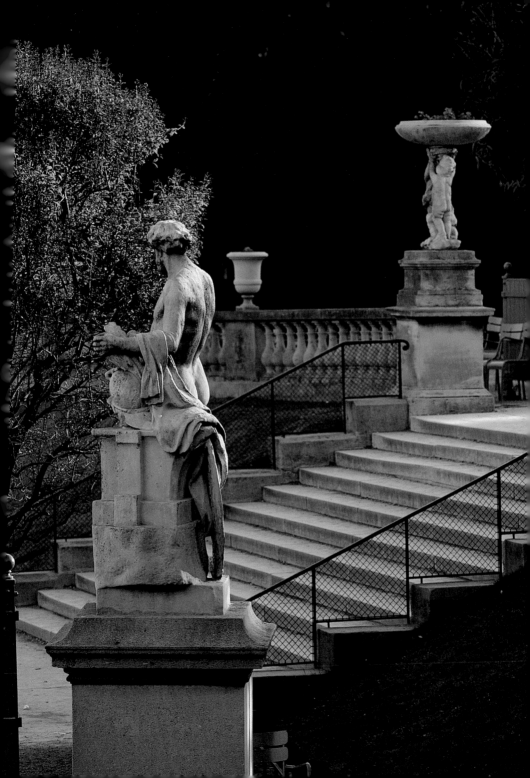

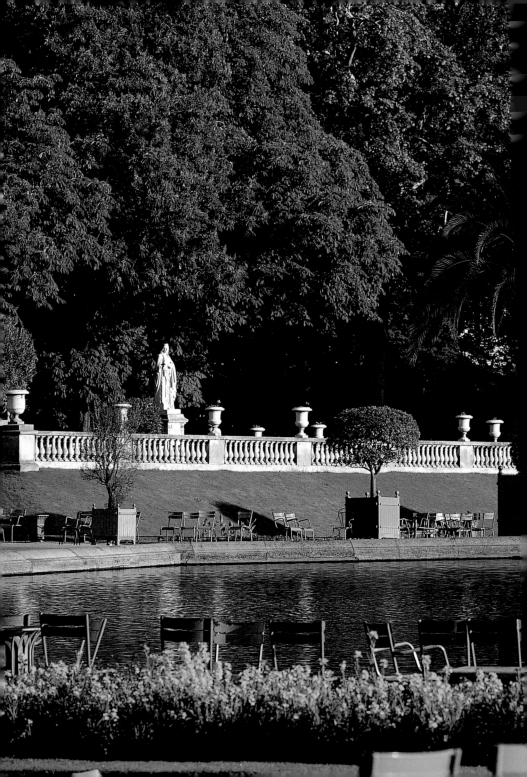

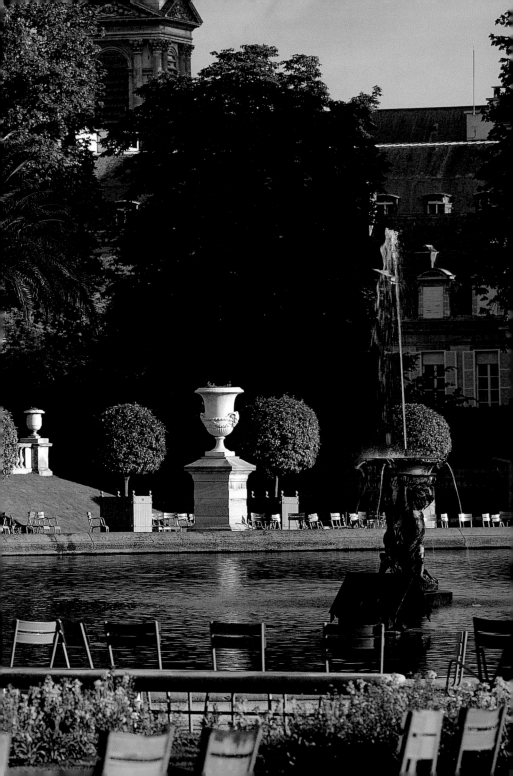

# Gardens

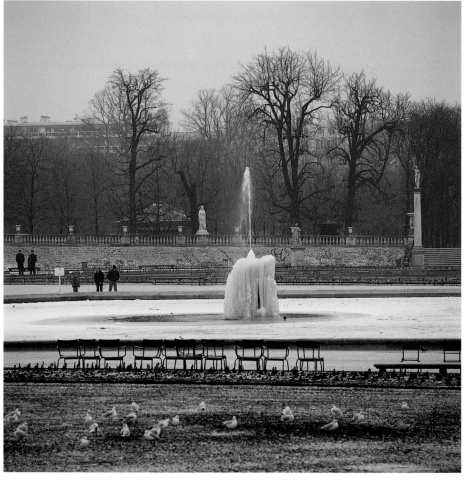

Luxembourg Gardens after ten days of extreme cold, 6ᵗʰ arr.

*preceding double page*

The chairs surrounding the pool
at the Luxembourg Gardens
start attracting passersby
as soon as the weather begins to get warm.

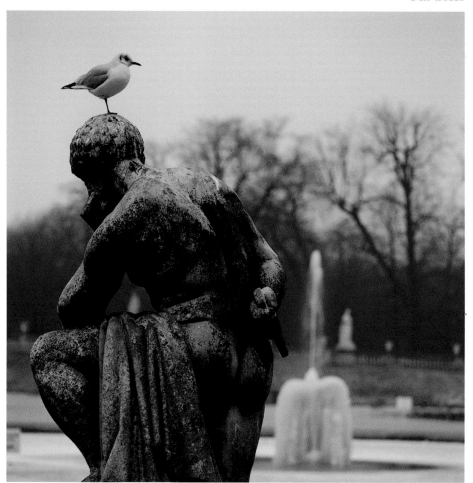

Luxembourg Gardens in winter, 6<sup>th</sup> arr.

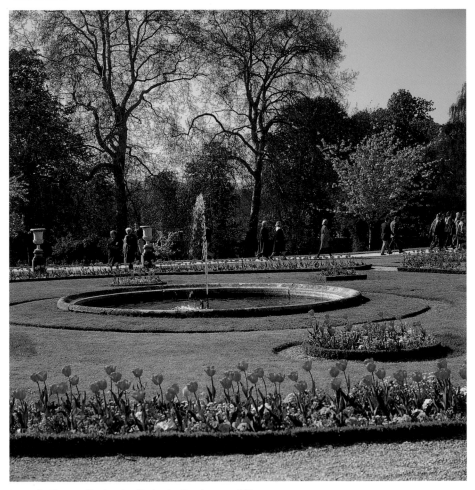

Parc de Bagatelle, in the Bois de Boulogne, 16th arr.

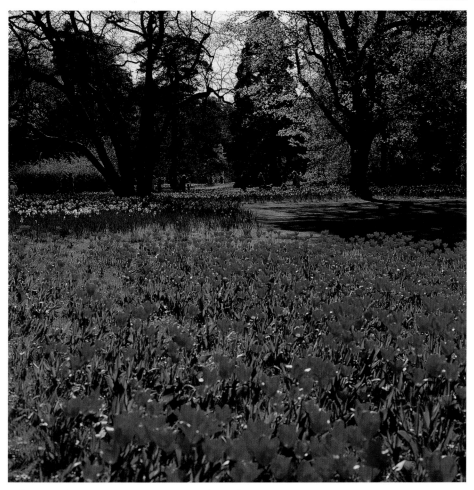

Tulips in bloom in the parc de Bagatelle, 16th arr.

Bagatelle, an English-style park in the heart of
the Bois de Boulogne, 16th arr.

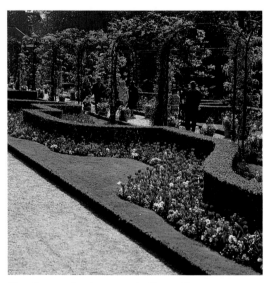

The flowers in the parc de Bagatelle
bloom from June to October, 16th arr.

The pathways in the parc de Bagatelle
make for a beautiful
stroll any time of year, 16th arr.

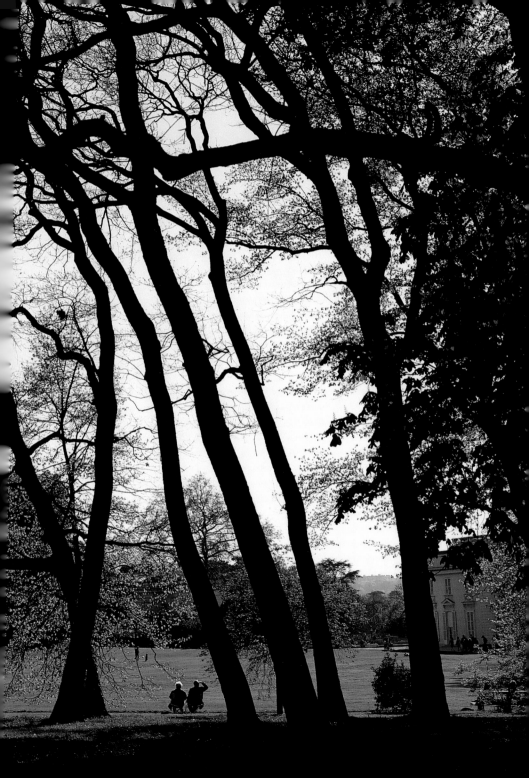

# Gardens

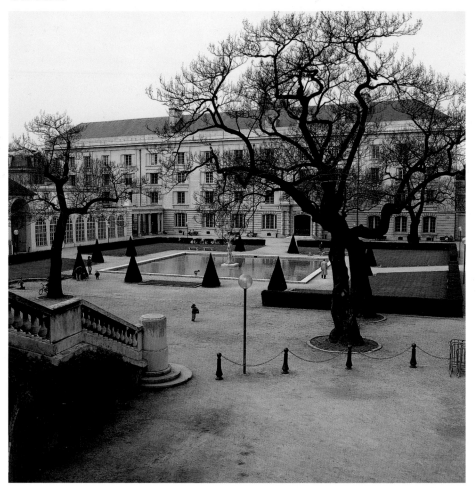

The garden courtyard at the old Polytechnical Institute, 5<sup>th</sup> arr.

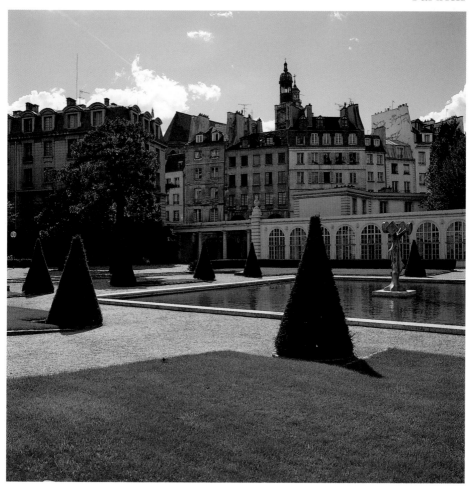

The garden at the old Polytechnical Institute, in the heart of the Latin Quarter, 5th arr.

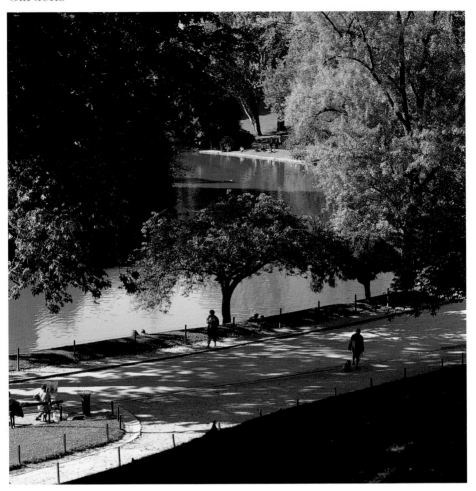

The lake at the parc des Buttes-Chaumont, 19th arr.

A footbridge suspended over the lake
leads to an island formed by rocks,
parc des Buttes-Chaumont, 19th arr.

436

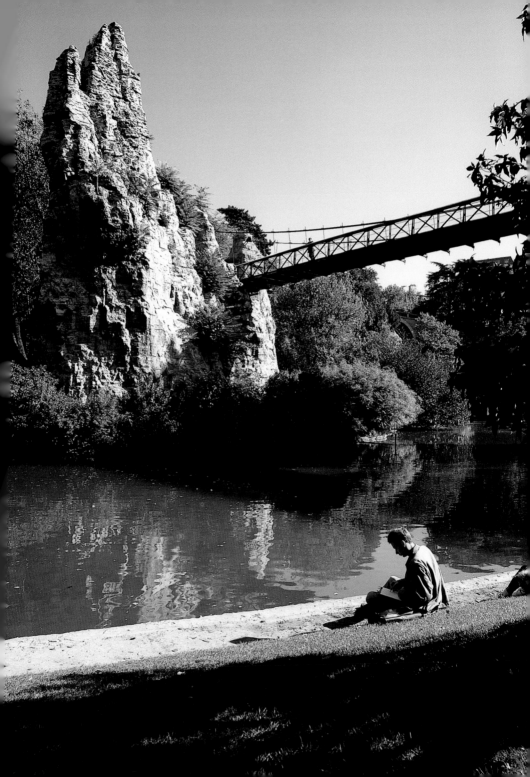

A safe haven in the heart of a busy neighborhood:
the parc des Buttes-Chaumont, 19th arr.

The terrain of the parc des
Buttes-Chaumont is uneven
and filled with jagged edges, 19th arr.

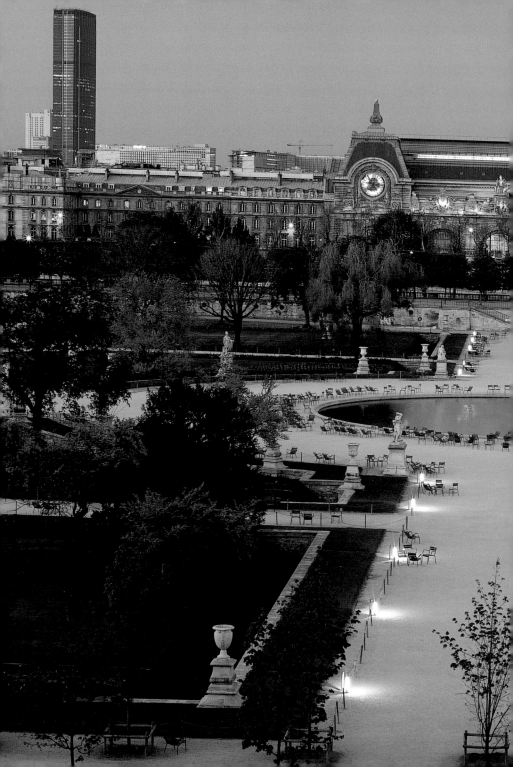

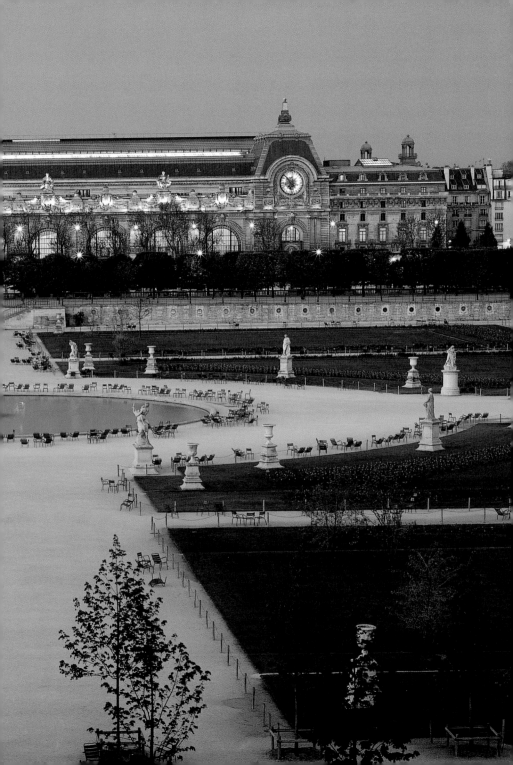

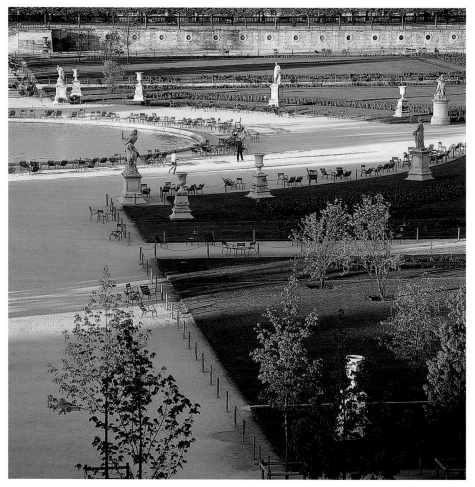

The Tuileries Gardens in front of the Feuillants, running parallel to
the rue de Rivoli, 1ˢᵗ arr.

*preceding double page*

The Tuileries Gardens, Right Bank,
and the Musée d'Orsay, Left Bank, 1ˢᵗ arr.

View of the belltower of the Sainte Clotilde
Church and the dome of the
Invalides, from the Tuileries Gardens.

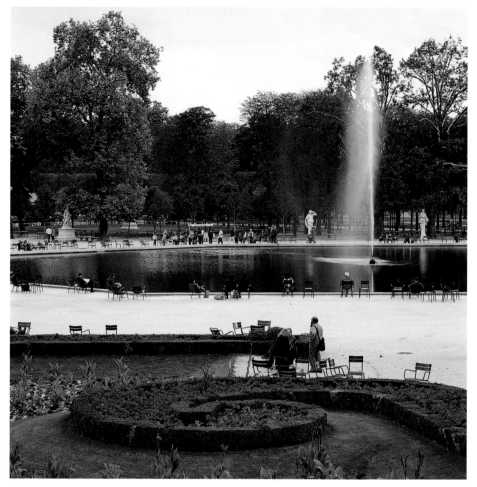

In front of the octagonal pool in the Tuileries Gardens,
the lawn planted with boxwoods, 1ˢᵗ arr.

*preceding double page*

The Eiffel Tower through the trees of the Tuileries Gardens, 1ˢᵗ arr.

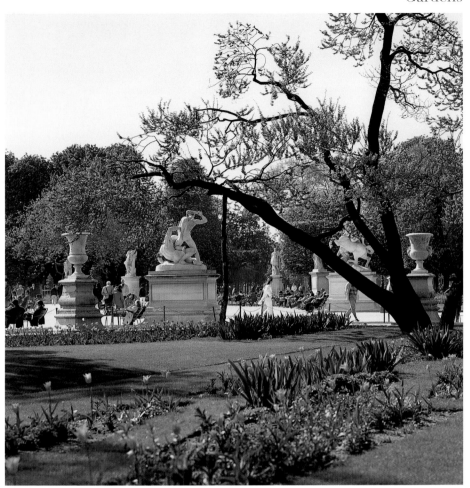

Springtime in the Tuileries Gardens, a veritable sculpture garden featuring classical and contemporary works, 1ˢᵗ arr.

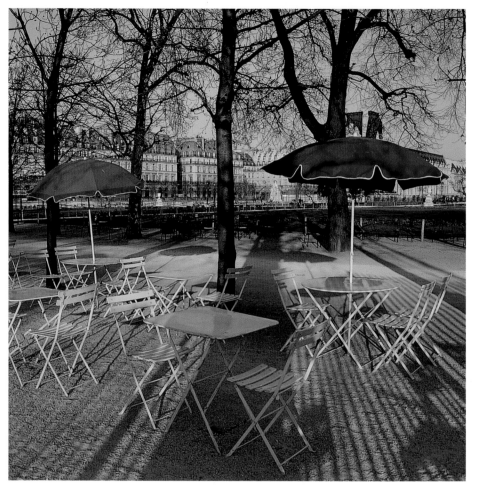

Tables in the Tuileries Gardens with a view onto the rue de Rivoli, 1ˢᵗ arr.

The Tuileries Gardens: a park designed
for children as well as adults, 1ˢᵗ arr.

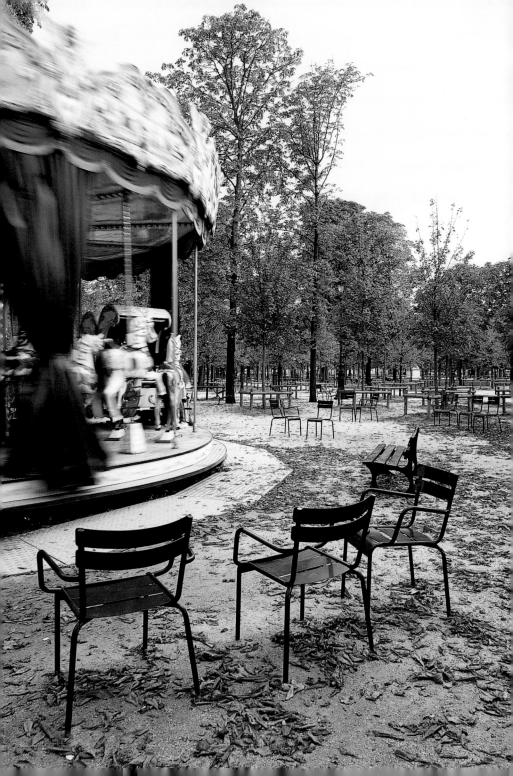

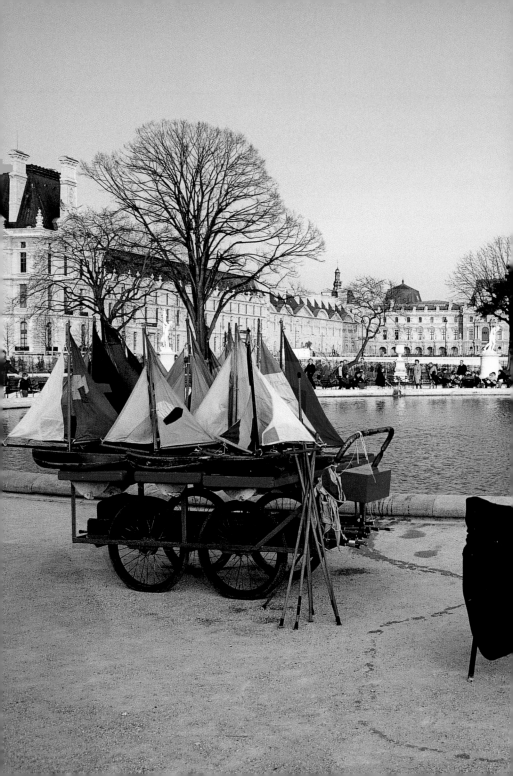

# Gardens

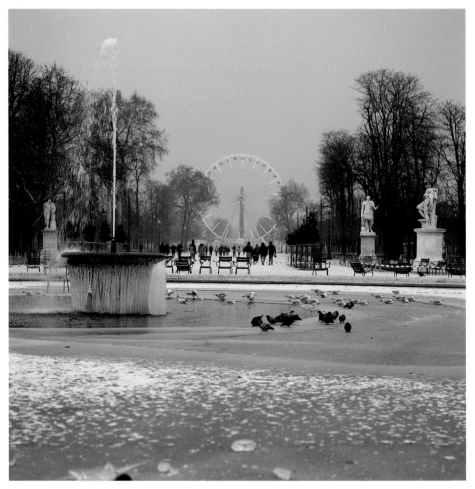

The Tuileries Gardens and the ferris wheel at the place de la Concorde, 1$^{st}$ arr.

*preceding double page*

Toy sailboats for rent at the Tuileries Gardens, 1$^{st}$arr.

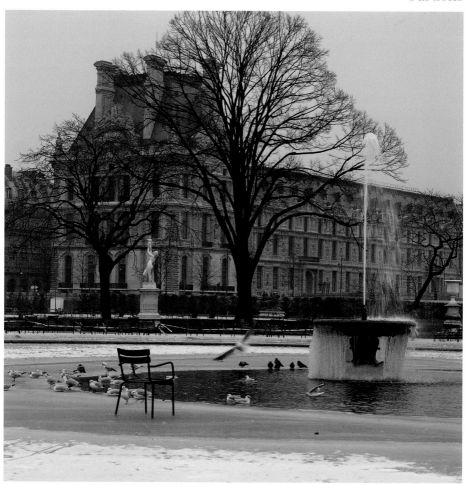

The Carrousel Garden and the Louvre, 1ˢᵗ arr.

Trees in the Bois de Boulogne, 16th arr.

Boats on the lake at the Bois de Boulogne, 16th arr.

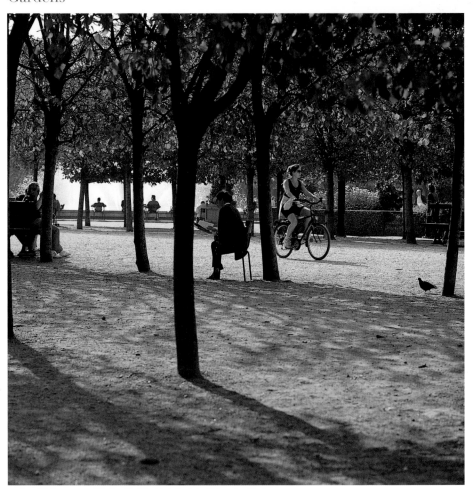

The recently-restored gardens at the Palais-Royal, 1st arr.

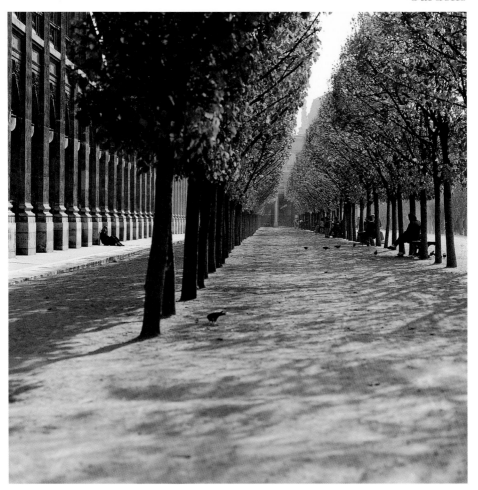

The gardens at the Palais-Royal complement the surrounding galleries that harbor elegant boutiques and cafés, 1st arr.

# Gardens

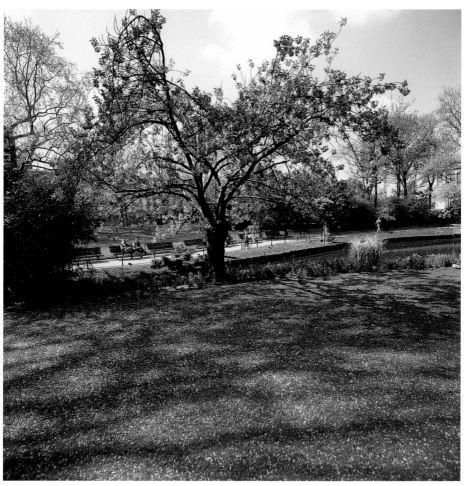

Japanese cherry tree in the Square des Batignolles, 17th arr.

In the north of Paris,
the Square des Batignolles, 17th arr.

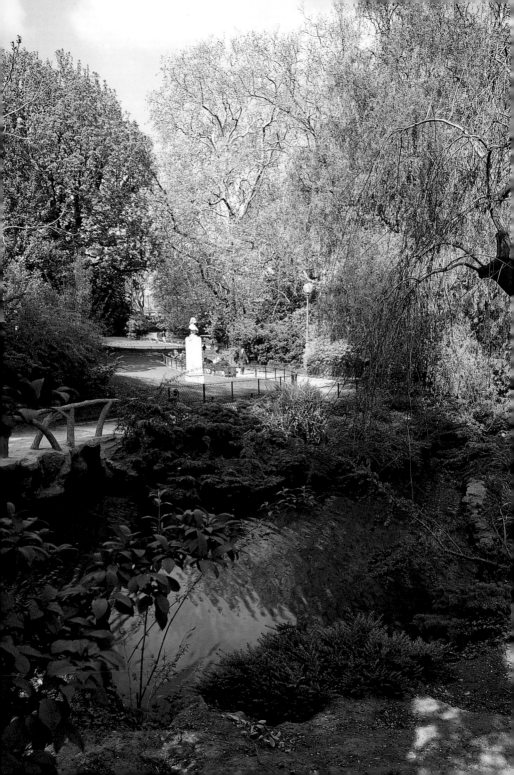

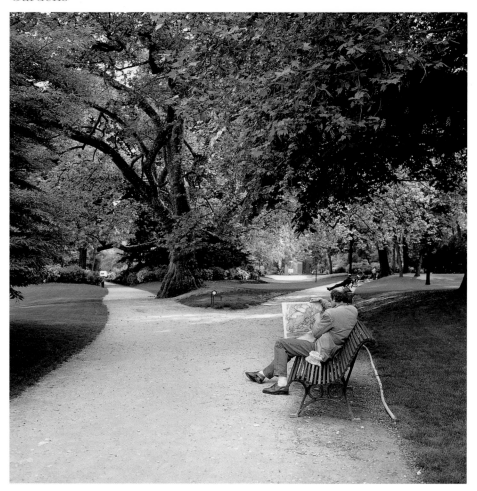

Painter at the parc Monceau, 8th arr.

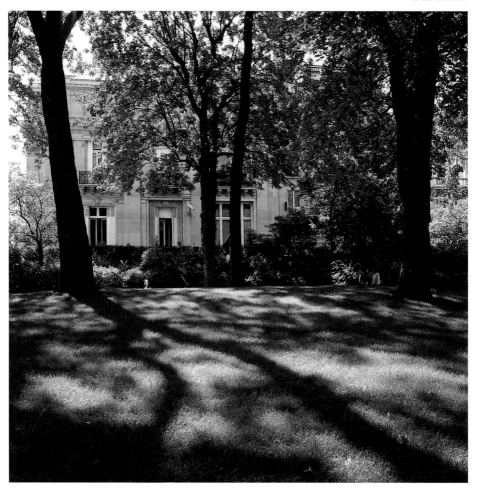

Two museums border the parc Monceau: the Nissim de Camordo Museum
and the Cernushi Museum, 8th arr.

# Gardens

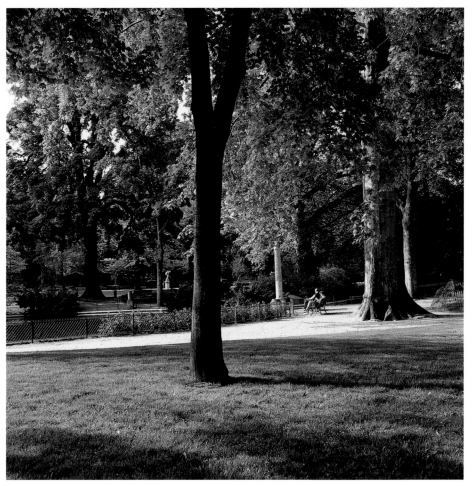

English garden in the parc Monceau, at the heart of an upscale neighborhood, 8th arr.

The columns of Naumachie are reflected in the pool at the parc Monceau, 8th arr.

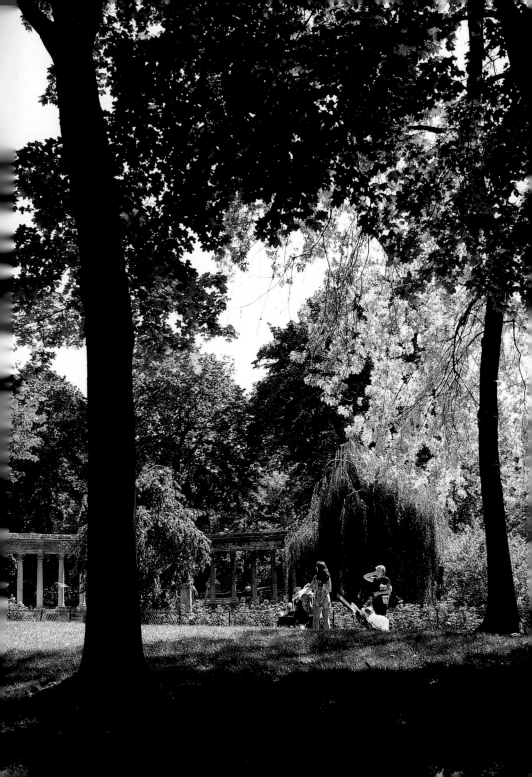

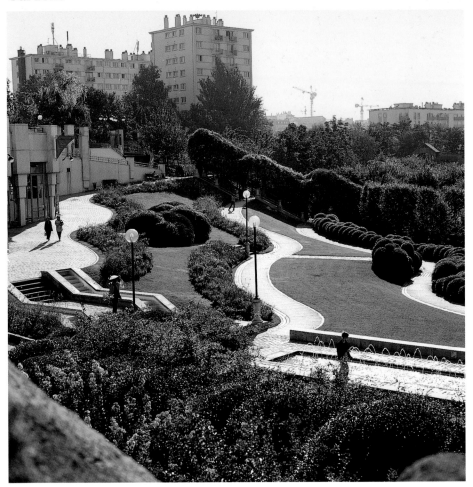

The parc de Belleville, 20<sup>th</sup> arr.

From the top of the parc de Belleville,
at the end of the rue des Envierges,
the view of Paris is spectacular, 20<sup>th</sup> arr.

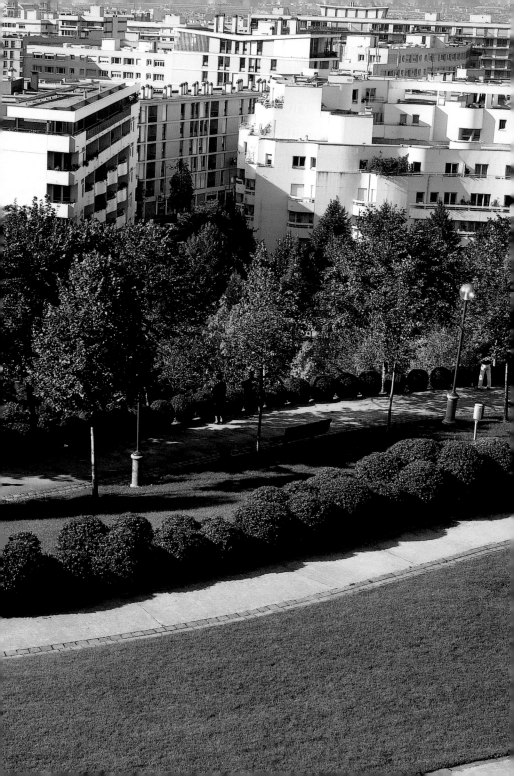

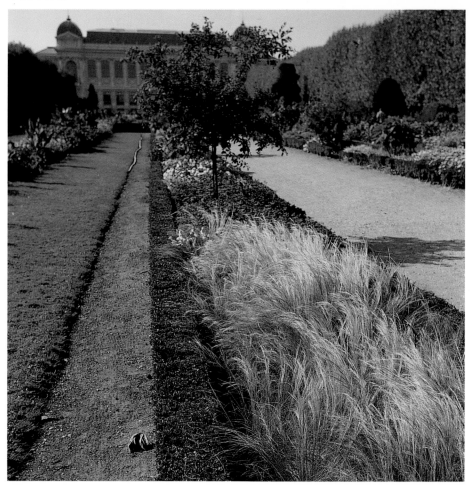

The Jardin des Plantes and the Museum of Natural History, 5th arr.

*preceding double page*
One of the two majestic planted passageways
in the Jardin des Plantes, 5th arr.

Plant-lovers can appreciate
the change of seasons
at the Jardin des Plantes, 5th arr.

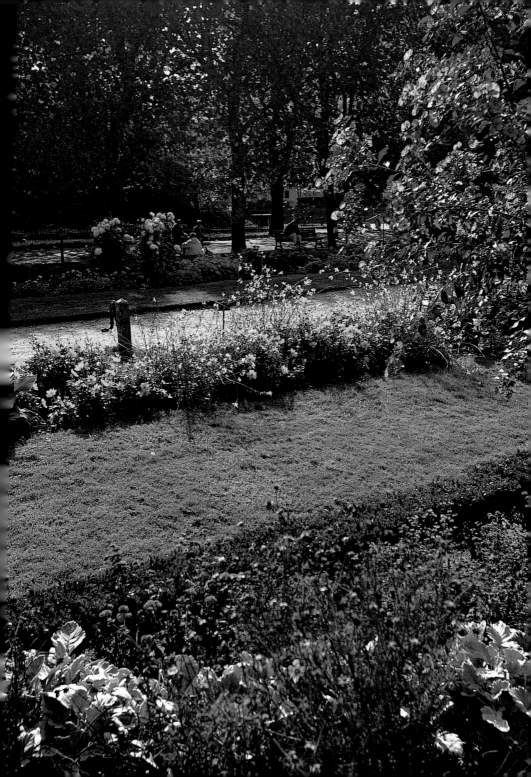

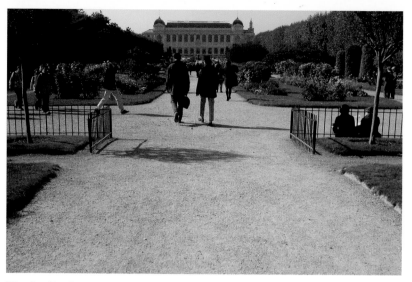

The Jardin des Plantes opens onto the banks of the Seine, 5ᵗʰ arr.

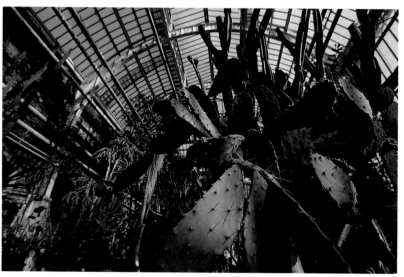

Cactus greenhouse, Jardin des Plantes, 5ᵗʰ arr.

Exotic greenhouse, Jardin des Plantes, 5ᵗʰ arr.

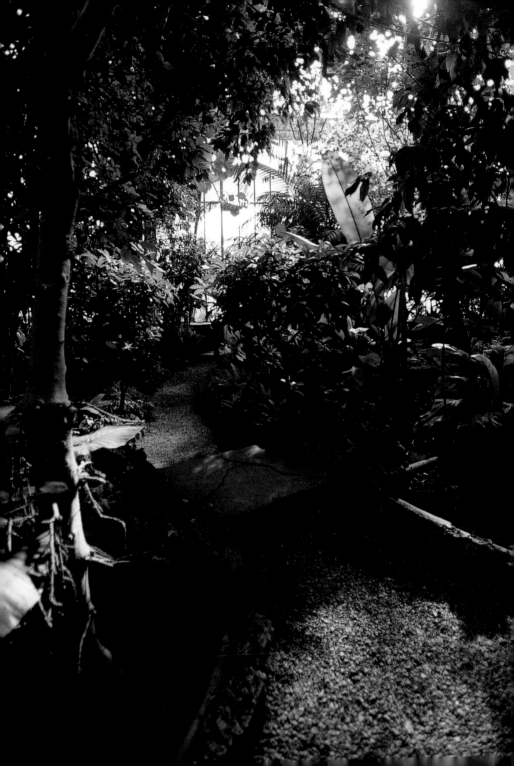

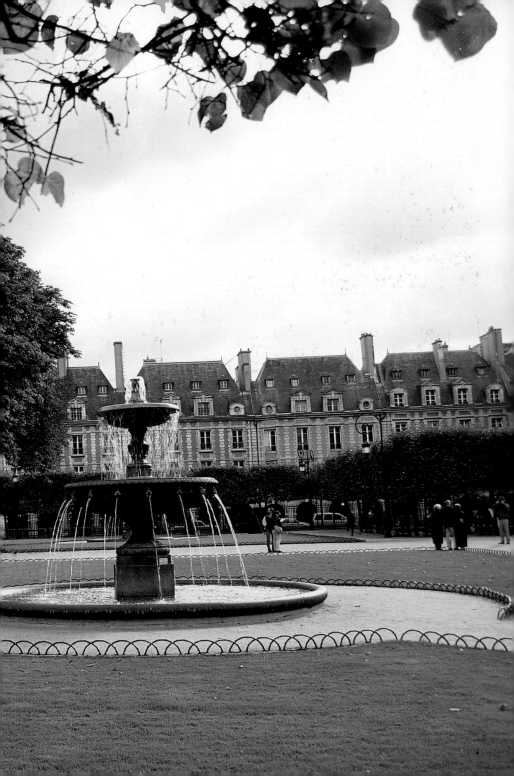

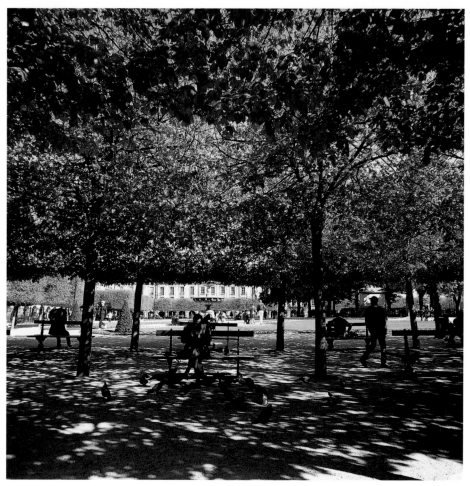

The place des Vosges, the *marais* neighborhood park, 4<sup>th</sup> arr.

*preceding double page*

Fountain in the garden at the place des Vosges, 4<sup>th</sup> arr.

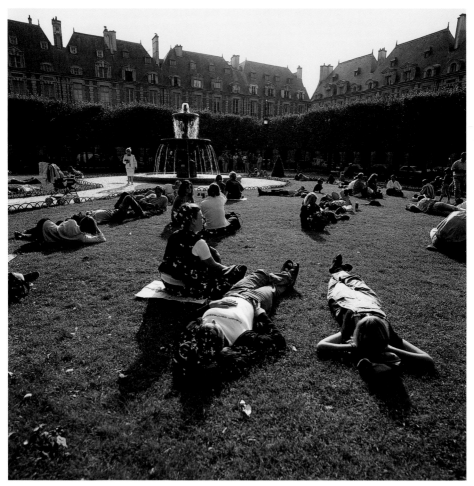

The place des Vosges, a historical public square bordered by brick-faced pavillons, 4<sup>th</sup> arr.

*following double page*

Footbridge in the Jardins de Bercy
in front of the Maison du Lac, an exhibition space, 12<sup>th</sup> arr.

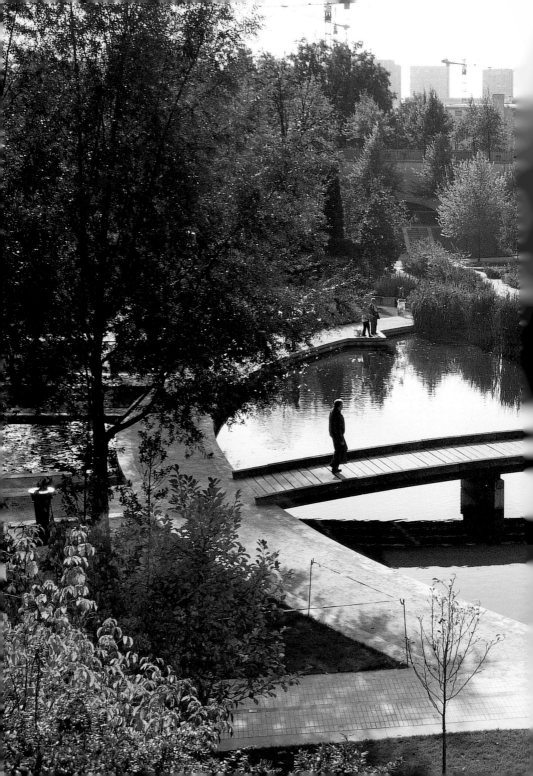

The Gardening House in the Jardin de Bercy, 12<sup>th</sup> arr.

An oriental-style meditation pavillion, in the Jardin de Bercy, 12<sup>th</sup> arr.

The parc de Bercy, toward the
east end of the city, is the
most modern park in Paris, 12<sup>th</sup> arr.

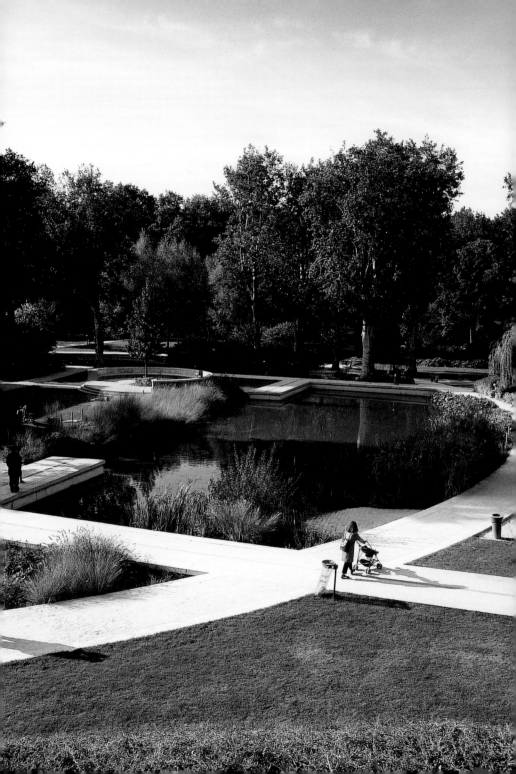

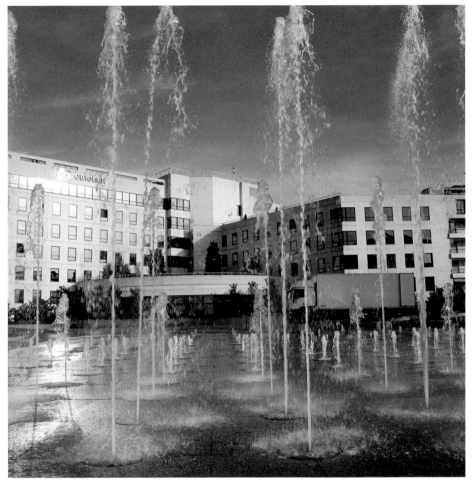

Water jets shooting up at the parc André-Citroën, 15th arr.

*preceding double page*

The parc André-Citroën, on the banks
of the Seine, designed by the
landscape artist Gilles Clément, 15th arr.

The hot-air balloon at the
parc André-Citroën
offers a beautiful view of Paris, 15th arr.

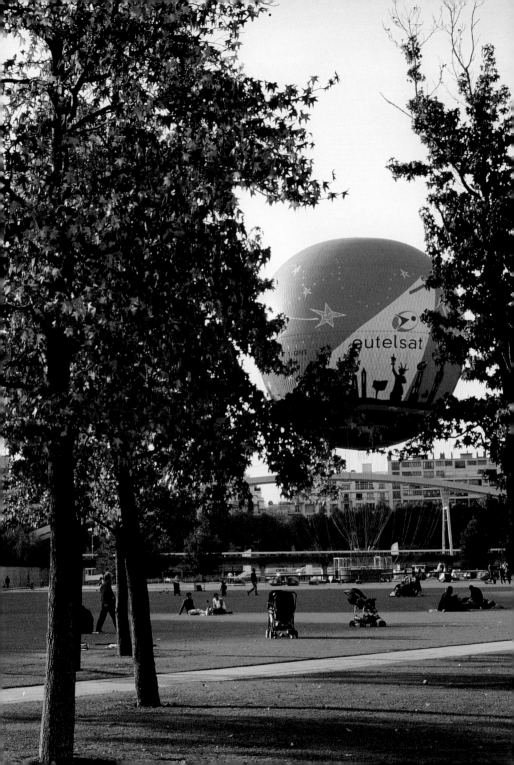

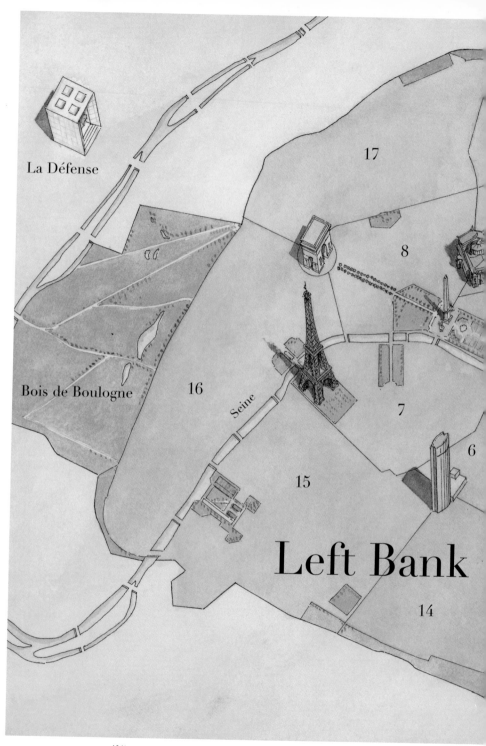

La Défense

17

8

Bois de Boulogne

16

Seine

7

6

15

Left Bank

14

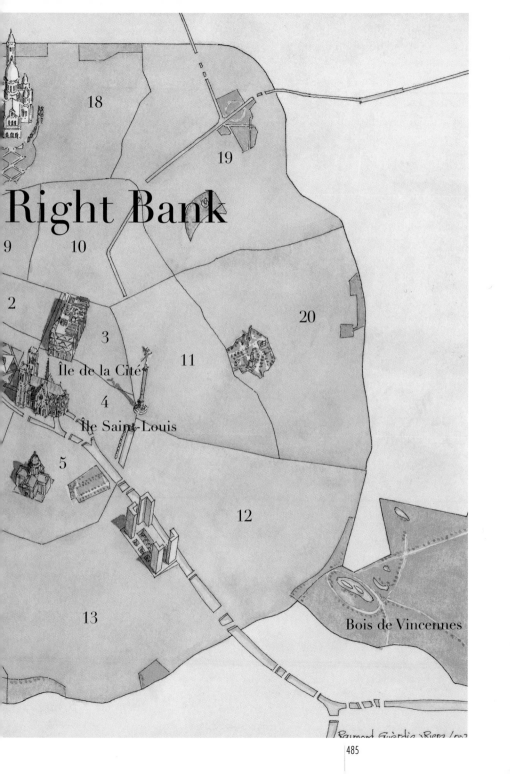

# Right Bank

18

19

9  10

2

3

Île de la Cité

11

20

4

Île Saint-Louis

5

12

13

Bois de Vincennes

# Photo Captions

Cover
   The Louvre Pyramid, designed by architect Ieoh Ming Pei, 1st arr.

Back Cover
   Le Pont-Louis-Philippe restaurant, quai de L'Hôtel de Ville, 4th arr.

Page 4
   *top:* Place de l'Hôtel de Ville, 4th arr.
   *middle:* Notre-Dame Cathedral, from the pont de la Tournelle, 4th arr.
   *bottom:* The Arc de Triomphe on the place de l'Étoile.

Page 5
   *top:* Bookstore in the Galerie Vivienne, 2nd arr.
   *middle:* The Jardin de l'Intendant and the Invalides dome, 7th arr.
   *bottom:* An old tree in the parc Monceau, 8th arr.

Pages 12–13
   Saint-Germain-des-Prés belltower, the dome of the Institute of France, and the Louvre, from the Left Bank.

Page 14
   *left:* Barge at the Pont-Neuf, 1st arr.
   *middle:* Late afternoon at Vert-Galant, on l'île de la Cité, 1st arr.
   *right:* A stroll on the Seine near the top of the quai d'Orléans, 4th arr.

Page 15
   *top:* Square du Vert-Galant at the tip of l'île de la Cité, 1st arr.
   *left:* Boats on the Seine.
   *middle:* Houses of the quai Saint-Michel reflected on the Seine, 5th arr.
   *right:* The Seine at the pont des Arts, 1st arr.

Page 110
   *left:* Cinema dome in the Défense neighborhood.
   *middle:* L'Écoute, sculpture by Henri de Miller in front of the Saint-Eustache Church, 1st arr.
   *right:* Le Fouquet's café terrace on the Champs-Élysées, 8th arr.